MARK ROTHKO

1903–1970

REVISED EDITION

Tate Gallery Publishing

cover
Number 12 1951
Christopher Rothko and Kate Rothko Prizel

frontispiece
Mark Rothko, 1964

ISBN 1 85437 212 2
A catalogue record for this publication is available from the British Library
First published by order of the Trustees 1987
for the exhibition at the Tate Gallery 17 June – 1 September 1987
Second impression 1987
Revised edition 1996, reprinted 1997 & 1999
Copyright © Tate Gallery and Authors 1987, 1999 All rights reserved
Published by Tate Gallery Publishing Limited, Millbank, London SW1P 4RG
Designed by Caroline Johnston
Colour origination by PJ Graphics
Printed in Great Britain by Balding + Mansell, Norwich, Norfolk

Contents

6 Foreword to the Revised Edition *Nicholas Serota*

7 Preface *Alan Bowness*

9 Mark Rothko *Irving Sandler*

21 Notes on Rothko and Tradition *Robert Rosenblum*

32 Reflections on the Rothko Exhibition *Robert Goldwater*

36 Rothko *David Sylvester*

38 Mark Rothko, the Subjects of the Artist *Michael Compton*

67 Selected Statements by Mark Rothko *Bonnie Clearwater*

76 Writings by Mark Rothko

90 Colour Plates

185 List of Works

189 Painting Materials and Techniques of Mark Rothko: Consequences of an Unorthodox Approach *Dana Cranmer*

199 Select Bibliography

205 List of Lenders

206 Photographic Credits

Foreword to the Revised Edition

It is almost ten years now since the first publication of this catalogue to accompany the Mark Rothko exhibition at the Tate Gallery. Since then a number of books have appeared on Rothko and his Abstract Expressionist peers but this catalogue, long out of print, continues to be of importance. The texts by Irving Sandler, Robert Rosenblum and Michael Compton, three leading art historians from both sides of the Atlantic, have already become classics of their time, while Dana Cranmer's essay on Rothko's materials and techniques provides a rare insight into Rothko's craft.

The republication of this catalogue not only endorses the Tate Gallery's high regard for Rothko and his importance within the Collection but permits students continued access to some of the most important writings on his art.

Nicholas Serota *Director*

Preface

Mark Rothko is one of those artists for whom the Tate Gallery has a special concern. The relationship began when the Trustees purchased a painting in 1959, not long before Rothko's very successful exhibition at the Whitechapel Gallery in 1961. It developed especially under my predecessor, Sir Norman Reid, who always spent time with the artist when he visited New York. Rothko came to feel, correctly, that his luminous paintings had found an unusually warm reception in the country of J.M.W. Turner, and he had many friends and admirers among painters, critics and general public alike.

No doubt this was the reason for the magnificent gift that he made in 1968–9 of nine of his finest paintings to form the unique Rothko room at the Tate. The pictures were selected by the artist to fit into a gallery of which a simple folding model has been made. Rothko was at the time finishing his last major work, the interdenominational chapel at Houston, Texas, and the room in which they are shown has become for many a place of spiritual experience, and a source of inspiration, very profound and personal in its effect. In the words of the poet Peter Redgrove:

> We brought
> the lanterns of ourselves in here
> And your imagination blotted our light up, Rothko;
> The black reached out, quenching our perfume
> As in a dark chapel, dark with torn pall,
> And our eyes were lead, sinking
> Into that darkness all humans have for company . . .*

Because of Rothko's special relation with the Tate Gallery it was an honour and a privilege for us to organise this exhibition, not only for the Tate but for several other Museums. Although Rothko is in some ways a very familiar painter, the range of his work is hardly known in Europe. With Pollock, Still, Newman and others he was of course one of the great protagonists of the art (in his case misleadingly) called Abstract Expressionist which gave New York painting its cultural supremacy in the 1950s. But the presence of many earlier figurative and surrealist paintings in this exhibition will give our visitors a fresh insight into the deep and serious significance of the sublime abstract paintings that Rothko made in the last twenty years of his life.

Our main debt of gratitude goes to the daughter and son of the artist, Kate Rothko Prizel

*Peter Redgrove: Into the Rothko Installation, published in *With a Poet's Eye, A Tate Gallery Anthology* (London 1986)

and Christopher Rothko, who are the most important lenders. Without their generous help and co-operation we could not have made the exhibition. We are likewise grateful to the Rothko Foundation whose Chairman, Donald Blinken, has been most supportive. It was his desire to see a major Rothko exhibition in Europe, and he entrusted us with the task. The Foundation's pictures have now been distributed to many Museums which have most kindly honoured the Foundation's commitment to the exhibition, among them above all the National Gallery of Art, Washington, the major beneficiary. The Tate Gallery was most fortunate to receive three important works from the Foundation, which have greatly strengthened our Rothko collection. Many other Museums, Foundations and Private Collections have helped to make the exhibition possible by lending valuable and vulnerable paintings. We deeply appreciate their support; their names are listed on page 203.

The Rothko Foundation has also given substantial financial support to this catalogue, which contains essays by two major scholars of the period, Professors Robert Rosenblum and Irving Sandler, and by two members of the staff of the Foundation, Bonnie Clearwater and Dana Cranmer. The most comprehensive text is written by Michael Compton, Keeper of Museum Services at the Tate Gallery, who has selected the works in the exhibition. The two articles by David Sylvester and Robert Goldwater are those that Rothko thought best described his work. However the most important feature of the catalogue is the comprehensive group of published essays by the artist himself. Our thanks are due, once again, to Kate Rothko Prizel and Christopher Rothko for permission to reprint these and to quote from unpublished material.

Other names should also be recorded. Diane Waldman provided much information from the files of her Guggenheim Museum Retrospective of the artist. Catherine Stover found for us a most interesting group of Rothko's letters in the Archive of the Art Institute of Chicago. The staff of the Archive of American Art have been most helpful in giving us access to their valuable documentation on the artist. Arnold Glimcher of the Pace Gallery, New York, has, as always, been unfailingly helpful. Ezra Stoller found and supplied to us prints of the Four Seasons Restaurant, where the Tate Gallery group of paintings was to have hung, and Philip Johnson sent us the plan.

To all of them our grateful thanks.

Alan Bowness *Director*

Mark Rothko

(In Memory of Robert Goldwater)

IRVING SANDLER

Robert Goldwater once cautioned against reading cosmic allegories and other literary fancies into Mark Rothko's nonobjective paintings. Such 'program notes . . . relax the visual hold of these canvases, filter their immediacy, and push away their enigmatic, gripping presence.'[1] It is noteworthy that even in this warning against the excessive interpretation of their content, an art historian as tough minded as Goldwater should have found it necessary to characterize Rothko's abstractions as 'enigmatic' – and also as 'apparitional.' He obviously could not avoid reporting on his subjective response, a response shared by other viewers, myself included, in sufficient numbers to indicate that inscrutable and preternatural qualities do inhere in Rothko's paintings. Indeed, these ineffable qualities are the source of their distinction, their greatness. But what can be said about them with credibility?

Because Rothko's paintings are enigmatic they have frequently summoned forth the kind of excessive commentary that Goldwater warned against, particularly in the fifties when such art criticism was common. Not surprisingly, the language of Rothko appreciation has been immoderately poetic. Or as Robert Hughes has written, 'out come the violins, the woodwinds, the kettledrums, everything.'[2] Art critics have churned out inflated rhetoric about Rothko's content, commonly ornamented with quotes from the Kabbalah and the like, although a few have written with insight, relying on their own experience. However, the quality of the prose, even at its best, has not approached the quality of the painting. Rothko has yet to find his Baudelaire or Apollinaire. Maybe he won't or can't, as John Ashbery, perhaps our greatest living poet, suggested. Ashbery remarked that he 'had produced a text [on Rothko] containing the words "shades snapped down against the day," "Rembrandt," "Dominican," "poverty," "Spinoza," and "the all-importance of fine distinctions." After having put this paper aside for a few days and come back to it I was infuriated by the inadequacy and silliness of what I had written. Rothko . . . seems to eliminate criticism.'[3]

In reaction against the glut of turgid subjective and poetic analysis of content, critics, for example Clement Greenberg, whose formalist approach dominated art criticism during the sixties, dismissed all such analysis as irrelevant. In the name of objectivity, they insisted on dealing exclusively with the formal components of art. Inquiry into issues 'external' to art was condemned as disreputable.[4] During the last decade, the formalist approach lost its sway over art discourse. It succumbed to a surfeit of wordy interpretations of formal minutiae. Critics in increasing numbers and with growing confidence have been investigating extra-aesthetic feelings and thoughts that inhere in the physical properties of works of art, taking care to

check their personal responses against the formal evidence, verifying them, as it were, or at least making them understandable.

Critics have also been looking to the artists' own statements of intentions for suggestions as to how their works might be perceived and for information as to how they came into being. Everyone is aware of the intentional fallacy, that an artist's intention is not necessarily conveyed by his or her works. But it can be tested against pictorial or sculptural 'facts.' Actually, there is no way to avoid considering an artist's aims if we know them; we cannot make believe that we do not. Even our awareness of a work's date conditions our experience of it, as Thomas McEvilley wrote. 'Imagine yourself looking at a painting in a gallery, by an artist whose name is unknown to you, and reading its date, from the wall label, as 1860; suddenly a gallery attendant approaches and corrects the label to read 1960. One's critical awareness shifts immediately in response to one's new sense of what the artist knew, what paintings the artist had seen, and what the artist's implicit intentions, given his or her historical context, must have been.'[5]

In the case of Rothko, the correlation between the statements he published in the forties and the pictures he painted is a close one, making the analysis of his intention valuable. Indeed, his remarks not only elucidate but at times appear to anticipate developments in his work. Rothko wrote that changes in his style or its 'progression' were motivated by a growing clarification of his content[6] – and content was primary. He and Adolph Gottlieb emphasized this as early as 1943, in a now-famous letter to *The New York Times*. They declared: 'It is a widely accepted notion among painters that it does not matter what one paints as long as it is well painted. This is the essence of academicism. There is no such thing as good painting about nothing. We assert that the subject [or content, as we would say today] is crucial.'[7] The 'subjects' that engaged Rothko and Gottlieb at the time (as well as Jackson Pollock, Clyfford Still, William Baziotes, and other painters who would soon be labeled the Abstract Expressionists) were, as they said, concerned with primitive myths and symbols that continue to have meaning today.[8] Beginning around 1942, Rothko employed the Surrealist technique of 'a free almost automatic calligraphy,'[9] to invent fantastic hybrids composed of human, animal, bird, fish, insect, and plant parts, protozoa and other primitive, often aquatic, organisms that seem to be engaged in cryptic mythic or ritual activities.[10]

Rothko conceived of these 'pictures as dramas: the shapes . . . are the performers. They have been created from the need for a group of actors who are able to move dramatically without embarrassment and execute gestures without shame.'[11] His mythic or Surrealist pictures, as they are now called, were inspired by Greco-Roman legends and tragic plays which Rothko believed expressed Man's fears and destructive passions.[12] His purpose was not to illustrate specific anecdotes but to suggest the 'tragic and timeless'[13] 'Spirit of Myth, which is generic to all myths of all time,' as he wrote of a canvas titled 'The Omen of the Eagle,' 1942, whose subject was derived from the Agamemnon Trilogy of Aeschylus.[14]

In 1946, Rothko began to think that specific references to nature and to existing art conflicted with the idea of the 'Spirit of Myth' or what he began to call 'transcendental

experience.'[15] The two terms are related but not the same in meaning. The one seems to issue from some deep, barely accessible stratum of being – one thinks of Jung's collective unconscious; the other is more readily available and directly apprehended. Rothko did not specify what transcendental experience was, but his writing on the whole suggests that it involves the release from banal, everyday existence, the rising above the self's habitual experience into a state of self-transcendence. That, as I see it, is what he meant by his 'idea.'

As Rothko wrote: 'The familiar identity of things has to be pulverized in order to destroy . . . finite associations.'[16] He soon stopped titling his pictures and expunged from them any semblance of nature, symbols or signs. These had become 'obstacles' in the way of a clear presentation of his 'idea.'[17] Instead of depicting 'fragments of myth' calligraphically,[18] Rothko began to paint irregular washes of color, but he found them too diffuse and drifting. Toward the end of 1949, he reduced these amorphous areas into a few softly painted and edged rectangles of atmospheric color, placed, or, rather, floated symmetrically one above the other on somewhat more opaque vertical fields. He also greatly enlarged the size of his canvases. These 'classic' abstractions, as they have come to be known, were at once unprecedented and the culmination of a long development, anticipated not only by the abstractions that immediately preceded them but by the banded backgrounds of the Surrealist pictures and even by the insistent rectangularity of his subway scenes of the thirties.

Rothko's radical simplification of format calls to mind his intention, and that of Gottlieb, which they stated in their letter to *The Times*. 'We favor the simple expression of the complex thought. We are for the large shape because it has the impact of the unequivocal. We wish to reassert the picture plane. We are for flat forms because they destroy illusion and reveal truth.'[19] Although Rothko thought of the biomorphic shapes in his Surrealist paintings of 1943 as simple, large and flat, these adjectives apply with far greater pertinence to the rectangles he began to paint six years later. To be sure, Rothko was not following a program, but he did seem to extend his ideas concerning content until he arrived at unprecedented forms.

Apart from Rothko's published statements, there is another written source that accounts for and in part may have even inspired his 'progression' into nonobjectivity. That source was Edmund Burke's philosophic inquiry into the sublime of 1757, which Rothko read, most likely before 1948, that is, before he began his 'classic' paintings.[20] The word 'sublime' which bears a close resemblance to 'transcendental experience,' has been applied to the abstractions of Rothko, and also of Still and Newman, so often as to become a cliche. Hughes spoofed its repeated use in an article on Rothko's retrospective in 1978, the 'sublime, sublime, sublime, sublime: the reflexes go clickety-clack, all the way down the Guggenheim [Museum] ramp.'[21] However, the sublime need not be thought of in inflated, hackneyed terms. It has been experienced by most if not all of us before certain natural phenomena and works of art. And it is to be expected that artists, such as Rothko, should have aspired to reveal their experiences of the sublime in their painting and sculpture, and that a few should have succeeded.

In his treatise, Burke listed the qualities which evoke the sublime, among them vastness, oneness, infinity, vacuity, and darkness. As if heeding Burke's warning that the imagination should not be checked 'at every change . . . [making it] impossible to continue that uninterrupted progression which alone can stamp on bounded objects the character of infinity,'[22] Rothko eliminated line from his paintings. The blurring of demarcations dislodges the rectangles, causing them to hover in and out, but it also turns the surface of each of his pictures into an allover field, creating an effect of oneness. Enhancing this effect is the spread of the rectangles across the canvas, terminating near the framing edges, declaring the wholeness of the work. At the same time, the field is continuous and open, suggesting an extension into infinity.

Having eliminated line, all that remained to convey content was color. (Rothko was disposed toward expression through color early in his career; during the thirties, he looked for inspiration to Matisse and Milton Avery when most other American vanguard artists venerated Picasso and Mondrian for whom drawing was primary.) Rothko built up his rectangular containers of color from lightly brushed, stained and blotted touches which culminate in a chromatic crescendo. These resonant nuances also function as subtle lights and darks which create atmosphere, a tinted aura that emanates from within the painting and suffuses the entire surface. This aura is at once glowing and shadowy; Lawrence Alloway remarked on 'Rothko's characteristic effect of light combined with obscurity' and added that it is 'anticipated by Burke when he observes that "extreme light . . . obliterates all objects, so as in its effects exactly to resemble darkness"'[23] Burke also remarked that dark colors evoke the sublime;[24] Rothko favored a somber palette, particularly after 1957. Moreover, because his vaporous colors are used in large expanses, they seem void, even suggestive of The Void. And because they do not call to mind anything of this world, they seem otherworldly. The colors, even the brightest reds and yellows in most cases, are sufficiently 'off,' dissonant, disquieting. They are not decorative, seductive and sensuous; thus they do not fulfill the familiar expectations of color. Instead, they evoke other-than-sensuous qualities.

Burke observed that the sublime is caused by 'greatness of dimension' and when 'the mind is so entirely filled with its object, that it cannot entertain any other.'[25] Bigness can overpower, reduce the observer. It can also produce an effect of intimacy; the latter is what Rothko desired. 'To paint a small picture is to place yourself [and the observer] outside your [and his or her] experience, to look upon an experience as a stereoptican view or with a reducing glass. However you paint the larger picture, you are in it.'[26] Rothko scaled his pictures to human size. He also wished for them to be exhibited in small rooms, drawing observers close up to the surface, enveloping them in luminous atmosphere while compelling them to contemplate the nuances of the painting. It is as if Rothko wanted to detach the observers from their prosaic environment and attachments which prevent self-transcendence and at the same time, to convey this experience dramatically – purely with color.

In this sense, Rothko's pictures can be viewed as backdrops in front of which observers are transformed into live actors, the range of whose response but not the particulars is controlled

by Rothko's 'idea.' The evolution of Rothko's painting can be interpreted in dramaturgical terms as the assimilation of myth-inspired action – the shapes as performers against banded backgrounds – into scene – the horizontal rectangles as a kind of stage set.[27] (And yet, the hovering rectangles also function as performers of a sort; their colors and sizes and the intervals between them are varied, directing attention to their interactions.) That Rothko had in mind an immediate and intimate communion between the painting and the viewer is suggested by the last statement he wrote for publication in 1949. It reads in part: 'The progression of a painter's work, as it travels in time from point to point, will be toward clarity: toward the elimination of all obstacles between the painter and the idea, and between the idea and the observer.'[28]

Rothko was preoccupied, at times obsessed, or so it seemed, with the observers' responses to his work.[29] The intensity of his concern is disclosed in a comment he wrote in 1947 that a picture 'lives by companionship, expanding and quickening in the eyes of the sensitive observer. It dies by the same token. It is therefore a risky and unfeeling act to send it out into the world.'[30] In 1952, he refused to submit two of his works to the purchasing committee of the Whitney Museum because of 'a deep sense of responsibility for the life my pictures will lead out in the world.'[31]

The problem of communication had troubled Rothko as early as 1943. He and Gottlieb had written to Edward Alden Jewell, the senior art critic of *The New York Times* that it was their 'function as artists to make the spectator see the world our way – not his way.'[32] But in the case of Jewell, they had not succeeded. He remarked that Rothko's 'The Syrian Bull' and Gottlieb's 'The Rape of Persephone' had left him in a 'dense mood of befuddlement.'[33] And these were two myth-inspired paintings – with recognizable imagery and explanatory titles. The 'classic' abstractions, because they were nonobjective, turned out to be considerably more befuddling, at least to most art critics. Those who commanded the greatest attention because their writing was stimulating and/or because of the prestige of the publications in which it appeared, did not see Rothko's pictures his way – or each other's way. It was very dispiriting for him, the gloom not lessened much by the fact that these critics with a few exceptions were very laudatory.

There were several critics whose writing addressed issues with which Rothko himself was concerned. For example, in 1954, Hubert Crehan wrote that in our culture light is a metaphor for spiritual essence. 'Rothko's work is charged with what we mean by matters of the spirit.' Crehan likened it to 'the Biblical image of the heavens opening up and revealing a celestial light, a light sometimes so blinding, its brilliance so intense that the light itself became the content of the vision, within which were delivered annunciations of things closest to the human spirit.' Crehan concluded: 'Rothko's vision is a focus on the modern sensibility's need for its own authentic spiritual experience. And the image of his work is the symbolic expression of this idea. Now it is virtually impossible to articulate in rational terms what this might be; we can have only intimations of it which come first to us from our artists.'[34]

As a critic, Crehan was peripheral, a California disciple of Still displaced in New York City.

In contrast, Clement Greenberg was widely recognized as a leading critic. In one of his most important articles, titled '"American-Type" Painting,' 1955, he wrote that Rothko was 'a brilliant original colorist.' His 'big vertical pictures, with their incandescent color and their bold and simple sensuousness – or rather their *firm* sensuousness – are among the largest gems of abstract expressionism.'[35] Greenberg's high praise probably pleased Rothko, but little else in his essay would have.

In Greenberg's opinion, the purpose of Abstract Expressionism was to break the hold of Cubism, repudiating in particular its contrasts of dark and light. These generate illusionistic space which destroys pictorial flatness, the very basis of painting. Moreover, Cubism was overworked and outworn. Rothko, Newman and Still had progressed further than their colleagues, because they had achieved 'a more consistent and radical suppression of value contrasts than seen so far in abstract art.' This had liberated their color, which 'breathes from the canvas with an enveloping effect, which is intensified by the largeness itself of the picture.'[36] Their vision was 'keyed to the primacy of color.'[37] Rothko accepted Greenberg's description of his formal innovations. But he objected to the implication that he was primarily a picture-maker whose intention it was to avoid any allusion to Cubism in order to paint flat color-fields. If it had been, he certainly would have suppressed light and dark contrasts more than he had – as much as Newman perhaps.[38]

Rothko also disapproved of Greenberg's purist point of view. Greenberg maintained that 'visual art should confine itself exclusively to what is given in visual experience, and make no reference to anything given in any other order of experience.'[39] This notion that painting ought to refer to nothing beyond itself, to be self contained like an object, was alien to Rothko. He once remarked that he would 'sooner confer anthropomorphic attributes upon a stone than dehumanize the slightest possibility of consciousness.'[40]

Greenberg's formal analysis was also foreign to a group of Abstract Expressionists generally labeled the painterly or gestural or 'action' painters which included Willem de Kooning, Franz Kline and Philip Guston. But they, like Greenberg, admired Rothko's painting, even though its intention was opposed to theirs. Elaine de Kooning, a respected painter and critic at the epicenter of this group, so esteemed Rothko that she tried to turn him into a self-expressive 'action' painter, borrowing Harold Rosenberg's notorious label. In an article titled 'Two Americans in Action,' 1958, she linked Rothko and Kline. As she viewed it, they both used the process of painting to encounter images of 'individual identity.' It was a sign of the power of Expressionist rhetoric at the time that it should be foisted upon Rothko's painting, even if it did not apply. De Kooning herself acknowledged that Rothko's pictures were devoid of idiosyncratic signs of 'action,' namely visible brushwork and drawing; his 'image seems to settle on the canvas indirectly, leaving no trace of the means that brought it there.' The upshot was 'tinted hallucinated cloth,'[41] a characterization that would have pleased Rothko were he not upset by the Rosenbergian rhetoric. De Kooning meant well in situating Rothko among the 'action' painters. She was a champion of that style, and Kline

was one of her favorite painters. She wanted to embrace Rothko in what she loved, but he did not want to be included.[42]

Unlike de Kooning, Rosenberg considered Rothko's works as the 'antithesis to action painting.' They were 'based on the idea of one idea. This was an aspiration toward an aesthetic essence, which . . . [Rothko] sought to attain . . . by rationally calculating what was irreducible in painting.' He was engaged in a 'marathon of deletions,' 'acts of subtraction,' 'reductionist aesthetics,' 'the act of purging,' and the like.[43] Rosenberg turned Rothko into a purist, as if he were an unfinished Ad Reinhardt. Had Rothko lived to read this review, he would have found it baffling. But even in his lifetime, the more art criticism about his work he read, the more convinced he must have been that 'the workings of the critical mind is one of life's mysteries,' as he and Gottlieb wrote to *The Times* in 1943.[44]

In 1949, Rothko stopped publishing statements, except for a letter to *Art News* in 1957.[45] He had come to believe that they instruct the viewer as to what to look for and thus stunt his or her mind and imagination.[46] However, in 1958, he felt the need to refute his critics and chose to do so by giving a talk at Pratt Institute.[47] He strongly denied any concern with self-expression, with Expressionism. He insisted that his aim was to formulate a message which transcended self and was about the human condition generally or, as he put it, the human drama. Rothko also denied that his purpose was to make formal innovations, although he allowed that he had 'used colors and shapes in a way that painters before have not.'

In rebuttal to the notion that he was an unpremeditated 'action' painter, Rothko stressed (not without irony) the deliberateness of his process. He enumerated seven ingredients that constituted his painting and claimed to 'measure [them] very carefully.' Above all, his work had to possess 'intimations of mortality.' Next in order (of quantity) was 'sensuality . . . a lustful relation to things that exist.' Three: tension. Four: irony, 'a modern ingredient – the self-effacement necessary for an instant to go on to something else.' And to make the awareness of death endurable; five, wit and play; six, the ephemeral and chance; and seven, hope, 10% worth. Rothko then said that he mixed his ingredients with craft – he dwelt on this – and with craftiness or, to use his own word, 'shrewdness.' His listing was also an ironic gloss on formalist analysis. He enumerated elements of human content as if they were measurable quantities, just as formal components were supposed to be.

Rothko not only refuted the ideas of de Kooning and Greenberg in his talk at Pratt, but he confirmed the direction his work had begun to take the year before – toward 'a clear preoccupation with death,' the sign of which was his growing use of tenebrous browns, deep maroons and plums, grays and black. Rothko had long thought of his painting as essentially tragic. In fact, in the letter to *The Times* of 1943, the only words he himself had written were: 'only that subject matter is valid which is tragic and timeless.'[48]

But Rothko's conception of tragedy was not always bleak, not in the late forties and early and middle fifties. In 1947, he remarked: 'For me the great achievements of the centuries in which the artist accepted the probable and familiar as his subjects were the pictures of the

single human figure – alone in a moment of utter immobility. But the solitary figure could not raise its limbs in a single gesture that might indicate its concern with the fact of mortality and an insatiable appetite for ubiquitous experience in face of this fact.'[49] This figure is Renaissance Man, and Rothko's comment signals his liberation from the restrictive vision of the Renaissance.[50] He also implied that Modern Man's tragic awareness of death freed him to *live*. This is an existentialist conception; as William Barrett, a philosopher friendly with the Abstract Expressionists, wrote: 'In the face of death, life has an absolute value. The meaning of death is precisely the revelation of this value.'[51] (The writing of Sartre and Camus was introduced into America only after the European phase of World War II ended in 1945. Rothko's statement was made in the following year, indicating the speed with which he embraced existentialist thinking.)

In reaction against the immobility of Renaissance Man, Rothko concluded: 'It is really a matter . . . of breathing and stretching one's arms again.'[52] The earlier 'classic' pictures suffused with expansive, translucent atmosphere seem to have provided such occasions for Rothko. But they are also tragic, because they evoke the sensual world and its dissolution into spirit (and/or death). As Robert Rosenblum remarked, they pit 'Rothko, the monk' against 'Rothko, the voluptuary.'[53] The choice is between two goods – the true essence of tragic drama. Rothko's talk at Pratt was far more pessimistic in mood. No longer did the awareness of death give rise to an urge for life; now both were barely endurable. Rothko's growing anguish caused him to darken his palette. The atmosphere in most of his pictures turns oppressive, making it difficult figuratively to breathe and stretch.

In 1958, Dore Ashton accounted for this change in tone. 'Rothko struck out with exasperation at the general misinterpretation of his earlier works [as decorative] – especially the effusive yellow, orange and pinks of three years back.' The new pictures speak 'in a great tragic voice (although one borders on irritable despair).'[54] Indeed, it appears that the tragic ingredient in Rothko's work as a whole grew in proportion to the others. In many pictures painted in the last two years of his life, particularly in the hopeless 'black' ones, there is little but the intimation of mortality.

In his talk at Pratt, Rothko formulated his self-image as an artist. His function was not that of a formal problem-solver or a self-revealing Expressionist but of a contemporary seer who, on the authority of an inner voice, envisions and reveals new truths about the human drama. He said: 'I want to mention a marvelous book, Kierkegaard's *Fear and Trembling/The Sickness Unto Death*, which deals with the sacrifice of Isaac by Abraham. Abraham's act was absolutely unique. There are other examples of sacrifice [that seem related]: Brutus, who as a ruler put to death his two sons [because they had broken the law. Brutus's tragic decision was understandable; the choice was between two known "universals": the State or the Family.] But what Abraham was prepared to do [on God's command audible only to himself] was beyond understanding. There was no universal that condoned such an act. This is like the role of the artist.'

God did not require Abraham to sacrifice Isaac. Abraham's problem then became, as

Rothko saw it: what to tell about his vision – even to his own wife. What would she believe? What would the neighbors believe? What is believable today, in an age of modernist skepticism? Not monsters, demi-gods, gods, God. Their images, symbols and signs have lost their power to grip the modern imagination. A contemporary artist could only be reticent. It was a matter of shrewdness, as Rothko said in his talk at Pratt. Besides, 'there is more power in telling little than in telling all.'

What was to replace conventional subjects? The answer to this question, as Rothko viewed it, was his own self-transcendent experience as revealed through art, through painting and, above all, color, the inherent expressiveness of color. Such experience, personal though it is, possesses intimations of The Transcendental, 'of the presence of God, the all-holy.'[55] In this sense, it is religious or, because it is not based on any established dogma, quasi-religious. To put it another way, transcendental experience generated through the creation and apprehension of art is analogous to that generated through religion. Because such experience is 'real and existing in ourselves,'[56] it is human. Because it is intense, it is dramatic. Because it calls to mind death, it is tragic. And when it promises nothing beyond, it can be unbearably tragic. Rothko's talk at Pratt was studded with the words 'human,' 'drama' and 'tragic.'

Who would believe a private vision revealed through nonobjective art? Rothko was skeptical whether his abstractions, because they were unprecedented, were comprehensible to anyone else. This caused him great anxiety, exacerbated by the hostility they elicited. But he also spoke of being surprised not only that there was an audience for his work, but that this audience seemed to be waiting for 'a voice to speak to them' and responded totally to it. 'There was a revolution in viewing, a "well at last, that's exactly what should have been done." This was a reaction based on life not on art. This is the thing to be explained.'[57]

A nagging question remains. Were Rothko's paintings of transcendental experience too private, too humanly vulnerable, too reduced, even impoverished in their pictorial means to be major? Hughes thought so. He granted their mythic and quasi-religious resonance but added: 'In an age of iconography, he might have been a major religious artist . . . He did not live in such an age.' Certainly, Rothko could not partake of the fusion of 'myth, dogma, symbol, and personal inspiration that gave religious artists from Cimabue to Blake their essential subjects.'[58] Yet, even in a time of modernist doubt, when leading philosophers such as Sartre and Camus have asserted that our universe is lacking in ultimate meaning, that it is absurd, even in such an age there remains the yearning, the need, for self-transcendence. It has become difficult to specify but the urge for it not only has not lessened but can stir passions as intense as those in any past age. The same impulse that prompted earlier artists to invent their monsters and gods motivated Rothko to seek self-transcendence through nonobjective painting. For him – and for many of us – his pictures are a convincing 'revelation, an unexpected and unprecedented resolution of an eternally familiar need,'[59] as much as that can be resolved in our age.

Rothko stopped publishing statements in 1949 because of his 'abhorrence of . . . explanatory data.'[60] Let the viewer be! But art criticism would not cease. If anything, the

explanatory data seemed to grow excessive, one indication of which was Peter Selz' catalogue of the Rothko retrospective at The Museum of Modern Art in 1961 where Selz wrote of Rothko's paintings as 'open sarcophagi . . . [which] moodily dare, and thus invite the spectator to enter their orifices.'[61] But there was rigorous writing, above all Goldwater's review of the retrospective, which stretched formal analysis to the point where it evoked poetic interpretation without overdoing it. Rothko greatly admired Goldwater's essay, in part for its reticence.

Confronting the central issue in Rothko's work, Goldwater wrote: 'Rothko claims that he is "no colorist," and that if we regard him as such we miss the point in his art. Yet it is hardly a secret that color is his sole medium. In painting after painting . . . there are handsome, surprising and disquieting harmonies, and supposedly difficult colors are made to work together with apparent ease . . . There is a sense in which one is inclined to agree with him, or rather to say that Rothko has been determined to become something other than a colorist . . . [What] Rothko means is that the enjoyment of color for its own sake, the heightened realization of its purely sensuous dimension, is not the purpose of his painting. If Matisse was one point of departure . . . Rothko has since moved far in an opposite direction. Yet over the years he has handled his color so that one must pay ever closer attention to it, examine the unexpectedly joined hues, the slight, and continually slighter, modulations within the large area of any single surface, and the softness and the sequence of the colored shapes. Thus these pictures compel careful scrutiny of their physical existence . . . all the while suggesting that these details are means, not ends.'[62]

from: Pace Gallery, New York. *Mark Rothko Paintings 1948–1969.* 1–30 April 1983.

NOTES

1 Robert Goldwater, 'Reflections on the Rothko Exhibition,' *Arts* (March 1961): 44.

2 Robert Hughes, 'Blue Chip Sublime,' *The New York Review* (21 December 1978): 16.

3 John Ashbery, 'Paris Notes,' *Art International* (25 February 1963): 73.

4 See Clement Greenberg, 'Art: How Art Writing Earns Its Bad Name,' *Encounter* (19 December 1962).

5 Thomas McEvilley, 'Heads It's Form, Tails It's Content,' *Artforum* (November 1982): 57.

6 Mark Rothko, 'Statement on His Attitude in Painting,' *The Tiger's Eye* (October 1949): 114.

7 Adolph Gottlieb and Mark Rothko (in collaboration with Barnett Newman), 'Letter to the Editor,' *The New York Times*, 13 June 1943, sec. 2,9.

8 See ibid and Adolph Gottlieb and Mark Rothko, 'The Portrait and the Modern Artist,' broadcast on 'Art in New York,' *Radio WNYC* (13 October 1943). Unlike Gottlieb and Newman, Rothko was not interested in primitive art.

9 Mark Rothko, *Statement* [exh. cat., Art of This Century Gallery] (New York, 1945).

10 Rothko and his friends such as Gottlieb, Newman and John Graham were interested in myths in the thirties. See John D. Graham, *System and Dialectics of Art* (New York: Delphic Studios, 1937). In 1969, Rothko inscribed the date 1938 on the back of *Antigone*, a Surrealist picture. However, if Rothko did paint pictures in this style so early, he did not show them, even privately, to his close friends Gottlieb and Newman, who would certainly have remarked on them. The earliest published date of a Surrealist painting by Rothko is 1942, ascribed to 'The Omen of the Eagle,' reproduced in Sidney Janis, *Abstract and Surrealist Art in America* (New York: Reynal & Hitchcock, 1944), 118. This fact was confirmed by Bonnie Clearwater, curator of The Mark Rothko Foundation.

11 Mark Rothko, 'The Romantics Were Prompted,' *Possibilities I* (Winter 1947–48): 84.

12 Gottlieb and Rothko, 'The Portrait and the Modern Artist.' Rothko's reading of Friedrich Nietzche's *The Birth of Tragedy* stimulates interest in Greco-Roman mythology.

13 Gottlieb and Rothko, 'Letter to the Editor.'

14 Mark Rothko, Statement of 1943, in Janis, *Abstract and Surrealist Art*, 118.

15 Rothko, 'The Romantics Were Prompted.'

16 Ibid.

17 Mark Rothko, 'Statement on his Attitude in Painting.'

18 Rothko, *Statement*, 1945.

19 Gottlieb and Rothko, 'Letter to the Editor.'

20 Edmund Burke, *A Philosophical Enquiry into the Origin of Our Ideas of the Sublime and the Beautiful* (1757; New York, Columbia University Press, 1958).

 Rothko, Newman and Still were close friends in the late forties. It is likely that if one considered a book important, the others read it or, at least, heard it duscussed at length. Newman was sufficiently impressed with Burke's treatise to remark on it in 'The Sublime Is Now,' *The Tiger's Eye* (December 1948): 51. In a New York interview (3 November 1964), Rothko spoke favorably of Robert Rosenblum, 'The Abstract Sublime,' *Art News* (February 1961), and Lawrence Alloway, 'The American Sublime,' *Living Arts* (June 1963), partly because of their reliance on Burke.

21 Hughes, 'Blue Chip Sublime,' 16.

22 Burke, quoted in Alloway, 'The American Sublime,' 15.

23 Ibid., 18.

24 Ibid., 12.

25 Burke, *A Philosophical Enquiry into . . . the Sublime*, 72, 57.

26 Mark Rothko, statement delivered from the floor at a symposium on 'How to Combine Architecture, Painting and Sculpture,' The Museum of Modern Art, 1951, published in *Interiors* (May 1951): 104.

27 See Irving Sandler, 'New York Letter: Rothko,' *Art International* (1 March 1961): 40.

28 Rothko, 'Statement on his Attitude in Painting.'

29 Rothko spent a good deal of time at his retrospective exhibition at The Museum of Modern Art in 1961 eavesdropping on viewers, such was his curiosity about their responses. I accompanied him on several occasions.

30 Mark Rothko, Statement in 'Ides of Art,' *The Tiger's Eye* (December 1947): 44.

31 Mark Rothko, Letter to Lloyd Goodrich, Whitney Museum of American Art (20 December 1952).

32 Gottlieb and Rothko, 'Letter to the Editor.'

33 Edward Alden Jewell, 'End-of-the-Season Melange,' *The New York Times*, 6 June 1943, sec. 2,9.

34 Hubert Crehan, 'Rothko's Wall of Light: A Show of his New Work at Chicago,' *Arts Digest* (1 November 1954): 19.

 Rothko was bolstered by a few artist friends, such as Gottlieb, Newman, Still, and Tony Smith. For example, Smith, not yet known as an artist, was a trusted colleague of Rothko, Still, Newman, and Pollock. What struck him about their painting was its alloverness. 'There was no distinction between figure and ground . . . Moreover, their pictures seemed untouched by human hand – no autograph, no handwork. Pollock got away from the manipulation of paint with the drip; Rothko with washes; and Still, with the palette-knife. All of this led to a transcendental image. And this image hasn't been fully appreciated yet.' Smith was inclined toward a visionary art in the early forties. He met Rothko in 1945; about his Surrealist work, he remarked: 'It was in his light. His underwater clay was radioactive.' Conversation with Tony Smith,

South Orange, New Jersey, (28 December 1966).

The importance of Smith as a significant audience for Rothko, Pollock, Still and Newman has not been properly acknowledged. He played the same role for them that Morton Feldman said Frank O'Hara played for him in 'Frank O'Hara: Lost Times and Future Hopes,' *Art in America* (March-April 1972): 55. 'What really matters is to have someone like Frank standing behind you. That's what keeps you going. Without that your life in art is not worth a damn.'

[35] Clement Greenberg, '"American-Type" Painting,' *Partisan Review* (Spring 1955): 193.

[36] Ibid., 189,194.

[37] Clement Greenberg, 'After Abstract Expressionism,' *Art International* (25 October 1962): 28.

[38] Newman objected to Greenberg's formalism as strongly as Rothko did. Greenberg considered Newman's work more radical that Rothko's because it was flatter. For this reason, Greenberg's disciples, more doctrinaire than their mentor, esteemed Newman more than Rothko. Max Kozloff, in 'Mark Rothko (1903–1970),' *Artforum* (April 1970): 88, remarked on the 'relative dearth of critical comment on his [Rothko's] art during the sixties . . . [It] is sad [in part because Rothko was hurt] that the importance of his work to such artists as Morris Louis and Jules Olitski was not more emphatically noted.'

[39] Clement Greenberg, 'Modernist Painting,' *Arts Yearbook 4* (1961): 107.

[40] Mark Rothko, 'Personal Statement,' *A Painting Prophecy – 1950* [exh. cat., David Porter Gallery] (Washington, D.C., 1945).

[41] Elaine de Kooning, 'Kline and Rothko: Two Americans in Action,' *Art News Annual*, no. 27 (1958): 176.

[42] Mark Rothko, 'Editor's Letters,' *Art News* (December 1957): 6. He strongly rejected Elaine de Kooning's classification of his work as 'action' painting. '[It] is antithetical to the very look and spirit of my work.'

[43] Harold Rosenberg, 'The Art World: Rothko,' *The New Yorker* (28 March 1970): 90–95.

[44] Gottlieb and Rothko, 'Letter to the Editor.'

I could have made a stronger case by including vulgar popular criticism, such as that of Emily Genauer, who in 'Exhibit Holds Art Without Subject Line,' *The New York Herald Tribune*, 18 January 1961 wrote of Rothko's paintings as 'first-class walls against which to hang other pictures,' and Frank Getlein, who in 'Art: The Ordeal of Mark Rothko,' *The New Republic* (6 February 1961) wrote: 'The paintings get bigger and bigger, like an inflating balloon. Similarly, in the work . . . the surface gets thinner and thinner, the content gets purer and purer hot air.'

[45] See 42. A few statements attributed to Rothko were published after 1949. See 26. Seldon Rodman, in *Conversations with Artists* (New York: Devin-Adair, 1957), 93–94, recorded what he remembered of a swift, unfriendly encounter with Rothko. See also Dore Ashton, 'Art: Lecture by Rothko,' *The New York Times*, 31 October 1958, 26.

[46] Katherine Kuh, 'Mark Rothko,' *The Art Institute of Chicago Quarterly* (15 November 1954): 68.

[47] Mark Rothko lectured at Pratt Institute, New York, on 29 October 1958. The talk was not taped. I took detailed notes on the lecture which have not been published. Dore Ashton's notes on the same lecture appear in 'Art: Lecture by Rothko.' Unless otherwise identified quotes are taken from my notes.

[48] Gottlieb and Rothko, 'Letter to the Editor.'

[49] Rothko, 'The Romantics Were Prompted.'

[50] See Douglas MacAgy, 'Mark Rothko,' *Magazine of Art* (January 1949): 21.

[51] William Barrett, quoted in Sandler, 'New York Letter.'

[52] Rothko, 'The Romantics Were Prompted.'

[53] Robert Rosenblum, 'Notes on Rothko's Surrealist Years,' *Mark Rothko* [exh. cat., The Pace Gallery] (New York, 1981), 9.

[54] Dore Ashton, 'Art,' *Arts and Architecture* (April 1958): 8.

[55] Thomas F. Mathews, 'The Problem of Religious Content in Contemporary Art,' a lecture delivered to the International Congress on Religion, Architecture and the Visual Arts, New York (30 August 1967). Mathews' thesis was that the painting of Rothko, Still, and Newman was the valid religious art of our time.

[56] Gottlieb and Rothko, 'The Portrait and the Modern Artist.'

[57] Conversation with Mark Rothko, New York (22 September 1960).

[58] Hughes, 'Blue Chip Sublime,' 16.

[59] Rothko, 'The Romantics Were Prompted.'

[60] Kuh, 'Mark Rothko.'

[61] Peter Selz, *Mark Rothko* [exh. cat., The Museum of Modern Art] (New York, 1961), 14.

[62] Goldwater, 'Reflections of the Rothko Exhibition,' 43–44.

Notes on Rothko and Tradition

ROBERT ROSENBLUM

I still vividly recall how, way back in the 1950s, informed and intelligent art-world people in New York would argue passionately and usually angrily about the pros and cons of Abstract Expressionist painting. Hard though it is to believe today, when these masters have all the hoary authority of Matisse or Picasso, some thirty years ago, even in the city that nurtured them, the likes of Pollock or de Kooning, Rothko or Newman were still topics of raging controversy. Turning friends into enemies, they generated a polemic between those evangelical enthusiasts who felt that an overwhelming mutation of new pictorial truth and beauty had just been born on Manhattan Island and those stubborn nay-sayers from whose eyes the scales had not yet fallen. The battles were bitter, and generally fought as a conflict about black-and-white aesthetic rejection or espousal. Some found Pollock's poured paintings ridiculous examples of coagulated chaos, an offense to art, whereas others found in them seraphic release, a thrilling depiction of disembodied energy. Some found Newman's austere reductions to a single or double vertical zip on a monochrome ground an insult to all existing standards of visual nourishment, whereas others found them tonic distillations of pictorial structure to a rockbottom core. Some found de Kooning's or Kline's jagged contours and bristle-ridden brushwork the equivalent of chimpanzee scrawls or of undisciplined violence, whereas others found them the vehicles of authentic feeling and spontaneity. And some found Rothko's luminous veils of color fraudulent voids, whose nothingness defied any reasonable expectation of what one should look at in a framed and painted rectangle of canvas, whereas others found them mysteriously silent and radiantly beautiful. But whether these paintings were loved or hated, it was generally assumed in the 1950s that they were somehow totally new forms of pictorial art. Created in New York after the apocalyptic conclusion of World War II, they seemed to signal a drastic rupture with pre-war traditions of both European and American painting. You might find them great or awful, but they clearly belonged to a completely unfamiliar kind of art that bore little if any comparison with what had come before.

Even the imagery of most Abstract Expressionists contributed to this feeling that the historical coordinates of time and space had been annihilated, leaving us before visions closer to the Book of Genesis – primeval chaos, primeval shape, primeval light – than to paintings that might proclaim they were created in New York City in the decade following the war. And even today, it comes as something of a shock to see paintings by Rothko of the 1930s that depict, say, the artist himself, as a flesh-and-blood man wearing the clothing of that decade, or a subway station in Brooklyn, whose turnstiles, cashier, and passengers immediately evoke the Depression Years. We still, it seems, expect Rothko to provide a transcendental image that would take us beyond history.

Nevertheless, all of this has been changing slowly, at times imperceptibly, so that to our surprise, Rothko, like his colleagues, appears today not so much as an artist so radically new that his art can only face forward, but rather as an artist so thoroughly steeped in earlier traditions of western painting that his art faces backwards, more a grand summary and conclusion than a beginning. Already in the 1950s, especially through the potent authority of Clement Greenberg's efforts to place Abstract Expressionism in the modernist tradition of the very greatest pre-war painting from Paris, it dawned on many of Rothko's admirers that his dense seas of color might not have existed without the example of Matisse, a point the artist himself acknowledged by entitling a painting of 1954 'Homage to Matisse'. And clearly, the presence at the Museum of Modern Art of such masterpieces as Matisse's 'Blue Window' and 'Red Studio' could provide the most solid and beautiful touchstones for any artist who would explore the possibility of creating paintings from resonant color alone. (It may be more than a coincidence that MOMA acquired 'The Red Studio' in 1949, the very year in which Rothko achieved the full-scaled conviction of what was to become his signature format: tiered clouds of color magnetized before the symmetrical pull of horizontal and vertical axes.) Indeed, the connection between Matisse and Rothko, like the one that had begun to be made via Greenberg's criticism between late Monet and Pollock, gave credence to the Darwinian evolutionary theory that would bring the grand genealogical table of modernism, whose seeds were planted at MOMA before World War II, into glorious fruition with the new species engendered in post-war New York.

Nevertheless in feeling, if not necessarily in form, Rothko did not always fulfill his putative role as a descendant of Matisse; and it began to be seen, too, that in Rothko, the brooding element of the mystical, of the ascetic, of a range of gloomy, otherworldly associations was alien to the terrestrial pleasures afforded by Matisse. No less mysteriously, the emotions that Rothko's paintings generated in many spectators, old and young, in no way emanated from the work of a much older artist, the Bauhaus-trained Josef Albers, who, in the 1950s, as in his series, 'Homage to the Square', was also creating iconic images of floating, immaterial color planes that vibrated forwards and backwards in immeasurable spaces. Indeed, a comparison between Albers and Rothko, artists whose works might be described objectively with similar language, makes clear the difference of subjective response evoked by Rothko's paintings, which, it would seem, create for most sympathetic spectators a living, breathing ambiance that is solemn, awesome, even tragic, whereas Albers' paintings convey rather an aura of cool, lean precision, the products of didactic experimentation in the domain of color theory and geometric proportion.

Of course, artists are human beings like the rest of us, and their work may reflect, like any human personality, different, even warring impulses. In the case of Rothko, there is, to be sure, a fully Epicurean potential that manifests itself instantly at any Rothko show by the recurrence of colors and color chords so rarefied that the words for our primary and secondary hues – blue or red or green – that are often applied to the titles of his paintings seem laughably inadequate to describe chromatic sensations closer to something like tangerine or puce or

crimson. In this, Rothko often emerges as a voluptuary who could savor and refine those elusive hues associated with the glories of the French hedonistic tradition, from Monet and Renoir to Bonnard and Matisse. Yet there is always, too, the countercurrent of a monkish opposition to this sensuous façade; and part of these paintings' emotional density resides in what is almost a conflict between pleasure and its denial, between the immediacy of hues that can glow like a sunrise and their inevitable extinction.

In this dialogue, Rothko's wide range of tonal values acts as a constant curb, for his most gorgeous colors are often blotted out by the darkest of storm clouds or evaporated into near-invisibility by an invading stratum of white atmosphere, as if the life of the senses were being assailed or pushed away to some distant realm of memory. And of course, looked at with the chronological sweep provided by a retrospective exhibition, Rothko's art, in terms of the shifting proportions of this renunciatory element, can offer a dramatic scenario, in which the frequently somber brownish or grisaille tonalities that dominate many of his Christian subjects of 1945–46 (e.g., the variations on the theme of the Entombment or Gethsemane) are at first suppressed throughout the 1950s and then re-emerge with welling and pervasive force in the 1960s, the final decade of a career terminated by suicide on 23 February 1970. To be sure, this simplistic translation of the pictures into an accelerating triumph of death over life has countless exceptions – there are works of the 1960s as overtly ravishing and seductive in color as anything from the preceding decade – but the over-all pattern, with its growing pull toward a vision of a final annihilation of light and color, is unmistakable.

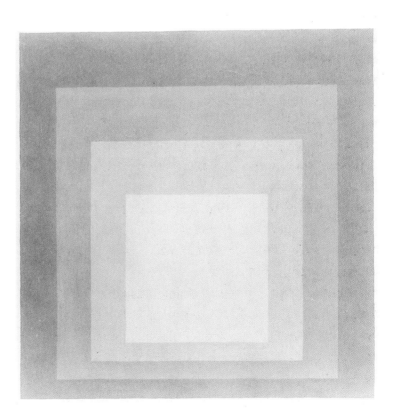

Josef Albers, 'Homage to the Square: Departing in Yellow', 1964, *Tate Gallery*

With our hindsight of the tragic conclusion to Rothko's life and the desperate isolation he apparently experienced in his last years, it is tempting to read his darkening palette as a direct projection of his own sense of doom; but it should be said that in this evolution, Rothko's art, as distinct from his personal life, also follows patterns of old-master ancestry. It has often been noted that the old-age style of many of the greatest artists of the western tradition reveals a final conquest of substance by shadow, of local color by expansive atmospheric veils, of the world of tangible matter and objects by the world of spirit. In terms of nineteenth-century painters, the examples of Turner and Monet are conspicuous; but, before them, Titian and Rembrandt best exemplify this ultimate obliteration of the palpable, sensual world in a resonant ambiance of engulfing obscurity where only flickers of golden light remain. Indeed, the murky browns that begin to dominate Rothko's paintings of the 1960s almost suggest the artist's own response, in the language of abstract art, to the drama of dimming chiaroscuro so evident in the final decades of these museum masters.

Even without the constant references in Rothko's own statements to the themes of drama, of tragedy, of rapt immobility, of a preoccupation with death, it soon became clear from the paintings themselves that whether or not their pictorial means depended in good part upon the lessons of the French modernist tradition, their emotional ends belonged to a very different kind of heritage. Already in 1961, after sensing more and more the affinities of feeling and structure Rothko shared with two of the greatest Romantic landscape painters, Friedrich and Turner, I proposed in an article, 'The Abstract Sublime,' that the ambitions and the achievements of Rothko's art extended these nineteenth-century masters' efforts to depict the awe-inspiring infinities of the natural world as a metaphor of the supernatural world beyond. It was an insight that I was to elaborate more fully in a book published in 1975, *Modern Painting and the Northern Romantic Tradition; Friedrich to Rothko*; and still today, a quarter-century after my first intuitions about this theme, these art-historical resonances remain valid to me. It is surely Friedrich and Turner who first pursued most passionately and

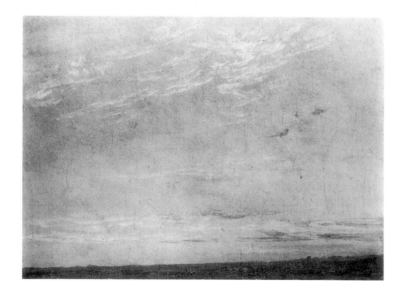

Caspar David Friedrich,
'Evening (Abend)', 1824,
Mannheim, Kunsthalle

J.M.W. Turner, 'Seascape
with Storm coming on',
c.1840, *Tate Gallery*

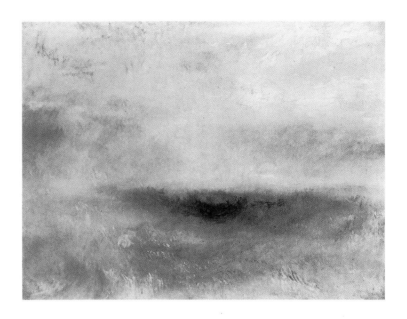

successfully the creation of a pictorial world without matter, usually conveyed through a
vision of landscape, seascape, or skyscape that would free us from the pull of terrestrial gravity
and immerse us, without ruler or compass, in some primordial element of water, cloud, color,
light or a fusion of all these ungraspable mysteries of nature. This unpolluted realm, in which
the very horizon line is apt to vanish forever from sight, becomes almost a spritual catharsis, a
release from the prosaic facts of the often sordid urban realities in which these works were
actually painted and exhibited; and by implication, too, this almost sacred domain of nature
could be haunted by the ghosts of those Christian traditions that were so ruptured by the late
eighteenth century. Often, in fact, Friedrich and Turner in their visions of nature trespass on
formerly Christian territory – angels can appear in their heavenly, golden light; a cruciform
structure can sanctify a landscape; a solitary figure can be immobilized, as if praying to an
altarpiece in a church, while standing before a vista in nature that might carry us to
unnameable, uncharted regions: death, resurrection, the deity itself. But without the
conventions of an easily intelligible language of Christian symbolism, these messages are
often blurred, more suggestive than narrowly legible, casting a wider, vaguer net of
associations that, in the modern world, could find responses in a secular audience more easily
than the orthodoxies of traditional religion. Rothko's paintings, too, have often elicited these
transcendental emotions in spectators; and if it may be wondered how an abstract painting
can possibly be religious in character, it should be remembered that Friedrich's con-
temporaries, too, found that the master's effort to make a landscape painting usurp the place
of a Christian altarpiece of the Crucifixion was incomprehensible, even blasphemous.

As for the altar-like character of Rothko's paintings, their impact of unmitigated frontality
and symmetry, the equivalent of an iconic symbol of a religious cult, also has deep resonances
in the modern tradition, embodying a structure that Friedrich himself, not to mention Blake

and Runge, would use to evoke a sense of supernatural truth and permanence. It is worth noting here that perhaps the closest visual parallels in the modern tradition to Rothko's paintings are found in the mountain landscapes of the Swiss Symbolist, Ferdinand Hodler, who consciously explored a pictorial structure of spare, skeletal symmetry that could transform not only his figural compositions but his Alpine views into what are virtually secular shrines. In his depiction of Lake Geneva crowned by the Savoy Alps, 1906–07, we seem to have reached nature's Holy Grail. The mountain range at the top is so lofty, so pure, so remote from us and from the tug of gravity that it seems to be made of the same immaterial stuff as the lake below and the clouds above, a floating vision inaccessible by earthbound transport. Moreover, the suggestions of an atmospheric halo that enframes the entire vertical image, with its hovering horizontal tiers, recall the marginal aureole of color that usually sets off Rothko's own intangible clouds from the edge. In the case of both Hodler and Rothko, these visions are seen as emblems of a final truth, awesomely static and distant. And by their sheer frontality and symmetry, they impose an intimate, one-to-one confrontation upon the spectator. To look at these works obliquely is the equivalent of avoiding their command to stand motionless on line with their central axis, so that their embrace may be total.

In the 1950s and 60s, it was customary in New York to celebrate chauvinistically the triumph of Rothko and his Abstract Expressionist colleagues over European and especially French art; and the rapidly growing international recognition of these new works made it clear, so it then seemed, that the center of artistic vitality had crossed the Atlantic after the war. The less emphatic implication of this was that these artists, whose imagery was so willfully universal in character, so far beyond the specifics of time and place, had at last overcome the provincialism and indigenous character of American painting, and could now proclaim that they and American art at last belonged to the world at large and could close the door with relief upon the parochial traditions of pre-war America. But this viewpoint has also been gradually altered by looking backwards instead of forwards, so that by now, in the 1980s, Rothko appears to belong not only to European but to more regional American traditions. Most specifically, he has begun to be seen as the heir to a movement that was first defined and named in the 1940s, Luminism. Referring to a mode of landscape painting (as well as photography) that flourished in the third quarter of the nineteenth-century, Luminism has, of course, to do with the dominion of light. To be sure, the many American painters who practiced this mode have strong affinities with earlier European painting, especially with the work of Friedrich and Turner; but there is little doubt that the abundance and intensity of these visions speak for their importance to a peculiarly American experience.

Typically, a Luminist painting confronts us with an empty vista in nature (often a view of sea and sky from the shore's edge) that is more colored light and atmosphere than terrestrial soil; and if there is any movement at all in these lonely contemplations of a quietly radiant infinity that seems to expand in imagination even beyond the vast dimensions of the North American continent, it is that of the power of light slowly but inevitably to pulverize all of matter, as if the entire world would eventually be disintegrated by and absorbed into this

primal source of energy and life. A surrogate religion is clearly a force here, too, and scholars of Luminism have been quick to point to the analogies between this perception of a natural American light that can slowly lead us to the supernatural and the transcendental thought of Emerson and Thoreau, who also sought a mystic immersion into the powers of nature. Given the welling enthusiasm for and information about Luminism in the last two decades (it has been the subject of books and exhibitions, and has been digested into every standard new history of American art), there is persuasive evidence for its central importance in American visual and cultural traditions; and with this in mind, Rothko's art can often be seen as resurrecting, in an abstract mode, the Luminist tradition. Although in their fidelity to a literal description of, say, an irregular coastline, many Luminist paintings veer from an absolutely head-on, symmetrical confrontation with the source of light, some do venture into this fearful territory with compelling results. For example, in John Frederick Kensett's 'Sunset by the Sea', 1872, the sun is seen as the living core of the painting and of all of nature. Located on a central axis over a starkly unbroken horizon line that stretches to the edge of the canvas (and, by implication, infinitely beyond that), the sun, its circular shape obscured by the blinding gold of heat and light, radiates in all directions, its almost supernatural, halo-like glow, the fountainhead of an unidentifiable deity, turning even the sea below into a weightless mirage and the passing clouds above into an ethereal prelude to an invisible heaven. Before such a painting, it is hard not to think of Rothko, for whom disembodied light and color are also such potent metaphors of an unseen world of spirit and destiny; and even the iconic structure and the aura of hushed silence bear out these strong affinities.

It is fascinating to see, too, how this familiar motif of contemplation by the sea, whose covert messages can lead us to visionary realms, could be pushed by other American artists into more overt translations that at times make the introspective point ludicrously explicit. So it is that in 'Memory', 1870, a painting by the odd Elihu Vedder, often considered a proto-

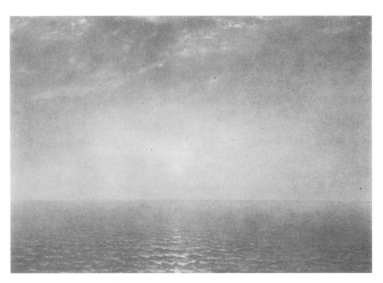

John Kensett, 'Sunset on the Sea', 1872, *Metropolitan Museum of Art, New York*

Symbolist, the Luminists' waterside locale remains, but from this centralized view of coast, sea, and sky (a format that evokes Rothko's own familiar trinities), there appears in the dark clouds, as if in a spiritualist's seance, a ghostly head of a woman, a memory, perhaps, of a lost love or relative, but an apparition that clearly tells the spectator how this meditation upon nature's infinities, as viewed from the water's edge, can guide us directly to a world of spirit.

Such paintings, to be sure, can be found with countless variations, from visionary authenticity to postcard kitsch, and the student of American art may well be able to establish continuities that would take us from the later nineteenth-century to Rothko's own generation. As only one indication of the way in which such a motif was transformed into a more audaciously modernist mode, there is a series of three early watercolors of 1917 by Georgia O'Keeffe entitled 'Light coming on the Plains' that perpetuates, with subtle variations among them, this frontal, symmetrical vision of primordial light, now even further reduced to a quietly vibrant emblem of the horizontal axis of the earth versus the concentrically arced radiations of the distant light of a rising (or setting?) sun seen just above it. So distilled is O'Keeffe's image that, even though it must be inspired by the austere and parched purities of

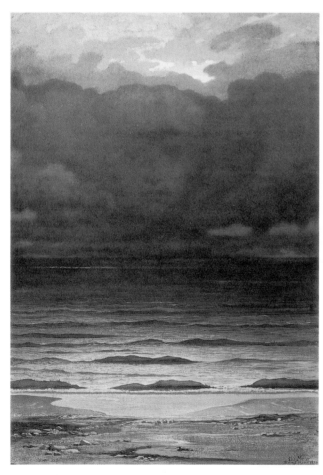

Elihu Vedder, 'Memory', 1870
Los Angeles County Museum of Art

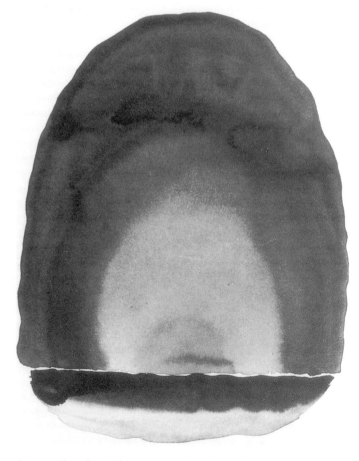

Georgia O'Keeffe, 'Light Coming on the Plains II',
1917, Ammon Carter Museum, Fort Worth, Texas

the desert landscape in western Texas, where she was living that year, it seems, like many Luminist paintings, to transcend the documentary specifics of local geography and to lead us to the brink of a universal source of light. Pushed only a stop further toward this brink, the very edge of a mystical void, the vision of Rothko could be born.

Although such transcendental ambitions, whether in their original European guise or their later American variations, have become apparent in Rothko's work, he was, after all, not only a seeker of spiritual truths, but first and foremost an artist who loved to paint beautiful pictures; and indeed, within his career, we often sense a struggle between a desire to create sheerly seductive paintings, in the nineteenth-century tradition that would make the cult of beauty a religion in itself, and a need to check these sensuous urges with the impulses of an artist-monk who had taken vows of pictorial chastity. But even when his ascetic spirit reigns, Rothko can still be seen as a master of exquisite nuance who works within the realm of veiled tonal refinement that was first espoused by Whistler. Connected, like Rothko, with both American and European culture, Whistler could create in both his figural and landscape paintings a kind of puritanical aestheticism that would have as a goal a pictorial surface of delectation for the eye, but would then restrain this hedonistic potential by a constant paring down and muting of sensation. In his seascapes, in particular, Whistler's vision often strikes chords that resound in Rothko's direction, as in his translations of waterside views of the Thames into mysterious scrims of subtly filtered light. It may be the remoteness of Japan rather than of the deity that lies behind these imaginary excursions to a never-never land accessible to cultivated sensibilities even in Victorian London, but Whistler's pictorial means, rather than any spiritual ends, lay the foundations for many of the evocative effects that Rothko was later to explore. In 'Nocturne: Blue and Silver – Cremorne Lights', 1872, the most prosaic view across the Thames to a famous pleasure garden has become a totally ghostly mirage, with even the industrial buildings at the upper left bearing no more weight than the evanescent reflection of artificial light on the water. Matter, gravity, perspective have been banished in favor of a spectral world of tiered and floating planes that seem both as immediate as the picture surface itself and as remote as something seen behind closed eyes. Even Whistler's favored format, two or three broad zones of the haziest tonalities both fused and separated by the glimmer of a horizon line, announces the structural combination of elemental clarity and infinitely varied subtlety that Rothko would make his own. (It perhaps should be mentioned too, in terms of the affinities between Whistler and Rothko, that the American painter Milton Avery, who exhibited together with Rothko as early as 1928 and is usually cited as a formative influence on him, also belongs to this Whistlerian, Anglo-American tradition of puritanical aestheticism, often reducing Matisse's already reductive color and drawing to a bone-dry spareness that undercuts the sensuality of his French prototype.)

In his search for endlessly refined variations upon a single, simple theme, Rothko, like Whistler, embraced a profound faith in the realm of the aesthetic; and in this preference, too, for ever-more-subtle reworkings of the same motif, he again looks backwards to a major

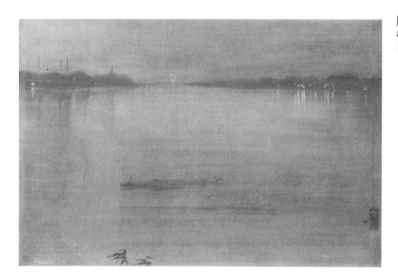

J.M. Whistler, 'Nocturne in Blue and Silver: Cremorne Lights', 1872, *Tate Gallery*

ancestral table of the nineteenth-century. Monet, in particular, had systematically launched the possibility of choosing one subject – a haystack, a row of poplars, a bend in the Seine – and exploring a potentially infinite number of variations upon it in which endlessly elusive sensations of colored light both veil and reveal new aspects of an elementary motif. As in Rothko's chromatic and tonal variations upon his own archetypal structure, Monet's series paintings offer the widest possible range of aesthetic discriminations, from the blazing intensities of sunlit reds and oranges with their blue-violet reflections to the near-invisibility of pallid hues concealed by the fog of dawn. In Monet, as in Rothko, this total immersion in the evanescent phenomena of colored light and atmosphere can lead through the looking glass of perception into a more subjective world of dream and meditation; and these reveries could even be physically extended to create a complete visual environment that might become an engulfing shrine, a sanctuary from the outside world. This potential was, of course, realized by Monet not only in the hermetic realm of home, studio, and watergardens he was to create for himself at Giverny from the 1890s until his death in 1926, but in the mural-sized panoramas of water landscapes that he painted in the 1920s and that would be installed in Paris, in the Orangerie, in two oval-shaped rooms officially dedicated in 1927, the year after his death. For Monet, and now for the public, his vision of an immaterial watery realm that was both ravishing painted surface and a vehicle to a more introspective voyage into a fluid, floating world without substance or direction had become an all-embracing experience, an almost religious shrine or, as André Masson was to put it in 1952, 'the Sistine Chapel of Impressionism.'

It is fitting that Rothko's art, too, often evoked and, on several occasions, actually realized these potentials of meditative enclosure. Already in 1960, at the Phillips Collection in Washington, D.C., Duncan Phillips had installed in a separate room their three Rothkos to which a fourth was added in 1964; and here, within a gallery context, the seclusion and

sanctity of a special chapel for Rothko's work were suggested. But as in the case of Monet's series paintings, this kind of grouping could conjure up still grander architectural potentials. Even before the Phillips installation, Rothko had been commissioned in 1958 to paint a series of murals for The Four Seasons Restaurant at the Seagram Building, canvases which the artist then felt inappropriately grave for their locale and which he finally donated to the Tate Gallery in 1969, stipulating that they be seen in a room by themselves; and between 1961 and 1963 he also worked on a mural commission for Harvard University. But the most poignant fruition of this potential was the product of an enlightened commission by Dominique and John deMenil for an interdenominational chapel in Houston, Texas that, alas, was finally completed and dedicated only on 27–28 February 1971, exactly one year after the artist's suicide. Like Monet's oval rooms at the Orangerie, the Houston Chapel hovers between a shrine of art and a shrine of the spirit, an avowal by a great painter to devote the whole of his being to the religion of art, a consuming goal whose hybrid success as sanctuary and museum is affirmed by the countless visitors in our secular world who make pilgrimages there to look and to turn inward. And it is also a reminder that in the Houston Chapel, as in the presence of all of Rothko's canvases, we feel that the artist who decades ago seemed only to face forward, challenging and even destroying the premises of modern painting, now seems only to look backwards, a resonant synthesis, perhaps even a conclusion to the most venerable traditions of western art.

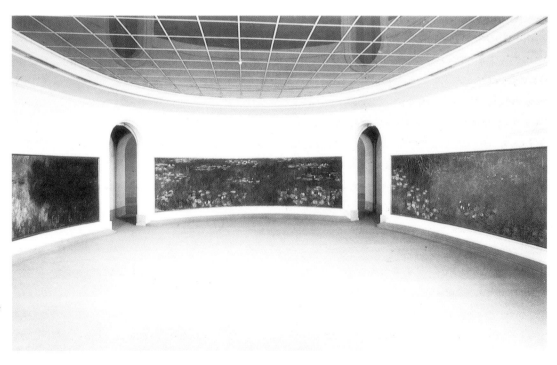

Claude Monet, View of the first room of Water Landscapes, c. 1919–26, *Musee de l'Orangerie, Paris*

Reflections on the Rothko Exhibition

ROBERT GOLDWATER

In Mark Rothko's pictures the apparent end lies close to the apparent beginning – so close in fact, or in apparent fact, that they are almost indistinguishable. If this suggests that the paintings are simple (without complication), so indeed they finally are, or have become, if it implies as well that they are simplist (without subtlety), this is only because here is the unavoidable area of discussion. This is the argument they engender and provoke – whether and why being the first, they are not (as I think they are not) the second. To the extent that this discussion remains unresolved, the works remain enigmas, forcing scrutiny while rejecting inquiry. I believe this is the underlying sense of Rothko's definition of clarity: 'The elimination of all obstacles between the painter and the idea, and between the idea and the observer.' It is only analysis, desiring to reach a conclusion and thus dismiss observation, that demands a decision. In the painting, no resolution is needed; the two poles – beginning and end, simplist and simple – coexist, and without interruption ask questions of each other. Nor should discursive argument attempt to resolve the riddle by insistence upon any answer of either/or.

The provocation may be stated in another way. Rothko claims that he is 'no colorist,' and that if we regard him as such we miss the point of his art. Yet it is hardly a secret that color is his sole medium. In painting after painting of this exhibition there are handsome, surprising and disquieting harmonies, and supposedly difficult colors are made to work together with apparent ease. Rothko's concern over the years has been the reduction of his vehicle to the unique colored surface which represents nothing and suggests nothing else. There is no need to enumerate the possibilities that have been refused (every painter must refuse the whole history of painting); what is important is that the colored rectangles remain. They are the obvious object of attention, whether of the naïve or the initiated observer. Since they represent nothing and lead nowhere, since gesture is absent and in these soaked surfaces canvas and pigment fuse, the colors confront and arrest us. Yet Rothko says he is 'no colorist.'

There is a sense in which one is inclined to agree with him, or rather to say that Rothko has been determined to become something other than a colorist. In the late forties, following the grayed harmonies of his symbolist ideographs, in which the muted hues pulled together the sand-toned backgrounds and the fluid shapes that floated in or on them, his color was structural. It established relations of planes and suggested depth, and while there was rarely a wide range within a given canvas, and there was a tendency toward pastel tones, the combinations were gay, harmonious, attractive. But as structural, spacebuilding color was replaced by areas on the single plane of the canvas or floating disembodied in space, Rothko began to employ deliberately difficult combinations. Many of the light-toned warm-hued pictures of the middle fifties juxtapose supposedly clashing bands of the spectrum, and in the

increasingly cold and somber works, the murals and the others, of the last several years, browns and reds and blacks are barely separable.

Of course what Rothko means is that the enjoyment of color for its own sake, the heightened realization of its purely sensuous dimension, is not the purpose of his painting. If Matisse was one point of departure – cf. No. 19 (1948) and other works of this time – Rothko has since moved far in an opposite direction. Yet over the years he has handled his color so that one must pay ever closer attention to it, examine the unexpectedly joined hues, the slight, and continually slighter, modulations within the large area of any single surface, and the softness and the sequence of the colored shapes. Thus these pictures compel careful scrutiny of their physical existence, of their variations in handling and arrangement, all the while suggesting that these details are means, not ends.

The forcing of this double awareness seems to me a major part of Rothko's achievement. Its existence makes pointless the argument about whether 'less is more.' Much of the history of modern painting is the history of such 'reductions' and 'renunciations,' that have both broadened and deepened our vision. And this one feels in Rothko's work. There has been a singlemindedness in the pursuit of a vision, an insistence upon one direction, an exploration of the possibilities of one means that is admirable, often overwhelming, and (why not say so?) at times exasperating in its refusal to relax. This has much to do with the size of the pictures, and with Rothko's insistence upon controlling the conditions of his public exhibitions. (One suspects that in the world of the contemporary artist only such braced and tense self-confidence can achieve such concentration. This at least is the face he presents to the world, and who knows what false starts have been made upon canvas or in the mind?) It is related as well to the violence which the artist attributes to his own work, and which to the observer, faced with the horizontal harmonies of these tremendous canvases, seems more closely akin to violent self-control.

Some writers have interpreted Rothko's works in literary terms, likening them to Greek drama, gathering from them the notes of impending doom, or seeing in them the symbolic action of storm clouds gathering on an immense horizon. In his catalogue of the exhibition which he organized, Peter Selz (who has upset the Museum's long-standing tradition of historical objectivity by the accents of eulogy), compares him to a Michelangelo who 'has given us the first, not the sixth, day of creation,' and whose murals 'may be interpreted as celebrating the death of a civilization.' (One asks, what civilization?) The reading of such cosmic allegories into these abstract canvases can only arouse the suspicion that the 'immediate impingement' of 'these silent paintings with their enormous, beautiful, opaque surfaces' (which Selz speaks of elsewhere) is not enough. Such literary fancies are program notes that relax the visual hold of these canvases, filter their immediacy, and push away their enigmatic, gripping presence.

I have tried to suggest something of the character of that presence. If we relate colors to moods in the generally accepted fashion, the emotional tone varies from canvas to canvas, and we may speak of a general impression of gaiety or sadness, aggressiveness or withdrawal.

Rothko himself has talked of his expressing basic emotions. Yet one characteristic remains constant; there is always an utter seriousness, even in those pictures where reds and yellows predominate. Partly this stems from the compositional uniformity, partly from the total absence of gesture, a method so all-pervading as to constitute a fundamental point of view. These are motionless pictures; but despite the repetition of the horizontal – line or rectangle – they are not pictures at rest. The floating shapes convey no sense of relaxation. Nor is there a hint of how they came to be, nothing that suggests the action of the artist (*pace* Action Painting), either through gesture or direction or impasto, nothing that defines the imposition of the will, either through an exact edge or a precise measurement. And yet in the unrelenting frontality of these pictures, their constant symmetry, and simplicity, there is the immediate conviction of an enormous will. At close range this will is mitigated. The rectangles terminate softly and irregularly, their sizes and intervals obey no commensurate rhythm, their symmetrical placing is approximate, their uniform surfaces are not quite smooth and even. And lacking all traces of the process of their making, they are divorced from the will that created them. They are thus at once enormously willful and yet unrelated to a formulating will. Apparently unprovoked in the making, they seem removed and indifferent to examination, yet they entice us to discover what is intention, what is chance.

The exhibition as hung at the Museum of Modern Art magnifies the static, apparitional character of Rothko's work. It ignores the first sixteen of Rothko's thirty-two exhibiting years. Half the canvases in the show have been done during the last six, and many of these belong to the large mural series of 1958–59. Thus even the movement of development has been underplayed, and the insight of origins has been denied the spectator, who is confronted by a vision without sources, posed with a finality that permits no questions and grants no dialogue. It demands acquiescence, and failing that, stimulates rejection.

More than ten years ago, before any public recognition, Rothko stated this imperious attitude: 'A picture lives by companionship, expanding and quickening in the eyes of the sensitive observer. It dies by the same token. It is therefore a risky act to send it out into the world. How often it must be impaired by the eyes of the unfeeling and the cruelty of the impotent who would extend their infliction universally.'

Yet, in a way not given to most paintings, Rothko's pictures remain sufficient unto themselves. In answer to the old philosophic saw about the noise of the tree that falls in the forest, they exist without the observer – or so one feels. Because of this quality, each one also exists without its fellows, and inevitably an exhibition, even one as little retrospective as this, does some damage to the ideal isolation each canvas properly requires. This is particularly true in the first-floor galleries of the Museum of Modern Art, where the canvases have been hung close together, and where, too often, the vista of another room, another mood, another idea, disturbs the concentrated view. Suddenly we are aware of colors, where we are being asked to commune with presences.

For this reason the most successful arrangement is the small chapel-like room in which have been hung three of the mural series of 1958–59. Partaking of the same somber mood,

they reinforce each other, as they were designed to do. It is significant that at the entrance to this room one pauses, hesitating to enter. Its space seems both occupied and empty. One is a distant spectator, examining with a stranger's separateness decorations the center of whose existence has been withdrawn, much as today we look (barred from entering by a chain) at the frescoes of some no longer used ancient chapel in an Italian church. Only there we know that this was once an intimate and active place; here we have become our own admiring strangers. It is thus not surprising that Rothko should have decided against delivering these murals to the 'elegant private dining room' for which they had been commissioned.

All the pictures in this exhibition have been hung unframed. Given their soaked, mat colors, their basically rectangular structure, their silent nature, and their growth from large to larger formats, one might suppose (as the mural project suggests) that they might marry the wall, ideally as frescoes, and failing that as totally covering canvas. And yet, despite their size, these are still easel pictures. Their projection from the wall, and the shadow this projection casts, bringing them away from the wall, are essential to their unity. Their floating planes and indeterminate space demand isolation. In order to function they must be kept apart from actual space and tangible architectonic planes as separately existing objects. Otherwise they are in danger of descending gently into the limbo of 'decoration' – a threat that, like 'emptiness,' Rothko employs as a sharpened instrument of their vitality.

Inevitably one asks why these paintings must be so big. There is a critical cliché which holds that small pictures can be just as 'monumental' as large ones, and which may even have some validity for certain kinds of pictures (Masaccio, Piero) in which sculptural human forms are cramped into a too confining space, although the implication of size is never the same as its fact. For Rothko's art it manifestly does not apply. The justification of size is simply its effect, and in this it is no different from any other character of the work. Small, these pictures would not be the same; therefore they would have to be other pictures. The human scale counts. Granted Rothko's creative obsession, granted his insistence upon a visionary simplicity, and a subtlety within that simplicity, scale is the means he has employed to make his pictures both distant and demanding. He has imposed his vision upon us. Is not this what art is for?

from: London, Whitechapel Art Gallery, Oct.–Nov. 1961
Mark Rothko: a retrospective exhibition. Paintings 1945–1960 pp. 21–25

from: *Arts Magazine*, Vol. 35, No. 6, March 1961

Rothko

DAVID SYLVESTER

Faced with Rothko's later paintings in the exhibition at Whitechapel, one feels oneself unbearably hemmed-in by forces buffeting one's every nerve, imagines the gravity of one's body to be multiplied as if some weight borne on one's shoulders were grinding one into the ground; one feels oneself rising against these pressures, riding them, carried away into exhilaration and release; pain and serenity become indistinguishable. This complex of feelings is familiar enough in the experience of tragic art, but tempered and complicated by other appeals to the senses and intellect and imagination – involvement in a specific type of human situation; the re-creation of familiar elements of reality in a way that makes them seem more real than in life; the benign equilibrium of a lucid architectonic structure; the poetic evocation of unexpected connections; the sensuous delight of beautiful colour or sound. There is nothing of all this in these paintings. Here emotion is unadulterated, isolated.

In retrospect, Rothko's image – a haunting image, I suspect, even for those who respond to its presence only mildly – provides its incidental satisfactions. It projects itself onto our vision of reality: looking along Park Avenue at the great glass-fronted slabs with their edges dissolving in the light, it is difficult not to be reminded of Rothko's looming, soft-edged stacks of rectangles. And it projects itself onto our taste: its combination of Indian red and brown and black can be rediscovered in fashionable ties and shirts of recent design.

But the evocative quality of the form, the seductive charm of the colour, become irrelevant when the paintings are confronted. These paintings are beyond poetry as they are beyond picture-making. To fantasise about them (as the catalogue does), discover storm-clouds or deserts in them, or sarcophagi, or aftermaths of nuclear explosions, is as corny as looking at Gothic architecture and thinking of the noonday twilight of the forest. These paintings begin and end with an intense and utterly direct expression of feeling through the interaction of coloured areas of a certain size. They are the complete fulfilment of Van Gogh's notion of using colour to convey man's passions. They are the realisation of what abstract artists have dreamed for 50 years of doing – making painting as inherently expressive as music. More than this: for not even with music, where the inevitable sense of the performer's activity introduces more of the effects of personality, does isolated emotion touch the nervous system so directly.

The claims which Rothko has made for his work seem on the surface decidedly perverse. He says he is 'no colourist,' which might well be thought affected in view of the dully glowing splendour of his harmonies. He denies the view common among his admirers that his work is Apollonian, quietist, maintains that on the contrary it is nothing if not violent, Dionysian – the perverseness of this claim being that it seems pretty extravagant to attribute violent

passion to paintings whose means of expression – the hushed colour, the design in terms of horizontals – are traditionally associated with serenity and stillness. But the claims are not perverse: it is not when he talks that Rothko is paradoxical but when he paints. The value of his painting lies precisely in the paradox that he uses seductive colour so that we disregard its seductiveness, that he uses the apparatus of serenity in achieving violence. For of course the stillness is there as well, and that is just the point: violence and serenity are reconciled and fused – this is what makes Rothko's a tragic art.

The achievement is parallel to Mondrian's who, using means the obvious potential of which was the creation of a perfectly static art, evolved a world of form in which stillness is locked with violent movement. Of this consummation in terms of the physical – to put it rather schematically – Rothko's art is the equivalent in terms of the emotional. Their work is as it were the Parthenon and the Chartres of abstract painting – a vulgar analogy, perhaps, but one whose relevant implications include the point that a Mondrian dominates us as a compact entity out there, beyond our reach, a Rothko incorporates us, envelops us in its light. The analogy also serves to emphasise that a Rothko is awe-inspiring as a cathedral is, not as a mountain is: the effect of its scale is not to make us feel puny beside a sublime vastness. It has a scale transcendent enough to command, accessible enough to reassure.

The strength of the great monomaniacs of modern art – who also include Giacometti, Rosso, Monet – in relation to their audience is that they are not distracted by success or by failure. Their vulnerability is that they are peculiarly subject to hazards of presentation, since their work pushes the medium to extreme limits where there is no margin between glory and absurdity, so that, shown in the wrong light or at the wrong height, it can so easily go the other way. At Whitechapel the exhibition is worthy of the exhibits.

from: *New Statesman*, 20 October 1961

Mark Rothko, the Subjects of the Artist

MICHAEL COMPTON

F. NIETZSCHE *The Birth of Tragedy* 1872

How is the lyrical poet at all possible as artist – he who according to the experience of all times, always says 'I' and recites to us the entire dramatic scale of his passions and appetites.

GEORGE-ALBERT AURIER *Symbolism in Painting* 1891

The artist must also have the gift of emotivity . . . the transcendental emotivity, so grand and so precious, that makes the soul tremble before the pulsing drama of abstraction . . . symbols, that is ideas, arise from the darkness.

MAX WEBER *Essays on Art* 1916

The imagination or conception of an arrangement of forms or of a particular gamut of color in a given rectangle is not a matter of means, but an inner spiritual vision.

Rothko came to the United States in 1913 as Markus Rothkowitz, one of the vast number of immigrant Jews from Eastern Europe who fled from the persecution of their people and who sought a better life.[1] It seems that he never felt secure in the face of the power of the state or of large institutions and often referred to the image or memory of the pogroms against his people. The 'better life' that he sought was not to elaborate a house with goods or to integrate himself into society; it was, on the contrary, one that owed much to the moral and religious teaching he had inherited. In his early life he took action on the side of those he saw as oppressed, in strikes and demonstrations, but increasingly and eventually exclusively he absorbed himself in painting as a prophetic and moral, that is incorruptible, way of life. To have been a utopian anarchist in his teens, to have been politically active in the period of the New Deal and Common Front, and to have become an abstract painter in the 1940s was, of course, not unique, but the nature and intensity of Rothko's commitment and a part of the great power of his best paintings seem to derive from the same inner need.

Rothko's sense of oppression may have been reinforced by his earliest experiences in America. His father Jacob was a pharmacist who had settled in Portland, Oregon. Marcus, his mother and sister traveled west across the Atlantic to join him, not in steerage but in the

relatively comfortable second class. But Jacob died seven months later and his family thereafter suffered the humiliation of poor relations working for an uncle.

Rothko, however, passed through high school quickly and with great success, obtaining a scholarship to Yale University where he is described as having been a gifted student in mathematics, a voracious reader and an expressive speaker. But the tiny number of Jews were not well received by the dominant 'wasps,' and as an immigrant radical he must have been particularly suspect in the period immediately following the Russian Revolution. It seems that Rothko and the University rejected one another. His scholarship was cancelled after a year and after a second year he left without taking a degree.

Although Rothko had taken art classes at high school, in these early years he thought of being a musician or writer and, a little later, an actor, so that his eventual choice of painting seems to have been at first an almost casual decision. Chance brought him into an art class: 'All the students were sketching the nude model and right away I decided that was the life for me.' The evidence of Rothko's subsequent life and painting shows that it was not the nude model that defined such a life but something else, surely the degree of independence of the painter in total control of his own creation. All the same he took a course in anatomy and, after another visit to the west coast, he enrolled in 1925 under Max Weber, himself a Russian Jew and one of the pioneers of the modern movement in the United States. Weber's work of the previous eighteen years had covered a wide range of styles derived from French painting but he had settled on a kind of expressionism in which the artist's inner spiritual vision determines an arrangement of colours and forms that are also figures or landscape. Weber's book, *Essays on Art* published in 1916, is essentially symbolist rather than expressionist in character, in the sense that it combines a reverence for the art of the past with a profound concern for the spiritual; it was neither iconoclastic nor esoteric. This points to Weber's French rather than German artistic inheritance.

Rothko's own paintings of the 1920s and 1930s are generally of the traditional types of figure, genre and landscape composition. Their chronology has not yet been finally established but it seems that he worked in a different style for each of these categories. This may be considered as a means by which he developed the painterly devices recycled in the transitional paintings of the late 1940s. His pure landscape style, especially in watercolor, is plainly influenced by John Marin, then a leading figure in American art. The style was on the one hand indubitably modernist, developed from Cubism, and the content sometimes modern, that is urban, but over all was a sense of atmosphere, light and weather as an appeal to the spirit, and an oriental calligraphic elegance.

More important are the figure paintings, derived indirectly from Matisse and his contemporaries, but relatively sombre in colour. The intermediate influence of Weber was replaced by that of Milton Avery, who did not teach Rothko but provided a social ambience, a circle of artists and their friends, within which Rothko thrived. The inventiveness and clarity of Avery's colour harmonies affected Rothko only slowly and, when Rothko reached the zenith of his own powers, that debt was fully returned. Avery was only ten years older, not so

established as to be an authority figure to confront with rebellion but mature enough to offer Rothko an example of a fully dedicated and integrated life and professionalism. At the same time his apartment and studio represented painting and the life of art as a release from the dirty and crowded neighbourhoods of Manhattan where Rothko lived – a salvation in art.

Rothko's figures remain for the most part essentially within the genre tradition. They have escaped, just, from the studio to lie on a schematic beach or to stand in a barely indicated room. They are not doing anything in particular; their attitudes and muted gestures signify states of mind that are general, seeming to indicate levels of animation or emotional arousal rather than specific feelings or anecdotal responses. A beach is, after all, a place where one lies and experiences the state of one's own body. In this sense he remained an heir of Matisse and a colleague of Avery, but a personal repertoire of forms, handwriting and colour developed. These included cranked forms, rectilinear backgrounds, the grouping together of forms which are not harmoniously related, heavy painterly outlines and the embedding of closely linked colours in one another. The careful editing of some and the cutting away of others among these devices was to become the technical basis of his abstraction in the late 1940s and a prologue to his greatest work. Occasionally hints of neo-classicism appear in the diminished heads and enlarged lower limbs, possibly inherited indirectly from Picasso or Braque of the 1920s.

By the summer of 1934 Rothko had become active in the social politics of art and joined the Artists' Union. But his style and subject matter were not radically transformed. His view may have already been (like that of Stuart Davis, a very active syndicalist) that the most revolutionary act, within painting itself, is to paint in one's own way. Certainly he was against populism and provincialism. There does seem to be, nonetheless, a shift in his work towards urban themes and a heightening of disquiet. This is expressed by architecture and location of figures rather than by any very extreme distortion or dramatic facial and gestural expression. Colours are higher keyed but pastel (mixed with white) and the architecture seems to pass quickly by De Chirico to the fifteenth century of Masaccio, Masolino and Piero della Francesca. Perhaps only because they do recall such prototypes, his paintings of this time sometimes resemble Italian art of the 1930s such as that of Sironi and even Campigli more than that of American or French contemporaries. They were sometimes referred to by the Italian name *Pittura Metafisica*. The placing of figures occasionally recalls the devices used in the cinema in the thirties and forties to create tension.

Rothko associated himself with a group of artists in the Gallery Secession 1934, reformed in 1935 as 'The Ten,' who were opposed to Social Realism and Regionalism. They covered a range from expressionism to geometric abstraction. He felt himself to be an avant-garde painter, but his work at this time shows that this was more a sense of kinship with other artists than of going further than the others in some direction.

By now he was an established member of the profession, both in having exhibited several times (two one-man shows) and in terms of his self image. But he sold little and expected to sell little as a member of the avant-garde, specifically one who opposed authority as represented

by the rich. His wife made money as a designer of costume jewellery and he did occasional graphic work for payment. From 1929 he also held a job teaching art to children at the Center Academy, a Jewish foundation where he seems to have been the initiator of the art programme.

His extensive notes for a lecture at the Center Academy,[2] composed in the late 1930s, perhaps after ten years in the post, are the work of a gifted, forceful and cultured writer, clearly the same man as the passionate speaker recalled by many people who met him in these years. He follows Cizek, a Viennese writer on art education for children, in arguing that they, like primitive artists, have an innate sense of form that should be allowed to develop freely and without intellectual intervention. He notes that 'modern art has, often in the guise of the anthropologist or archaeologist, ruminated among its own elementary impulses as well as the most archaic form of man's plastic speech [i.e. painting and design]. It has eclectically arranged and rearranged its discoveries . . . what is fortunate [is] that in modern art the scaffolding has been left. It has not been obscured by style and tradition.'

Among these notes are several lists of formal devices, presumably those he found in primitive and children's art which form the scaffolding of contemporary art. The terms do not seem to be systematically arranged and were perhaps provisional, for example:

TYPES OF COMPOSITION
Scale
Negative
Interval
Symmetry
Diagonal
Flat space and third dimension
Classical and Symmetrical arrangement
Checkered and perpendicular to the diagonal not to the picture plane
Strips of grass and strips of sky
Absorbent surface
Non-absorbent
Glazing
Opaque
Painting into wet color
Painting around an object
Analysis
Atonalism
Relationship between medium and technique
Color must be sensuous or functional

The concern exhibited in these lists for the means of art is, for Rothko, unusually explicit, possibly because it may be contemporary with a more naturalistic phase in his own art or

because he was considering speaking to a lay audience about children's art. However, it seems clear that for him such means were not a matter of craftsmanship or technique but the innate basis of expression.

His ruminations (to re-use Rothko's own word) can indeed be read so as to reveal some of the preoccupations latent in his work of about this time. His concept of scale and space is certainly exemplified in the city paintings; 'painting into' and 'painting around' describe two of his common practices. At the same time it is hard to avoid reading these lists, almost bare as they are of any reference to subject, as the description of an abstract painting. Indeed, they point to some of the features of his first fully abstract style. It may be deduced then, with some risk of over-simplification, that Rothko's eventual abstraction amounted to an heroic attempt to strip his art of the inessentials of anecdotal illustration etc., in order to reveal a fundamental, because innate, sense of form. It is this sense of primacy that distinguishes his formal analysis from, for example, that of the Russian cubo-Futurists which it in some ways resembles (and which he almost certainly did not know).

It appears from this, moreover, if any further argument is necessary, that Rothko, like other members of the Artists' Union, did not secede from any kind of orthodox Marxism to Trotskyism and then to liberalism. He was already there. The concept of individual freedom was fundamental to his art and to his sense of self; it is identified with something he considered instinctive.

The next phase of Rothko's art shows a sharp divergence from what had gone before, but is hard to date exactly. The earliest exhibition of pictures of the new type was at Macy's department store, New York, in January 1942, but perhaps the features of it had been developed rather earlier. Adolph Gottlieb, who was Rothko's closest associate at the time, has recalled the onset of this phase several times, dating it to 1941. Speaking to Lawrence Alloway,[3] Gottlieb remembered in 1968 how Rothko and he, 'discussing the impasse of American painting in 1941, were considering alternatives, what to do instead of subway scenes with Pittura Metafisica hints, like Rothko, . . . They decided that a change of subject matter was needed and concurred on their *next* subject; classical mythology. Rothko began his Aeschylus watercolours and Gottlieb painted the *Eyes of Oedipus*, his first pictograph.' Granting the general accuracy of Gottlieb's account of the conversations, we do not have to regard it as a true representation of the motivation of the two artists. The choice of mythology as a subject is represented as if it were arbitrary; nothing could be less likely in Rothko's case.

The date-span of Rothko's mythological period is remarkable – it coincides with the worst period of the War, following the fall of France and Japanese victories in the Pacific. Moreover Gottlieb and Rothko were both Jews and very conscious of the fact, though not orthodox. They were keenly aware of the renewed and more terrible pogroms in Europe but they chose a generalised Mediterranean myth rather than specific Jewish themes, which preoccupied Max Weber, for example. Their response both to American isolationism and to the surge of patriotism following Pearl Harbor was to depart as far as possible from the 'American Scene' (and from Jewish ethnicity) in the direction of universalism. One may consider this an

expression of that mysticism or transcendentalism that has often arisen in the face of intolerable conditions; more immediately, it may have been a response to the failure of the consensus of the political Left as a result of the Molotov-Ribbentrop pact and the invasions of Poland and Finland.

Dore Ashton quotes A. Lloyd in *Art Front*, October 1937: 'As Marx pointed out, the role of the myth is to express the forces of nature in the imagination . . . only an autochthonous mythology . . . coming from the . . . same cultural superstructure of the same order can be an effective intermediary between art and material production, despite the bourgeois super-stition that any mythology, even one personally transformed into a kind of private religion, can form such a link.' Against this, the Federation of Modern Painters and Sculptors, of which Rothko was a leader, asserted in 1943:[4] 'We . . . condemn every effort to curtail the freedom and the cultural and economic opportunities of artists in the name of race or nation . . . we condemn artistic nationalism which negates the world traditions of art at the basis of modern art movements.' Rothko wrote in 1942 that his painting 'deals not with the particular anecdote but with the spirit of Myth, which is generic to all myths at all times.'

The internationalism (and timelessness or ahistoricism) of this view is of course a manifestation of Rothko's constant assertion of the universality of art, but it may be associated with temporal and other matters, apart from the rejection of Regionalism, Marxist or otherwise. The great exhibitions at the Museum of Modern Art in New York, especially *Cubism and Abstract Art* and *Dada Surrealism and Fantastic Art* (both 1936), were an expression of commitment to the best art, wherever it came from (with a strong bias to the European), and were consequently an affront to the parochial Americans. They were less explicitly an assertion of the supremacy of art over politics and economics and of its independence of history. Rothko's new work is, in a sense, a tribute to the Museum of Modern Art as a cultural compendium and a signal that he was taking part in a contemporary international movement. This tendency seems to have been in train before the arrival of many high ranking modern artists after the fall of France, but it may well have been reinforced by that migration, as many have considered. The physical presence of the giants brought their work within easy reach and dissolved the Americans' self-imposed, if tacit, assumptions of provinciality.

Rothko's paintings and drawings of about 1941–43 often seem to derive formally from Etruscan or Roman sarcophagus reliefs. They are commonly divided into two or three horizontal zones filled respectively with heads, bodies and legs in non-natural proportions. These pictures may be interpreted as an attempt to reach a higher level of significance or at least a new intensity. They certainly represent a step in a progression of subject: from myth of the artist (studios, nudes, figures at ease etc.) and myth of the present day (city, subway, etc.) to myth of the human species.

Weber, in spite of his high evaluation of primitive art, had been concerned only with the magic of the subject before us. The myth of the nation had been a concept put forward by Marxists, that of the human species owed much to Nietsche and Jung. Whether or not Rothko had extensive knowledge of Jung's work he had certainly read Nietzsche's *Birth of Tragedy*

carefully. These writers reinforced the view that he had found in Cizek, and no doubt Weber, that the springs of art are at a level historically and psychologically prior to and more fundamental than culture, although they produce variant forms in other places and at other times.

The subject matter that he chose turned from the intimate and the contemporary to dramatise this fact. The fusion and transformation of mythical figures and creatures is of course a common feature of Surrealist art and is associated with the theory of dreams. If Rothko followed Jung in this, he may also have seen the device of making chimeras as well as the subject matter itself as a way of going above and beyond contingent reality. I have argued, as others have, that Rothko saw in painting a salvation from the arbitrary power of authority. He wanted to save his work from the power of the rich and himself from the power of lawyers and politicians. He objected to the attempts of the Artists' Union to marshal the work of artists and in 1939–40 he saw the apparent destruction of western civilization and the corruption of Communism. His art looked for roots that would be so deep in humanity that they could countervail all this.

The transition from the relief-based paintings of the very early 1940s to the floating works of the rest of the forties marks the divorce from the explicitly Mediterranean. His work became much more calligraphic and his preferred medium was watercolour or gouache. The forms can be described as biomorphic; classical references almost disappear. The works of this second Surrealist period represent a necessary stage to what was to come but the precise relationship has not yet been clearly determined. It is argued that, aided by the example of the Surrealists and by their anthropological and psychoanalytic theory, Rothko was going back in historical time in order to reach the roots of personal consciousness, basing this on the long-standing idea that individuals recapitulate the evolutionary history of the race.[5] Accordingly, Rothko explored backwards through Classical and Judaeo-Christian myth to images of primitive life forms set against backgrounds which resembled both stratigraphic charts and diagrams of levels of consciousness. The implication is that in his later abstract works he approached very nearly to an image of the state of the unborn and newly born child, and, mythically, that of the uncreated universe, in which there are no objects external to the omnipotent self – no form and void.

Such a view is tenable but the detail is not so plausible. Rothko did often set his images against a horizontally stratified background, but the images themselves are not related to this, either morphologically or symbolically, and they cross over the dividing lines arbitrarily. In short, Rothko's compositions are pictorial and the parts are represented as contemporary with one another and inhabiting the same space. During this quite short period the influence of some of the principal artists of the School of Paris, Ernst, Miró and Masson, was more important to Rothko.[6] The references, if any, to geological stratigraphy are more likely to come through these sources and to have been sanctioned by the precedent of their art.

In comparison with European Surrealists, however, Rothko, and also Gottlieb, Pollock, Tobey and other American artists, used signs and symbols stripped of literal signification, in

the same way that they used images stripped of literal representation. Signs and human constructs would be felt as human and significative at a deep level, but specific local meanings would be supplied only by the responsive viewer and would be associative. This usage resembles to some extent the nineteenth-century French Symbolist theory of correspondences, which can itself be seen as a prototype of psychoanalysis.

The importance of symbolic activity and of symbolic subject matter to Rothko cannot be overstressed. It distinguishes him fundamentally from all the other abstract artists whose work is either more gestural or more analytical, and allies him to those Europeans who were the heirs and culminators of Symbolism: Kupka, Kandinsky, Mondrian and Malevich, none of whom came from Mediterranean cultures. The only contemporary European artist who came near to Rothko's position on this subject was Paul Klee, but Klee's art does not have the same dramatic intent that Rothko claimed by his evocation of Aeschylus. Neither do I know any clear statement of such a theory in Surrealist literature.

The concept of 'The Primordial' was also important and may have represented for Rothko the generalised myth of which the articulated Classical myth is the rationalised expression. He came to feel that myth was defunct in the contemporary world and that, since its expression in rituals and objects was no longer possible (the awe attached to these having been wasted) only a non-specific expression would have power. As Ann Gibson has explained, this possibility is related to the Freudian notion of an idea being stripped of its verbal (or other conventional) formulation and returned to its original manifestation as an image. It is not known whether Rothko was aware of Freud's theory but the fact remains that no view could have been more attractive to an artist following the path that Rothko had taken.

Certainly, the notion can be associated with Rothko's development of abstraction and he may have derived it from the artist John Graham who noted the value of abstraction in a text of 1937:

> Abstracting is the transposition (transmutation) of the phenomenon observed into simpler, clearer, more evocative and organically final terms. Since the very nature of art rests on abstracting, then it is only logical to pursue the course of abstracting fearlessly to its logical end . . . abstraction as a figure of speech opens the unconscious mind and allows the truth to emerge.
> Methods of Abstraction:
> a) Disassociation of form and color observed and reassociation of the same in new, more significant terms.
> b) Isolation by a powerful gesture of a portion of space or a phenomenon study of the same and drawing of furthest possible conclusions.

Furthermore, this passage is followed by:

> The purpose of art in *general* is to reveal the truth . . . to create new values to put humanity face to face with a new event, a new marvel . . .

The purpose of art in *particular* is to re-establish a lost contact with the unconscious (actively by producing works of art), with the primordial racial past . . .

The abstract purpose of art is to arrest the eternal motion and thus establish personal contact with static eternity.[7]

Graham's view seems very similar to that which produced Rothko's art in the later 1940s, even though, unlike Rothko, he repudiated morality and subject matter. None the less, Rothko's morality and subject matter are very like Graham's definitions quoted here.

I have perhaps given too much weight to Graham but his is the most extensive and articulate expression in prose from a circle to which Rothko was close. Yet in detail his formulas do not apply to Rothko for one of his aphorisms reads, 'Symmetry has no place in art,' another, 'The edge of paint where one color meets the other ought to be absolutely spontaneous and final.'[8] The problems which Rothko faced when he turned to the mythical were remembered by Gottlieb in 1968: '. . . we very quickly discovered that by a shift in subject matter we were getting into formal problems that we hadn't anticipated. Because obviously we weren't going to try to illustrate these themes in some sort of Renaissance style . . . so we suddenly found that there were formal problems that confronted us for which there was no precedent.'[9]

But the formal problems for Rothko were not to be dissociated from the drama in his work. The shapes that Rothko created were now seen by him as personages functioning in the space of the canvas. They could be extemporized and, having been given pictorial life, could struggle for existence and territory in the field of the canvas.

* * *

The next development in Rothko's work begins with a broadening and more expressive rendering of the schematic and biomorphic forms of the mid-1940s. They become more painterly and the relations between them are dramatised more and more in terms like those listed in his notes for the speech at the Center Academy, and less and less in terms of puppets on a stage. That is, the struggle for space is fought out by pictorial means only. Rothko wrote to Barnet Newman in 1946,[10] 'I have assumed for myself the problem of further concretizing my symbols,' by which he meant essentially making them more abstract. Harold Rosenberg's recollection of Rothko's[11] preoccupation at the time of Roosevelt's last election (1944) confirms that this process had been going on for at least two years and that it was supported by a feeling of consensus among artists.

Like other artists who have turned to non-representational art, Rothko seems to have needed the support of contemporaries to make the decisive change. During the 1940s he had formed ties with some of the individuals and institutions that were to be identified with Abstract Expressionism: beginning with Gottlieb, he associated at various times with Newman, Still and Motherwell. He does not seem to have been close to Pollock, Gorky or de Kooning, but his development to abstraction ran roughly parallel in time with theirs. He

exhibited, as they did, at Peggy Guggenheim's Art of This Century Gallery and at Betty Parson's Gallery. Journals were imagined and even published. The artists felt they had something in common and a sense that they could compete qualitatively with the Europeans.

The engine of Rothko's change was, in practice, the elimination of all elements which could appear to be representational. Herbert Ferber recalled:[12] 'From the time he began to leave his Surrealist phase he did what he once described to me as avoiding subject matter to the extent that if he saw something in one of his paintings that resembled an object, he would change the shape.' This may be considered a simplified version of Rothko's position that, since in modern society objects and gestures have no transcendent significance, they must be removed in order to preserve transcendence.

In his more representational works Rothko had always distorted his figures. The elongation of those waiting on the subway in his pictures of the 1930s is the simplest distortion. A comparison of these pictures with say 'Woman Sewing,' (no. 2), shows that the characteristic use of such distortion is primarily to affect the way in which the figures occupy the space of the picture. The images form and articulate the compositional axioms of the painting so the distortion is not primarily a forcing of the emotional rhetoric of the figures, as it is in much expressionist painting. Rothko's conversion to abstraction was gradual and reluctant but it allowed him to produce the effects of distortions without having to use force on his subjects. He could let his forms grow and live on the canvas freely and freedom was the essential medium of his expression.

The abstracted personages of Rothko's transitional works contest the space of the picture by standing up against one another, by engulfing or overlying one another, by raising the intensity or value of their colour or simply by aggrandisement. For such a drama the space must be quite shallow. The linear forms of the mid 1940s quickly disappear to be replaced by shapes which appear to grow from within on the canvas and are not confined by contours. As such forms grow larger and larger, they come up against the edge of the picture. The axiom of struggle within the space sets the edge as the limit, though the need for contained identity for the forms does not allow them to share a boundary with the canvas or to mimic it too precisely.

Instead, a rough parallelism is achieved, such as that along the upper edge of 'Woman Sewing.' Eventually the drive of the forms towards consistency led to their development into approximate rectangles or bands which were the characteristic of his mature work and he developed these pictures in the late 1940s.

Rothko established a growing reputation among the artists who were to be called Abstract Expressionists. He had an exhibition of paintings of this period for which he received 'adulation' in San Francisco, his New York shows were now reviewed by Thomas Hess, the editor of the leading magazine *Art News*. During the forties, Rothko produced most of his writings, which, while carefully avoiding anything in the nature of an explanation of his work (at a time when perhaps it was more easily explicable than others) were clearly intended to provoke some part of the public into an understanding of his aims. At any rate the artists felt

that they understood one another; they formed the essential audience, and there was a small group of writers, gallery and even museum people who could participate too.

The most concrete expression of this sense of community was the foundation in 1948 by Rothko and other artists of a school which they named 'The Subjects of the Artist.' The purpose of this school was not to teach students how to paint in 'the new style,' since of course there was no such thing. Its primary concern was with the springs of art, not its techniques, and it offered spontaneous investigation into the subjects of the modern artist – what they are, how they are arrived at, methods of inspiration and transformation, moral attitudes, possibilities for further exploration. The school and courses were completely unstructured and undisciplined (in conformity with the artists' views on education) and collapsed very quickly. The programme of lectures envisaged (mainly not given by artists) continued under the aegis of 'The Club' and led to the discussions between artists that, when published, had a great impact in England.

This episode proved to be very disturbing for Rothko. He felt he was on the verge of a breakdown at the end of 1948, and worried friends encouraged him to travel to Europe in the spring and summer of 1950. During this tour he wrote to Barnett Newman (7 August 1950):[13] 'We must find a way of living and working without the involvements that seem to have been destroying us one after another. I doubt whether any of us can bear much more of that kind of strain. I think this must be a problem of our delayed maturity that we must solve immediately without fail.' In painterly terms (which is what he certainly meant), Rothko

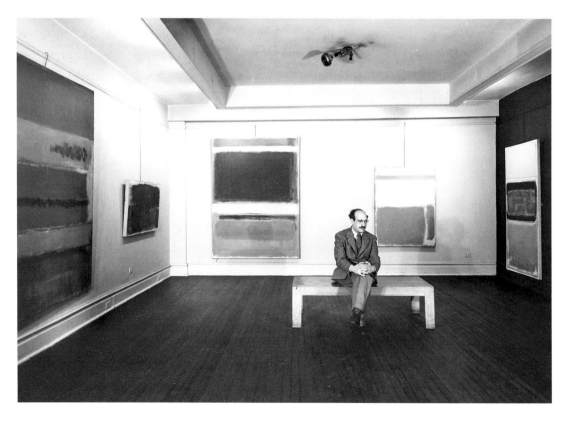

Rothko at Betty Parsons
Gallery, New York, c.1949

himself had reached maturity only in the previous year, and in the period he seems to be writing about, 1947–50 during which the 'involvements' were at their peak, most of the artists likewise achieved 'maturity.'

Rothko's association with Still from 1946 seems to have accompanied his achievement of a 'mature' way of painting. This had not led to any substantial stylistic borrowing from each other, although people have seen in Rothko's work of about 1946–47 an echo of Still's wrench-like forms of 1945–46, which can also be found in the European sources of both (e.g. Masson). As Dore Ashton implies, the more important factor was the pugnacious arrogance and truculence of Still, his contempt for European art and for the art world.

Still wrote to Betty Parson in March 1948: 'Please . . . and this is important, show [my pictures] only to those who have some insight into the value involved and allow no one to write about them. NO ONE . . . I no longer want them shown to the public at large, either singly or in a group.'[14] It was a position which he did not maintain in practice.

Rothko's own combativeness was reinforced by Still's, and he learned how to make a painting that was equally uncompromising. Rothko had shared in particular with Still, during the mid-1940s, a tendency (which in his own case was long-standing) to deform shapes towards the horizontal and the vertical. A tendency to symmetry also had appeared occasionally in Rothko's work (and is referred to in the Center Academy notes) for example, the 'Interior' of 1932 and 'The Omen of the Eagle,' 1943. The same tendency appears in the hieratic works of Still, for instance in '1945 H.' But Still's painting '1947-8-W No. 2' is rather exceptional for him in the combination of approximate symmetry with great simplicity and monumentality. This picture evidently appealed to Rothko strongly for he borrowed it and kept it by him for some time. It may well have been an encouragement to him in adopting an essentially symmetrical style throughout the 1950s and 1960s, although its colouring, texture and graphic characteristics are quite unlike Rothko's own. It may have exorcized the tendency to elaborately balanced but asymmetrical composition – as it were Mondrian in a fog – which had crept back into Rothko's work as he developed the struggle between organisms on the canvas.

<p style="text-align:center">* * *</p>

If Rothko shared anything with the other abstract expressionists, it was his sense of the canvas as a field of action. His canvases were often strips cut from a roll and the presence of the selvedge at top and bottom or on both sides shows that, up to the final phase of the execution of a painting, the width of the roll was a given dimension. The other dimension was chosen in relation to this and gave the basic proportion. As the pictures became simpler, the next choice was the equivalent but painterly division of the resulting canvas itself.

It is not clear whether the effective symmetry of the works was the result of a reduction of the battle for the surface into the simplest possible occupation of a segment or whether it was the choice of symmetry which reduced the shape of the struggle. More likely the choices were in fact integral to one another and to the essential choices of colour, edge formation, etc. Once

achieved, this synthesis became very stable, so it must have been satisfactory to Rothko, though it was some time before critics or collectors sanctioned it. It was a limitation which generated invention.

Three points essential to Rothko's understanding of his own work should be emphasised here. First the forms on his canvases were not colour fields, illusions or technical devices they were *things*. Second, they were at the same time objective *ideas*, and third the paintings were moral and prophetic statements. If Rothko attempted within this (at least with part of his mind) to produce a kind of art that would defy facile analysis and interpretation, he certainly succeeded. The literature on his art from about 1950 is very different from that dealing with earlier periods, especially the 1940s. For this later period there are virtually no published texts of his own, which could provide a peg to hang an argument on, and moreover no iconography, no influences and, with two or three important exceptions, no conspicuous development. Rothko wrote to the artists' journal *Tigers Eye* in 1950 saying that he would not publish again. He explained in a letter to Newman (no date probably Summer 1950):[15] 'The real reason is that at this time I have nothing to say in words which I stand for;' and, repudiating his mythical writing: 'I am heartily ashamed of the things I have written in the past.' Certain pictures of the sort that seem to indicate the maturity described in the letter to Newman quoted on p.48, and are in what became his established style in the 1950s, are dated to the year 1949. This probably meant those that he painted from about the summer of 1949 up to his departure for Europe in April 1950. But he probably continued to paint asymmetrical works during the same period – certainly he exhibited both types together early in 1950. But it is hard to imagine that he knew he had made a critical breakthrough in his work, for he almost immediately went on a six-month journey, like someone not knowing how to go ahead.[16]

The vertical configurations of Rothko's mature work are not in any direct way abstracted human or animal figures – they are not like van Doesburg's reductions of a cow, for example.[17] Their evolution from the pictures that may be seen as dramas acted out on the canvas makes this clear. But they do share some of the properties of his figure paintings of Rothko which, whether in his expressionist, *Pittura metafisica* or Surrealist phases, show him dividing the body into segments, varying the proportions of these segments and deforming them into shapes related to the configuration of the canvas.

Though he was very careful about written statements after 1949, Rothko did speak about his work informally. That is he seems to have said things to people outside the art community that would have been dangerously oversimplified and even misleading if made part of the currency of thought inside it. Up to 1950 he implied that the elements of his pictures could be likened to organisms and actors. Later he spoke as if they were *Papageno* and *Pappagena*, voices in an opera. He responded to the Nietzschean view of the primacy of music and sought to liken his own work to music. He apparently often referred to the elements of his paintings as 'things' but sometimes described them as representing moods or emotions, especially from the later fifties (although he also contradicted this idea). He spoke of paintings as portraits and

whole works remained always dramatic and moral. He was not concerned with colour relationships, in the sense that, say, Joseph Albers was, but with ideas and light. He did not regard his work as spontaneous but as deeply considered and crafted.

These phrases could describe the work of many lesser artists. They are not very specific, but the fault is with the words – Rothko's art itself was highly specific as well as powerful and original. Its power is manifested not only in its effect on viewers but in its range as a form. The mystery of Rothko's mature work, its unity, its diversity and its enigma, arises most basically because the painting is itself deemed an idea (not a product of an idea), but it is also in some sense a representation (but not of what is seen) and an arrangement of colour on a surface (almost never mentioned by Rothko after 1950).

There is, to begin with, the sense in which Rothko's paintings are about the human condition. Most of the 'organisms' or things struggling for space in his multiform pictures may be identified as individual patches of colour, that is a single hue modified by texture or by a mixture of closely related tints of white. More complex 'organisms' seem to be built up rather in the same way as are the figures in, for instance, 'Tiresias' (no. 21) on an axial structure; in other words, they are symmetrical or nearly so. In his Center Academy notes, the exercise of freedom involves the development of a particular scale: 'The scale conception involves the relationship of objects to their surroundings . . . it definitely involves a space emotion. A child [in painting] may limit space arbitrarily and thus heroify his objects.' Following the possibility adumbrated here, the great symmetrical paintings of his maturity are the apparent result of limiting the space around a painterly organism so as to 'heroify' it and, at the same time, enlarging the scale of the painting itself to heroic proportions in relation to the room space.

To be heroic is, in this sense, to be restrained by the space, to struggle against restraint of movement or freedom. One may speculate whether the emotional value attached by Rothko to this particular drama was related to his reportedly expressed resentment at having been kept so long in swaddling bands as a baby.[18] But he had reason to think it a well precedented truth of plastic expression. He might, for example, have cited Michelangelo's slaves, constrained by ropes and also by the form of the block of stone which they so completely occupy. In any case the drama of the work depends in part on attributing to the areas of paint some of the attributes of organisms, including of course man. He said: 'Rather be prodigal than niggardly. I would sooner confer anthropomorphic attributes on a stone than dehumanise the slightest possibility of consciousness.'

But Rothko also spoke of the intimacy of large scale: The effect is like looking in a cheval mirror – *you* are in it. In the symmetrical pictures, the action is identifiable as yourself occupying the whole world; it is not an action between other people or things. These pictures have been related (for other reasons) with Freud's omnipotence of the neonate, but Rothko may have fixed on this format (and scale) rather because it offers a possibility like that of music, which seems to take over almost the whole sense of being, becoming both the listener and his world.

It is a fallacy to think of the parts of a painting, divided, as they often are into two or three

parts, as being simply the head (mind), body (instincts), legs (machine) or conscious, preconscious and subconscious. The structure is more a way of allowing great variety without destroying the unity of the image and therefore its universality. Although Rothko consciously understood and used the formal devices of expression, the fact that he was not a formalist or an expressionist prevented him using the canvas itself as the sufficient means of unity. Moreover, the colours which he needed to achieve the poignancy that he desired would have made the unification of a complex asymmetrical composition too much a matter of careful balance and adjustment. The effect would have been that of arrangement, which he plainly despised above all. His canvases are never divided exactly into halves, thirds or quarters, proportions which would have been recognized as pre-planned. One may see that, with symmetry, he was able to use more extreme contrasts and discordancies of colour (by conventional standards) than he had risked in the more closely tuned multiform paintings.

In the 1930s Rothko was already speaking about the problem presented by the modern world of objects and symbols stripped of transcendence to the degree that they could no longer be used in paintings that aimed at universality (his version of alienation theory). He had aimed, accordingly, at a generalised sense of myth and eventually saw that references to actual phenomena had to be 'pulverised' (i.e. abstracted). What was left was what he had called a 'scaffolding' of formal devices, among which symmetry had another role. It is the device most often used in all cultures to turn a figure into a god. Such figures, which we call heiratic, are not related to anything about them and are therefore not dependent. They relate only to you and seem to oblige you to locate yourself in front of them. This is the relationship described by Rothko as intimacy and these were the terms in which, as I remember, his large paintings were discussed in London in the late 1950s.

The topic of unity versus diversity appears in Rothko's work of all periods. It is most often related to the human figure since, of course, the integrity of the body or self is so vital an issue and so full of dramatic potential. In paintings of the 1930s one may see the figure diminish to a stick (prototypes may be Picasso or Sardinian bronzes) and one may see heads or faces expanded into masks. These become the fused, multi-headed figures of the early forties, then chimeras or *corps exquises* under Surrealist influence, and, finally, the 'organisms' I have mentioned above. The chimera, originally a monster with lion's head, goat's body and serpent's tail, is a symbol of opposing characters in a single body and thus opens a possibility of drama. The conflict, being in the very structure of an organism is timeless and irresolvable, therefore universal, as Rothko required. So we may conjecture that Rothko's abstract paintings are, in this very abstract sense, chimeras.

Rothko considered his own painting to be tragic and also insisted that Mozart was a tragic composer. This dictum is not explained but we may assume from it that, for Rothko, tragedy does not arise essentially from the transgression of structural rules. At any rate he set for himself a rule roughly analogous to a musical form such as the rondo or sonata or to a poetic form such as the sonnet. It was sufficient to generate most of his work for twenty years. In poetry and music such a form gives unity or completeness to what, being deployed in time, is a

kind of narrative. A painting is seen instantaneously and is in no need of an imposed structure to bring it a shape and a conclusion. But Rothko re-emphasized the integrity of his image to a degree far beyond what most painters have considered necessary, and one may only conjecture that this was to allow him the possibility of extra conflict – that is – tragedy. The only means that he allowed himself in staging the tragedy were those of paint and, to set his scene, canvas. He differed, I think, from the view of his contemporaries expressed by Harold Rosenberg that they were actors in the theatre of the canvas, for Rothko did not think of his work in terms of an artist acting but of an artist creating a universal drama from his own experience. He said that he came increasingly to think of Shakespeare rather than of Aeschylus.

The dramatic conflict that Rothko created then, is in terms of the properties of his medium and format. These have been described by writers on Rothko as static formal characteristics. But, although he did not like the term 'action painting' applied to his work, his drama did require a sense of activity had taken place and Rothko, despite his craft, did not know exactly how a picture would turn out when he began it. In this sense also, his pictures did not represent existent ideas or feelings but, when successful, embodied, or were themselves, ideas.

This catalogue contains an essay on Rothko's techniques, but a short description is needed here if Rothko's tragic art is to be fully appreciated. It seems that, having established the shape of his canvas, Rothko generally washed it all over with a single tint, using size or glue, like a theatre set. This 'wash,' which was often continued round the edge of the stretchers would soak into the canvas and, because of its extent and the fact that it has no body or substance, may be considered space rather than simply a surface. The 'objects' on it seem to have been painted in a number of ways, for example; by spreading paint out from a centre, or by constructing a kind of frame which is filled in, or by being put together by parallel strokes. (The various devices are more conspicuous in the transitional or multiform paintings and in those of 1949–51.)

A long process of adjustment apparently followed, focusing on the boundaries between the objects and between them and the edges of the canvas, but it is clear that these adjustments required, or were required by, adjustments to the dominant colour or matter of the objects. Such changes or superimpositions, since they were expected, were part of Rothko's craft, giving richness to the result. However the exact nature of the transformation was not pre-planned. It could be a complete change of hue or value (light-dark). Such an area of change might coincide with the layer beneath, it might allow a fringe to escape or it might overrun the edges on one or more sides. Alternatively Rothko would rub a new colour or different shade into one that was already there but still wet. This might take place over the whole object, only over its centre, or only at the edge. He would reinforce a colour by overpainting with more medium, more pigment or more white, so as to effect the density, texture, or trans-lucency of the colour. He might tune the edge by rendering it sharper, softer, straighter or more curved, more linear or more painterly, by brushstrokes parallel to it, at right angles, or

at random angles. This in turn could affect the need for boundary zones. The effect of these and other workings is to give the objects greater or less emphasis, sonority, scale, clarity or three dimensionality (just as the underpainting in Renaissance painting does). They affect the way the 'objects' occupy the space.

Certain late drawings of 1961 that are encoded in wash and line instead of colour, being in a different medium, help to reveal, simplify and clarify some of Rothko's process. The objects are drawn as spirals or washes or hatchings; lines around them coincide or do not coincide so that the frontier between one and another sometimes becomes like the contour map of a canyon; the lines may be so close that they become an object in themselves. These drawings may show in what sense 'there was automatic drawing under the larger forms,' as Rothko said to Motherwell.[19] Similar lines embedded in a bright red band remain fossilized in 'Number 22 1949,' which Rothko kept to look at for several years.

Generally the width of one object in a painting will be similar to that above or below it, but sometimes Rothko clearly chose in advance it should not be – a particular colour might demand a specific proportion but more often it seems that the mutual adjustment of colour, shape and definition required that a form grow or shrink – which might reinforce or contradict the optical expansiveness of a colour field combination. It seems, therefore, that the initial motif for a picture was essentially a choice of colour-shape protagonists, as it were actors in the drama, but, once placed in the field, they might be radically transformed by the conflict.

The original relationships considered colouristically, seem to be of all the available chromatic dimensions, but some predominate at certain periods of his career. He appeared to explore, over a period, a particular colour range in a series of canvases, sometimes closely related. He painted several pictures at a time, but it is not clear whether, before the late 1950s, these would often have been related to one another in any very obvious way. Later, however, he thought that his pictures should be hung in groups associated chromatically rather than chronologically.

'Number 22 1949,' mentioned above, represents one typical drama (though it is otherwise very untypical). The range of hue is confined to the warm end of the spectrum: scarlet – orange – yellow, on a yellow ground. At the top of the picture a shortened, overlapping band is raised in value and reduced in saturation by adding white. This is balanced by a strengthening of the yellow towards orange in the ears that remain on either side.

Characteristically, where the orange becomes deeper in the lower motif, the field at the edge is left wider and protected by a paler fringe. The aggressive red across the middle, however, is allowed to invade the edge of the field.

'Magenta Black Green on Orange,' also 1949 has much more internal variety. It includes a green motif contrasting with the red field, there is a more indirect conflict, magenta-scarlet, and a value contrast, black and white. The black dominates by size and by occupying the upper two-fifths of the space. All the elements are highly inflected internally.

The range of colour combinations that Rothko used in the fifties and sixties is very wide,

perhaps because their final resolution was arrived at in such a complex way. One can say that he began around 1950 with the most dramatic combinations, of two or three principal colours, which were chosen so as to reinforce one another, mainly by relatively close harmonies. These could be set off by contrasting colours in smaller fields and by black and white, either as punctuation or as a principal theme. On the whole the most direct contrasts do not occur. When they do, they are modified or made unequal so that there is no simple confrontation equivalent to good versus evil. For example the contrasting colour to yellow is blue, but Rothko might set pale yellow against black. But if he uses blue, one or both objects may be desaturated with white or the blue may be warmed by a little red; contrasting red and green may be adjusted by cooling the red to pink.

The resolution of a picture often required the dividing of an upper and lower object by a belt, which might be a part of the field or be an object in itself. However, in some pictures which seem most precarious the objects simply meet at a fairly clear, straight horizon, without an interval. Here the degree of coincidence of the lateral edges of the objects becomes critical and most affects the degree of unity of the whole. These works seem flatter, although the advance or retreat of the colours is only stitched together by the dividing line.

Also rare are those canvases in which objects are given so much space that they hardly impinge on one another or on the edge of the picture. They are low in conflict and low in unity. One picture, 'Homage to Matisse,' is exceptional in a different way – the colours, though contrasting, are so boxed in and so unequal in impact that there is little drama, and yet it is a successful painting. Perhaps its comfortableness is dedicated to Matisse.

It should be possible to get some understanding of what Rothko thought was an eloquent or poignant picture from looking at what he considered to be failures or incomplete works. The Rothko Foundation received several of these, but there are few which are near enough to the point of success to be useful. I suspect that 'Untitled 1953' is a picture which Rothko abandoned as incomplete or incompletable – probably the latter. It seems now to be an effective picture but not quite a 'Rothko.' The problem may be that a belt sketched in above the black has been painted out and could not be replaced. The black has approached the edges too closely (or not closely enough) and so the bottom edge is not resolved. The contrast between the fine top edge and the broadly brushed bottom edge of the black is not justified. 'Yellow Orange Red on Orange' 1954 has a similar feathering of the lower edging of its red element but here the two objects are closely stitched together and both are allowed to float well within the canvas on all sides.

Objects with markedly different edge formations are a minority in Rothko's painting. Where this occurs it is generally at the bottom edge of the lowest object. I do not know of such a difference between the left and right edge, and suspect that this is related to the way the pictures were to be hung – very close to the angle between wall and floor.

The adjustment of colour and edging to the limits of the canvas is clearly a decisive part of the resolution of the picture like the final curtain of a play, and sometimes Rothko brings it off by a last minute change in the size of the canvas, for example, by bringing the stretcher in on

one or more sides so as to increase the tension at the edge and increase the scale of the internal figure. He might also adjust the colour of the canvas where it turns round the edges.

The drama or conflict between the objects in Rothko's pictures is enacted in this way at their edges but is particularly acute where two of them meet, most often in about the middle third of the picture. Generally the inner areas of the objects themselves are without any but the most subtle differentiations; there is nothing for the fovea of the eye to discriminate and dwell upon. However, as previously implied, each object is commonly bilaterally symmetrical top to bottom as well as side to side. They are not like, for example, lobsters with an aggressive end and a defensive one. The characteristics of the edge that is most in conflict with another object may be at least partly mirrored in the opposite edge. Quite often the edges are similar on all sides, which seems to be more generally true when the objects approach the edge less closely. On the other hand, very often, but not invariably, the greater the proximity to the edge, the sharper the definition (in colour, texture, parallelism or linearity). But these distinctions are not great; the integrity of an object is quite marked and so the tendency is to look at it fully as a single object. The nature of the edges, which are made subtle by over- and in-painting does not require sharply focused scrutiny. The local events do not appear as critical detail but are seen together as a general characteristic of the object. They do not attract disproportionate attention, in fact, on the whole, they reject it.

The way I have written about the pictures would certainly be regarded as destructive by Rothko, not only because it is analytic and overemphasizes the technical contrivances rather than the effect or purpose of the work, but because it may distort the nature of the conflict or harmony between the objects in his work. This is not really in the nature of a fight between objects but rather each element seeking to establish its own scale and presence. The shapes, colours, textures and patterns of brushwork all tend to this point. They likewise sharply differentiate his work from that of Newman, Still and others whose edges are sharply divisive and whose paint obliterates. The essential morality of Rothko's work, which he often spoke about, was expressed in his practice as an artist, self defining, radical and uncompromising, and therefore, in his sense, free. But this morality is expressed also in the medium and detail of his paintings, whose forms do not compromise with one another to find a place on the canvas. They seem to be inwardly generated and not imposed.

* * *

If the relationship of the objects to the edge of the canvas was a serious matter to Rothko, so was the relationship of the whole picture to the space in which it was to hang. This could affect the picture itself: the paintings executed from the later 1950s to the end of his life for particular architectural environments are characteristically different from the self-contained 'easel' pictures that I have been writing about. But Rothko was careful about the hanging of the latter. According to Sidney Janis, his dealer in the mid-1950s, he hung his largest pictures in the smaller rooms. They reached almost from floor to ceiling and sometimes projected even beyond the edge of a wall. Rothko was evidently anxious that they should not be absorbed and

subordinated as a pattern on the wall and that their colours should not be diminished by the whiteness of the background.[20] They were to expand and fill both the wall and the consciousness of the viewer, for to change the consciousness of the viewer was his aim. I think his insistence on lowering the lighting attested to by gallery owners, museum curators and friends, was to reinforce the same effect. It would make the surface texture of the paintings less visible, so that their colour would appear more as light. It would reduce the particularity of the objects in the paintings, making some of the devices that I have described, especially the edges, less conspicuous. It would also dematerialize the wall surface.

Rothko's pictures are among the most sharply affected by changes in the intensity and colour temperature of lighting and even by its angle of incidence. His studio is described as being sometimes strongly lit and sometimes dimly. Probably he painted in strong light so that he could make adjustments of hue, texture and edge, but would then judge the effect in lower light when these would become almost subliminal, subsumed in the whole effect.

From the moment that Rothko began to make his views public it is clear that he was concerned about the way his pictures should be experienced. Beginning perhaps with no more than the isolated or bohemian artist's perpetual battle against misunderstanding, this preoccupation seems to have become something more specific to him both as a man in society and as a painter. I have already mentioned several aspects of this. First of all he was hostile to critics, whom he believed trivialized art, wrote about superficialities or irrelevancies and misled the public. He was wary of gallery owners, perhaps because they took the paintings out of his possession and sold them to collectors who might turn them into trophies or into the decorative background of their living. He suspected that dealers gave more respect to collectors than to artists or their art, and he seemed to think that museum curators would treat pictures merely as the material of their craft.

He imagined and desired a public that would be open and sensitive to his work but he knew that most of his countrymen were hostile, ignorant and philistine. His best public, in fact, comprised a small number of artists, a smaller number of the elect from the groups I have described, and a few other people in the loose-knit community which Rothko inhabited and whom he felt he could trust not to distort his work for others or themselves. He did not demand technical expertise or cultural sophistication but rather a direct, passionate response, based on deep experience and concern for art.

His correspondence with Katherine Kuh[21] is the clearest account of what he was looking for; part of it was issued at the time in duplicated typescript as the only introduction to an exhibition of work by Rothko which she arranged in 1954. Originally she had put forward the idea that the introduction should comprise a correspondence between them, beginning with 'Information about what you are after – how you work and why you have chosen the particular form you have.' Rothko replied in part of a letter that has not been made public:

Rather than create the pretence of answers to questions which either should not be answered or are unanswerable, I would like to find a way of indicating the real involve-

ments in my life out of which my pictures flow and into which they must return. If I can do that, the pictures will return to their rightful place: for I think I can say with some degree of truth that in the presence of the pictures my preoccupations are primarily moral and there is nothing in which they seem involved less than aesthetics, history or technology. To that end nothing could be more stimulating to me than if you could find some way of indicating the real nature of your own involvement in the world of art and ideas, which, if I am at all a good judge, are very intense and human.

He continued later in the same letter with the moving and often quoted sentence:

If I must place my trust somewhere, I would invest it in the psyche of sensitive observers who are free of the conventions of understanding. I would have no apprehensions about the use they would make of the pictures for the needs of their own spirit. For if there is both need and spirit, there is bound to be a real transaction.

By the late 1950s Rothko came to think that such a group of observers, if it had ever existed, was not to be found, but in the letters to Kuh he also expressed his fear that writing about his art would lead to 'paralysis of the mind and the imagination.' All the same, for a time he continued to make the attempt. He argues in another letter that there is a problem of what he:

can say . . . for the question imposes its own rhetoric and syntax upon the answer regardless of whether this rhetoric can serve the truth, whereas I have set up for myself the problem of finding the most exact rhetoric for these specific pictures.

If this was a verbal rhetoric, one may presume that Rothko failed to find it, for he never published an account of the paintings. But he may have meant a way of showing the pictures themselves, which he stabilized about this time.

At any rate, shortly after, having thanked Katherine Kuh for provoking him to speculation about his ideas, he stopped their correspondence on this topic and turned to writing about the display of the exhibition. This was his best means (apart from silence itself) of influencing the way people should respond to his work or at least of encouraging the possibility of a full response. He did not even propose to visit Chicago to lay out the exhibition or to lay it out on a plan, which had been sent him but wrote:

I thought it may be useful to tell you about several general ideas I have arrived at in the course of my experience in hanging the pictures.

Since my pictures are large, colorful and unframed, and since museum walls are usually immense and formidable, there is the danger that the pictures relate themselves as decorative areas to the walls. This would be a distortion of their meaning, since the pictures are intimate and intense, and are the opposite of what is decorative; and have been painted in a scale of normal living rather than an institutional scale. I have on occasion successfully dealt with this problem by tending to crowd the show rather than making it spare. By saturating the room with the feeling of the work, the walls are

defeated and the poignancy of each single work had for me become more visible.

I also hang the largest pictures so that they must be first encountered at close quarters, so that the first experience is to be within the picture. This may well give the key to the observer of the ideal relationship between himself and the rest of the pictures. I also hang the pictures low rather than high, and particularly in the case of the largest ones, often as close to the floor as is feasible for that is the way they are painted.

The thoughts expressed here by the artist are perfectly consistent with other statements and recollections by friends over a number of years, for example, the instructions sent to Bryan Robertson for hanging the exhibition at the Whitechapel Gallery six years later, which also deals with wall colour and lighting.

The walls should be made considerably off-white with umber and warmed by a little red. If the walls are too white they are always fighting against the pictures. . . . The light, whether natural or artificial should not be too strong: the pictures have their own inner light and if there is too much light the color in the picture is washed out and a distortion of their look occurs. The ideal situation would be to hang them in a normally lit room, that is the way they were painted. They should not be over lit or romanticized by spots; this results in a distortion of their meaning.

The Chicago correspondence does not mention lighting but two years earlier, as Dorothy Miller[22] recalled, he had wanted very brilliant light, in order to outshine Clifford Still's show in the next room. His view that pictures should virtually cover the wall space had already been formed and was apparently almost simultaneous with his development of the very large picture itself. So was his idea that his work should be shown separately from that of other artists. (Still also held this view.) The later emergence of his opinion on wall colour and lighting may have accompanied his tendency from about 1957 to fewer, often darker less contrasting, colours. He referred to them as 'my mood pictures' and they exemplify his tonality from this period. He seems to have failed to persuade museum curators to accept his ideas on hanging in the extreme form that Sidney Janis allowed him to realize in his gallery.

It is evident that his views on the way his pictures should be shown, is in harmony with the pictures themselves. The morality in Rothko's work required that the paintings themselves should not be representations of an idea about the world but were conceived as being themselves the idea. That idea is one of a universal, unspecific and unlocalized state of being, dramatized by the creation of feeling – poignancy. In turn universality required the pictures to be presented as, and experienced as, an enveloping universal feeling by people who would not analyse or instrumentalize its source – the paintings themselves. The relationship of what I have called 'objects' within the pictures is expansive to the point of saturating the field. The same relationship should hold between picture and picture and dominate the response of the viewer as it had dominated the mind of the artist.

* * *

There is no doubt that his preference for collectors, public or private, who would hang his pictures as a complete and exclusive group is directly related to this view. He would allow the paintings to be hung separately on the wall provided that they were in a room by themselves. The exceptional works which illuminate the rules Rothko set for himself are the architectural series that he executed from 1958.

The first series were those intended for the Four Seasons Restaurant in the Seagram Building on Park Avenue, New York. They were commissioned in 1958 by the architect Philip Johnson who also, privately, bought pictures from Rothko. Presumably Rothko accepted the commission because he hoped it would allow him to create the kind of total ambience that he had sought to put together in exhibitions and also because he would have the chance to compete with the Pompeiian and Renaissance artists he admired. Soon after commencing work he travelled in Europe,[23] meeting a very respectful response from artists he met. It was a time when his European reputation, which had been growing for some years, was established by the works that toured Europe in the exhibition of American art organized by the Museum of Modern Art in 1958–59 and by his one-man show at the Venice Biennale in 1958.

Before he left for Europe he had set up a studio on the Bowery, his first studio away from home. It was big enough to paint the Four Seasons pictures and set them up on scaffolding that reproduced the conditions in which they were to be seen. The room in the Four Seasons Restaurant was 56 feet by 27, one end being a large window. Along one side were a series of doors which Rothko expected to be open, giving a view from the adjacent larger room of the restaurant. Rothko's room, being raised relative to this, was like a stage. The paintings that emerged seem to have been in three groups. The first were in what had become his normal configuration, but the small gouache studies look as if these were to be painted on a roll of continuous canvas like that which he subdivided to make his easel paintings or at least hung edge to edge. They contain the merest suggestion of architectural elements, and may have been intended only for one wall of the room.

The next group, probably painted on his return from Europe, resemble closed doorways, which as he said (after the fact) were to trap the viewers. He said also that they were influenced subconsciously by the blank-window architectural articulation of Michelangelo's Laurentian Library in Florence. This parallel is very apt, although the same sort of shapes occur in Rothko's work as early as his 'Interior' of 1932.

Rothko established a definitive scheme while working on this second group of paintings, some of which were exhibited as 'studies' for murals, and then painted a more or less final group which is the basis of the set now belonging to the Tate Gallery. However, works from one of these groups may have been included in another.

The final arrangement seems to have called for three pictures each 8 feet 9 inches high and 15 feet wide to be hung 4 feet 6 inches high on the wall opposite the doors; and three more pictures 6 feet high and 15 feet wide to be hung over the doors. In his retrospective exhibition of 1961–62, 'Mural Section 5' and 'Mural Section 7' were of the shallower type intended to go

Plan of part of the Four
Seasons Restaurant in the
Seagram Building, New York.
Philip Johnson, 1959

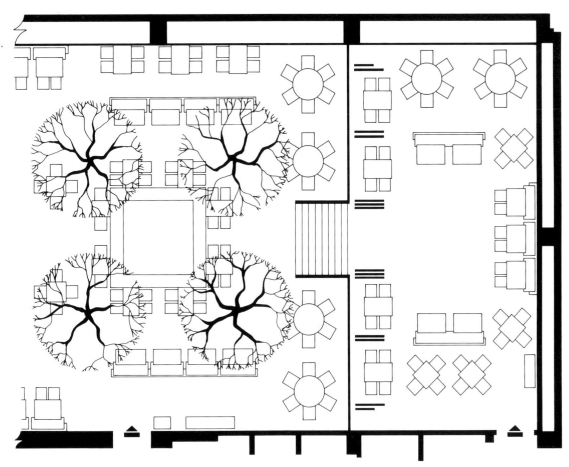

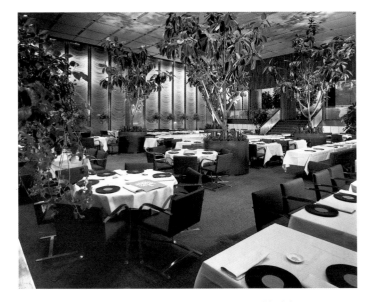

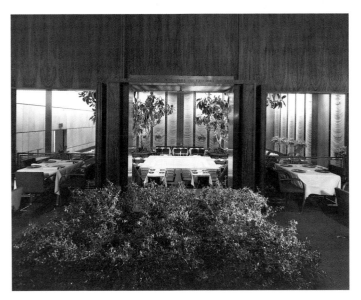

View of the Four Seasons Restaurant, with the 'Rothko' dining room
on right. Photographs: Ezra Stoller © ESTO. All rights reserved

View from 'Rothko' dining room into large dining room. Three of
the Rothko murals would have hung over the doorways

over the long doors, so we may assume that Section 6 was similar. Those on the opposite wall were evidently 'Sections' 1 to 3. Between the two sets of three, Section 4 is only 94 inches wide, so, assuming that the numbering went round the room, there can have been only one painting on the short wall. The implication of calling paintings 'sections' of a mural suggests that they may have been intended to touch at the edges, leaving a significant margin only at the ends of the wall.

What is clear is that in the process of working the internal image of Rothko's paintings changed. Among the possible reasons for the change were that the pictures would not be standing virtually on the floor, as his paintings normally stood, but 4 feet 6 inches or 7 feet 3 inches above it, and that, since people would be seated, they would not present themselves in front of each picture in turn, submitting to it completely, as they could in a gallery. The intimate relationship that he ordinarily sought was therefore denied and the image within the picture ceased to be a kind of mirror of the viewer and came to respond, instead, to the sense of the architecture. The forms within the pictures are not only empty like architectural spaces, but shrink from the edges. (This had been the first move, immediately contingent on the elimination of any gap between pictures in the studies for the first series.) But Rothko's glowing frieze was a complete surrogate for the zone of architecture it occupied, eliminating almost completely the sense of the wall.

Although he had achieved a set of paintings that was harmoniously related to the given space, Rothko withdrew from the project and returned the advance payment he had been given. The reason he gave was that he did not want his pictures to be a background to the eating of the privileged.[24] He may also have realized that the doors from the larger room could be closed reinforcing the privacy of the room and taking away its stage-like relationship to the larger dining room, which interested him.

The Harvard series which followed was to have occupied a meeting room, and again the pictures were to be raised from the floor. The colours resemble the earlier, less sombre, phases of the Seagram project but the architectural solution is developed further. Indeed there is a more specific architectural reference in the Mannerist dropped keystone effect which articulates the empty tabernacles or cartouches that are the dominant image.

<div align="center">* * *</div>

The years from the mid-fifties were the years of success for Rothko. He joined one of the leading galleries which showed the great French Masters as well as the Abstract Expressionists. Although he did not sell large numbers of pictures, those he did sell were at good prices. He was widely exhibited and was even promoted abroad as an example of the power of political freedom. His letter to Newman in 1950 had expressed his unease in the period of his breakthrough. His late success seems to have been just as disquieting. Although he denied that his pictures directly expressed his own emotional state, and this denial is fully justified by his ability to paint at all times in a wide range of expression, there is also no doubt that his prevailing mood became less and less optimistic. His disappointment over the

Seagram murals came at a time when he seems to have felt the dominant sensibility of the art world was turning against the whole of what he had stood for. Abstract Expressionism ceased to be the dominating influence on young artists. This should not have been a problem for Rothko, who did not like to influence followers stylistically, but the art that came to the fore was that of Johns and Rauschenberg, followed by the Pop artists, who made cultural context the very theme of their work and who climbed down from the peaks of transcendence and prophetic morality. Abstract art became at the same time formal, apparently rejecting any subject other than the problems of painting and sculpture as media.

Rothko even seems to have become progressively isolated from his contemporaries as each achieved success. He found that the steps he had taken to bring himself recognition and status left him with the support of galleries, collectors and museum officials even the President of the United States, instead of the support of colleagues and of those who were closest to art. He may have felt guilt about this – he certainly became more liable to depression. It becomes more and more difficult to dissociate the somberness of his painting, which even he described as obsessive, from his prevailing state of mind. This is not, of course, to say that the value of the works is their reflection of his mood for he remained able to transform the expression of his feelings into a cosmic drama.

Apart from his architectural paintings, only a slow development occurs in his art. The tendency to relatively close color harmonies is strengthened; certain colours – cold yellows, lime greens and even flame oranges – are much rarer from the later 1950s. The objects in the paintings are more isolated from one another in the 1960s; consequently they tend to have more regular edges and, for a while, rounded corners. The proportion of the canvas is often squarer and horizontal formats reappear. The rhythm is more measured and equally accented.

During a large part of his last period, that is from 1964, Rothko worked on his greatest project. He was commissioned to paint a set of murals for a chapel in Houston, originally to be Roman Catholic but eventually interdenominational. The commissioners were the extraordinary collectors and patrons Dominique and John de Menil. The plan of the chapel was again Philip Johnson's but the whole design was developed to accommodate Rothko's ideas on the hanging of his paintings and lighting (the latter not so successfully). It was as near the ideal situation as he could have imagined, for his murals would be virtually the sole objects of contemplation in the chapel and could exert their full power over the consciousness of the visitors. The murals in this octagonal space would surround the visitor and occupy almost the whole visual field. The doors were set back, no architectural feature broke the planes of the wall surfaces.

Rothko moved to a larger studio, a former carriage house, and again built in it a mock-up of the architecture. The paintings that he evolved were dark and close toned, great fields of black swallowed more and more of the pictorial space as he worked on them. The lack of any contrast in the dimmed light allows or required these forms to be sharp and straight edged. The resulting canvases are huge and have few fields in them but the whole group has a fine-

tuned and subtle harmony, carefully wrought by combining paintings into triptychs, by adjusting edges and by raising and lowering the sill height as well as by variations in colour mixture. The effect is tragic as well as sombre, the antithesis of Matisse's chapel at Vence which was its prototype only in its unity.

The paintings were essentially complete by the end of 1967 but Rothko was never to see them installed. The following spring he had a severe illness and, when he began to work again in the summer, it was on a small scale in acrylic on paper. He produced a very large number of such little pictures in a short time. Many of them are in the richer colours and configurations typical of the mid-fifties but it must be emphasized that he had never altogether abandoned that chromatic range. They must have been in part a recuperative exercise for a convalescent artist, but they are neither studies or literal recapitulations. They are genuine paintings, and this is surprising since, lacking the scale, they cannot work in the manner of the grand paintings. One wonders why they have, proportionately, the same form?

As he recovered he continued to paint largely in acrylic on paper but on a medium scale – more like that of the paintings of the mid- to late 1940s. There are several groups among these, beginning with a distinct series – the only one in his oeuvre without an architectural framework. Each painting is divided into two zones: very dark-brown, almost black above and warm gray below. The division rises or falls but is quite sharp, as if it were a horizon between a dark sky and gray earth. However, although more than other paintings since the forties, these have the quality of being external to the viewer, they are not abstract landscapes. The two zones are not floating fields or organisms, as in the 'classic' works, but they do not occupy the whole aperture of the painting, like a landscape. They are surrounded by a narrow, but carefully adjusted, edge of white. This was created by the masking tapes used to attach the paper to a backboard, but it is an essential part of the painting. Rothko generally avoided any discussion of the technical features of his painting, wanting only a direct response, but he several times drew the attention of visitors to this element. These pictures are, as always for Rothko, tragic expressions but this single example shows how Rothko underpinned his works with a conscious technical professionalism.

The other, slightly later groups, in what must have been one of Rothko's numerically most productive years, 1969, are not so clearly defined. One group explores the possibilities of black or very dark green or blue on a bright blue; another combines pale blue, grey, pink and terracotta on white. They revert to Rothko's floating-field structure and do not require the sharp edging of the black-grey series. These light-coloured works on paper, perhaps because of the matt medium, have a more objective physical quality than anything he had done since the mid-1940s and do not seem to be 'mood' pictures. Like the very last painting in vibrant red no.93, they certainly cannot be described as doom laden.

However Rothko was seriously depressed following his illness. He separated himself from his wife, living entirely in his studio, and died by his own hand in February 1970. Shortly before his death he concluded a long negotiation with Sir Norman Reid, director of the Tate Gallery, and gave to the Tate a group of works mainly from the Seagram third series. They

were installed in a room by themselves, as he had required, and have remained, I believe, the only group which is visited by individuals when they need a specific emotional or spiritual experience.

Rothko succeeded in creating pictures that transcend the context of museum or collection and retain their primitive power intact.

When I began to write this article I had in mind that I would try to answer the question why an artist for whom a painting was an assertion of a universal truth should paint more than one such picture. Of course he was, like other artists, partly an obsessional and partly a professional for whom each finished work posed a question that could only be answered by another work. This is sufficient in a limited way to account for his persistence.

But it does not answer the question at the level of meaning and aspiration and in fact I have not come to an adequate answer there, although some sort of an answer is implied by what is written and quoted above.

Rothko did aim at universality and at a sustained high intensity or poignancy. But he also revered Mozart and Shakespeare seeing that such a poignancy is itself found in the richness of experience. There are no ways of saying in one painting that (to put it crudely) morality and commitment must pervade all human response and action since there is nothing in art to

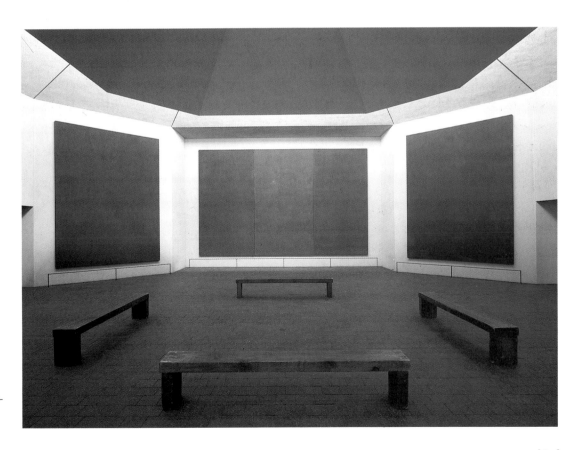

Mark Rothko, Northwest, North, Northeast wall paintings in The Rothko Chapel, 1965–66, Houston, Texas

correspond to 'all' or to 'must.' The only way is to paint and paint again to demonstrate the point in action – to demonstrate its richness as well as its necessity and to demonstrate its close link to the concept of freedom Rothko had to paint as long as he lived and he had to paint in a way that reflected his faithfulness to his purpose. He was a very ambitious as well as a great artist.

NOTES

[1] Most of the biographical information is derived from Diane Waldman, *Mark Rothko, 1903–1970, A Retrospective*, Solomon Guggenheim Museum, New York, 1978 and Dore Ashton, *About Rothko*, New York, 1983. Both publications cover his life in a more or less chronological fashion and have bibliographies and footnotes. The former has in addition a detailed chronology and many documentary photographs. No specific citations are given for these publications. The assertions in the present essay as to Rothko's views on his art are derived from the texts reprinted in this volume.

The title of this article is that of the short-lived school of art founded by Rothko and other artists. It has no meaning here other than to emphasize that, for Rothko, painting was not just an arrangement of colours and shapes but must have meaning.

[2] Clearwater, pp.67–8 in this volume.

[3] Lawrence Alloway 'Melpomene and Graffiti,' *Art International*, Vol.12, No.4, April 1968, p.21.

[4] The Federation of Modern Painters and Sculptors, press release for Third Annual Exhibition at Wildenstein and Co., June 1943.

[5] Stephen Polcari, 'The Intellectual Roots of Abstract Expressionism: Mark Rothko,' *Arts Magazine*, Vol.54, No.1, Sept. 1979, pp.124–34 and Ann Gibson, 'Regression and Color in Abstract Expressionism: Barnett Newman, Mark Rothko and Clifford Still,' *Arts Magazine*, Vol.55, No.7, March 1981, pp.144–53.

[6] For example Gail Levin in Robert Carlton Hobbs and Gail Levin, *Abstract Expressionism the Formative Years*, Ithaca, 1978, pp.31–32.

[7] John Graham, *Systems and Dialectics of Art*, 1937, 1971 edn, Baltimore, pp.94–95.

[8] Graham, op.cit., p.159.

[9] Quoted by Karen Wilkin in *Adolph Gottlieb: Pictographs*, Edmonton Art Gallery, 1977.

[10] Archives of American Art, Newman papers, 17 June.

[11] Recorded interview, 1977 and Joseph Liss recorded interview 1982, both Archives of American Art.

[12] Recorded interview, 1981, Archives of American Art.

[13] Newman papers, Archives of American Art.

[14] Betty Parsons papers, Archives of American Art.

[15] Newman papers, Archives of American Art.

[16] Letters among the Newman papers, Archives of American Art, including Bradley Tomlin to Newman, 14 Dec 1949, make it clear that Rothko was not in a confident mood at the time.

[17] Anna Carruthers Chave, in a thesis not seen by the present writer until after this text was written, argues that the abstract paintings continue to contain references to the figure and to traditional iconographic types.

[18] Robert Motherwell in conversation with Hobbs, Hobbs and Levin op.cit. p.119.

[19] R. Motherwell and S. Simon, 'Concerning the Beginnings of the New York School 1939–1943,' *Art International*, Vol.11, No.6, 4 May 1959, p.66, quoted in Polcari, op.cit.

[20] According to Dorothy Miller, recorded interview, Archives of American Art, in 1952 Rothko 'wanted all these (fifteeen to twenty) paintings touching around the four walls of the gallery (in the Museum of Modern Art) or with two inches between them' but he failed to persuade the curator.

[21] Correspondence with Katherine Kuh in the Archives of the Art Institute, Chicago.

[22] Recorded interview, Archives of American Art.

[23] The date of this visit is given as June 1958 by Diane Waldman and Dore Ashton but as Spring 1959 by the Museum of Modern Art, 'Mark Rothko,' Jan. 1961 and by John Fischer, 'The Easy Chair,' *Harper's Magazine*, July 1970, pp.16–23. It is not likely that he made visits in both years.

[24] Fischer, op.cit.

Selected Statements by Mark Rothko

BONNIE CLEARWATER

Rothko rarely made statements about his art after 1950, but he made several attempts earlier in his career to clarify his concerns and define his goals. In these early statements there are three dominant themes: the use of art as a universal language; the subject matter of his art; and the disparity between his ideal and its physical rendering. Although Rothko's paintings do not depend on discussion for their effect, his statements relate to what we feel and experience when standing before one of his masterpieces and give insight into the mind that created it.

Most of our knowledge of Rothko's philosophy and ideas on art comes from his published statements of the 1940s. During these years Rothko and his American colleagues, having gained confidence in the significance of their work, articulated their aesthetic beliefs, recorded the developments in new art as they occurred and attempted to make their production better known. The profusion of statements coincided with the organization of public and informal forums where the artists could discuss and exhibit their work, including meetings of the Federation of Modern Painters and Sculptors. The short-lived magazines *Tiger's Eye* and *Possibilities I* also featured statements and illustrations by these artists. Even *The New York Times* caught on to the emerging avant-garde, and its art critic Edward Alden Jewell provoked confrontations with artists, curators and dealers in his column.

By the summer of 1950, however, Rothko felt he had said enough about his work, commenting in a letter to Barnett Newman, 'I simply cannot see myself proclaiming a series of nonsensical statements, making each vary from the other and which ultimately have no meaning whatsoever . . . At this time I would have nothing to say in words which I would stand for . . . This self-statement business has become a fad this season, and I cannot see myself just spreading myself with a bunch of statements everywhere, I do not wish to make . . .'[1] Rothko's decision to cease discussing his work came with the resolution of his classic composition. It seemed no longer necessary to speak for his paintings as the viewer's response to them in 'human terms' was the only thing that was really satisfactory.[2] The few statements he did make in later years are in concordance with the ideas he presented in the 1940s, suggesting that his early discourses on art are reliable documents of his fundamental concerns.

From 1929 to 1952 Rothko instructed children at the Center Academy of the Brooklyn Jewish Center, a progressive school with a curriculum modeled after the educational principles of John Dewey. Teaching required Rothko to organize his ideas on art so that he could relay them to his students, their parents and other faculty members. By the late 1930s he had formulated his own teaching method based on his observations in class and on the

teachings of the Viennese art educator Frank Cizek, whose pioneering theories were published in English in 1936 and from which Rothko quoted in his notes.[3] Like Cizek, Rothko believed his role was to encourage the natural development of his students' creativity. As he recorded in the back of a sketchbook of the late 1930s:

> The difference between our methods and older methods is this. In the older methods a child was taught how to do various things. Given examples, his problem was to perfect himself in the imitation of them Our dictum is not to do so and so; but what would you like to express and how clearly and vividly can you express it. The result is a constant creative activity in which the child creates an entire child like cosmology which expresses the infinitely varied and exciting world of a child's fancies and experience Our children working from the point of view of expressing their ideas, meet their problems as they feel the need for them as their standards of maturity demand[4]

The question Rothko seemed to pose to himself at this time was how could he, a rational adult, develop a vivid form of expression. He believed that children created art instinctively, whereas the artist consciously uses and orders the elements in his work. Throughout his career he denied that art could be created by anyone who 'strips himself of will, intelligence and the bonds of civilization.'[5] For Rothko, painting was a philosophical pursuit. It was a result of thinking and, in turn, inspired thought in the viewer. The artist's real job, was to 'communicate what he knows about the world,' rather than just what he feels.[6]

In the early 1940s, Rothko ceased to paint in the expressionistic style that characterized his work of the Depression era, and began using archaic symbols to transmit the emotions associated with ancient myths. Like many of his colleagues, Rothko was receptive to Carl Jung's theories on the collective unconscious and archetypes. His interest in myth, however, dates to the beginning of his career when, at the age of 24, he researched archaic symbols and ancient art for the illustrations he produced for a book by Rabbi Lewis Browne entitled *The Graphic Bible*.[7] For this project Rothko consulted handbooks on ornament as well as texts on ancient civilizations, and studied the Metropolitan Museum of Art's Assyrian collection. The illustrations in the book consist of maps of Israel and its neighboring countries historiated with scenes and symbols reflecting and commenting on the accompanying text. Sphinxes, lions, serpents and the eagle of the Roman Empire are among the images populating the pages of *The Graphic Bible*. Some of the symbols in the book were charged with emotional connotations, such as roses, which Rothko drew to represent felicitous times for Israel, and thorns and thistles, which appear during mournful episodes. Rothko referred back to the illustrations in *The Graphic Bible* and some of its original sources in the early 1940s, when he introduced archaic images into his paintings of fantastic hybrids composed of human, animal, and plant forms.[8]

In the 1943 exhibition of the Federation of Modern Painters and Sculptors, Rothko and Adolph Gottlieb, close associates since the late 1920s, showed paintings which had affinities with ancient myths. They considered these myths universal and their beliefs influenced the

globalist philosophy of the Federation. According to the statement released by the Federation for this exhibition, Rothko's and Gottlieb's paintings, as well as the other entries, represented a globalist attitude among its members.[9] Having acknowledged that America had been greatly enriched by 'the recent influx of many great European artists . . . and by the growing vitality of our native talent,' the members of the Federation believed they had a responsibility 'to salvage and develop . . . Western creative capacity.' The urgency of this challenge was expressed in the release:

> Since no one can remain untouched by the impact of the present world upheaval, it is inevitable that values in every field of human endeavor will be affected. As a nation we are being forced to outgrow our narrow political isolationism. Now that America is recognized as the center where art and artists of all the world meet, it is time for us to accept cultural values on a truly global plane.[10]

Edward Alden Jewell's review of this exhibition mounted by the Federation printed in *The New York Times*, provoked Rothko into making his first public statement on his art. Jewell, admitting that he was confused by Rothko's and Gottlieb's works, wrote: 'You will have to make of Marcus Rothko's "The Syrian Bull" what you can; nor is this department prepared to shed the slightest enlightenment when it comes to Adolph Gottlieb's "Rape of Persephone."'[11] Gottlieb telephoned Jewell, offering to supply him with a statement on the paintings.[12] Eleven days after Jewell publicly declared his befuddlement, he printed excerpts from a letter co-authored by Rothko and Gottlieb. In the letter, the artists explained that their paintings embodied the following concerns and beliefs:

1 To us art is an adventure into an unknown world, which can be explored only by those willing to take the risks.
2 This world of the imagination is fancy-free and violently opposed to common sense.
3 It is our function as artists to make the spectator see the world our way – not his way.
4 We favor the simple expression of the complex thought. We are for the large shape because it has the impact of the unequivocal. We wish to reassert the picture plane. We are for flat forms because they destroy illusion and reveal truth.
5 It is a widely accepted notion among painters that it does not matter what one paints as long as it is well painted. This is the essence of academicism. There is no such thing as good painting about nothing. We assert that the subject is crucial and only that subject-matter is valid which is tragic and timeless. That is why we profess spiritual kinship with primitive and archaic art.[13]

Recently uncovered drafts for this letter reveal Rothko originally intended to write his own statement rather than collaborate with Gottlieb. In the most developed version of these drafts he wrote:

> I am glad to observe that . . . your remarks concerning my paintings at the exhibition of Modern Painters and Sculptors seem couched in the form of a question rather [than]

with the hostility which has usually attended your reviews of my work. This being so, I would like to try to explain myself to you and I hope that you can print this explanation publicly since you have raised the question publicly.[14]

The contents of Rothko's drafts were summed up in the fifth point of the published letter. Each revision defended the use of archaic symbols by modern artists and indicated the need for subject matter that was timeless and tragic. He explained his own fascination with archaic symbols was founded on their 'spiritual kinship with the emotions' which they 'imprison and the myths which they represent.' The fears, inhibitions and motivations of primitive man, that were the subjects of ancient myths, endured through the ages. By alluding to these myths, Rothko believed his paintings would be as relevant to his descendants as they were to his contemporaries, noting in one of his drafts: 'To say that this art is not of our time, is to deny that art is timeless, and to deny that the art which speaks for the moment is no longer relevant as art once the moment has passed.'

The letter Rothko and Gottlieb sent to Jewell was a compromise, as they both stated in later years; each going along with the other's ideas.[15] Barnett Newman edited the definitive letter and, although his name does not appear on the document, Rothko and Gottlieb were sufficiently pleased with his help that they gave him the two paintings in question – 'The Syrian Bull' and 'The Rape of Persephone.'

A few months after the letter appeared in *The New York Times*, Rothko and Gottlieb elaborated on their positions during the radio broadcast 'The Portrait and the Modern Artist.'[16] Gottlieb took the opportunity to clarify his definition of tragic subject matter remarking, 'All primitive expression reveals the constant awareness of powerful forces, the immediate presence of terror and fear, a recognition and acceptance of the brutality of the natural world as well as the eternal insecurity of life.' And Rothko emphasized, 'Those who think that the world today is more gentle and graceful than the primeval and predatory passions from which these myths spring, are either not aware of reality or do not wish to see it in art. The myth holds us, therefore, not thru its romantic flavor, not thru the remembrance of the beauty of some bygone age, not thru the possibilities of fantasy, but because it expresses to us something real and existing in ourselves . . .'

Rothko and Gottlieb used images which they believed represented the essence of myths and which could be comprehended by anyone acquainted with the 'global language of art.' To support this theory, Gottlieb noted that any artistically literate person would have no difficulty 'grasping the meaning of Chinese, Egyptian, African, Eskimo, Early Christian, Archaic Greek or even pre-historic art, even though he has but a slight acquaintance with the religious or superstitious beliefs of any of these peoples.'[17] By no means did they consider their works abstractions with literary titles. It was never their intention, Rothko stressed, 'to create or to emphasize a formal color-space arrangement.' If their titles recalled the myths of antiquity, they used them because:

they are the eternal symbols upon which we must fall back to express basic psychological ideas. They are the symbols of man's primitive fears and motivations, no matter in which land or what time, changing only in detail but never in substance, be they Greek, Aztec, Icelandic, or Egyptian. And modern psychology finds them persisting still in our dreams, our vernacular, and our art, for all the changes in the outward condition of life.[18]

Rothko and Gottlieb had been influenced by Surrealism in their use of myths, but they claimed they were not satisfied with exploring the unconscious in their art. As Gottlieb commented on the radio, 'The surrealists have asserted their belief in subject matter but to us it is not enough to illustrate dreams.' In the 1945 catalogue for an exhibition at the David Porter Gallery, Rothko remarked on his struggle with Surrealism:

> The surrealist has uncovered the glossary of the myth and has established a congruity between the phantasmagoria of the unconscious and the objects of everyday life. This congruity constitutes the exhilarated tragic experience which for me is the only source book for art. But I love both the object and the dream far too much to have them effervesced into the insubstantiality of memory and hallucination.[19]

Complete surrender to the unconscious did not seem possible to Rothko nor was it desirable. Moreover, he had little interest in the Surrealists' automatist technique. As he viewed it, the purpose of art was to portray ideas, and the appearance of his work grew out of the need to reconcile his ideal with its incarnation. His search for the means to represent his ideal dates to his work on *The Graphic Bible*. As he stated:

> In many cases, where sources were available and where they helped me in my conception, I used them. Everybody does that . . . I might have thought of something, or seen [an image] that I imagined to be useful for me in carrying out my idea, just as an artist feels that he requires a certain kind of model – he goes among human beings and finds one that comes closest to his ideal.[20]

Similarly, he noted on the 1943 radio broadcast how all the great portraits of the past resemble each other far more than they recall the characteristics of a specific model. 'What is indicated here,' offered Rothko, 'is that the artist's real model is an ideal which embraces all of human drama rather than the appearance of a particular individual . . . The whole of man's experience becomes his model, and in that sense it can be said that all of art is a portrait of an idea.'[21]

Rothko envisioned the philosophical approach to art as a route for advancing beyond the achievements of the early modern masters, Picasso in particular. 'Picasso is certainly not a mystic,' commented Rothko in the late 1940s, 'nor much of a poet, nor does he express having any very deep or esoteric philosophy. His work is based purely on a physical plane, a plane of exciting sensuous color, form, and design, but it does not go far beyond this.'[22] Other artists of Rothko's generation shared this attitude toward Cubism, which had also been advanced by Alfred Barr who wrote in the catalogue for the 1936 exhibition 'Cubism and

Abstract Art' at The Museum of Modern Art, 'The Cubists seem to have had little conscious interest in subject matter. They used traditional subjects for the most part, figures, portraits, landscapes, still life, all serving as material for Cubist analysis.'[23] To progress beyond Picasso then, artists had to introduce precisely what they perceived was lacking in his work. Rothko recommended a move 'toward esoteric reasoning; expressing qualities of, or the essence of, universal elements; expressing basic truths.'[24] The advance in art, as Rothko saw it, would necessarily be in content, not form.

Throughout his career Rothko claimed he was not concerned with the formal components of his paintings. The form was 'significant only insofar as it expresses the inherent idea.'[25] Once he had identified his subject, he was steadfast in his quest to invent the most effective means to communicate it to the viewer. He considered the development of his work a process of eliminating elements that obscured his intent, as he stated in the *Tiger's Eye*: 'The progression of a painter's work . . .' will be toward clarity: 'toward the elimination of all obstacles between the painter and the idea, and between the idea and the observer.'[26] He gave as examples of these obstacles: memory, history and geometry.

It was with great reluctance, however, that Rothko banished the figure from his work because, like most of the artists of his generation, he had studied the human form as the ideal representation of beauty: perfect in balance and proportion. 'For me the great achievements of the centuries in which the artist accepted the probable and familiar as his subjects,' wrote Rothko, 'were the pictures of the single human figure – alone in a moment of utter immobility.'[27] The intense emotions he hoped to evoke, however, could not be expressed by the shapeliness of the Greek gods. Neither was he satisfied with depicting contorted and mutilated figures to dramatize tortured emotion as he perceived their gestures as self-conscious and embarrassing. As he pointed out in 'The Romantics Were Prompted,' the archaic artist lived in a 'more practical society,' where the need for a transcendent experience was recognized and given official status. Therefore, Rothko believed, the archaic artist was able to use the figure or create hybrids and monsters to enact the human drama as their meaning was understood. 'With us the disguise must be complete. The familiar identity of things has to be pulverized in order to destroy the finite associations with which our society increasingly enshrouds every aspect of our environment.'[28]

To achieve the goals he had established for himself, Rothko realized he would have to invent images unlike any that had been seen before. His breakthrough occurred in the late 1940s, when he presented to the world paintings of soft luminous rectangles that seem to float on a thinly stained field. The large scale of these paintings, their intense color and bold form merge into a single powerful image, the unity of which is not to be analyzed according to its individual components.

The subject of these new paintings remained constant with his earlier pictures. In a 1952 interview with art historian William Seitz, Rothko identified the thread that held all of his work together.[29] Seitz, who was researching material for his doctoral dissertation, 'Abstract-Expressionist Painting in America: An Interpretation Based on the Work and Thought of Six

Key Figures,' quizzed Rothko on the development of his abstract paintings. In an attempt to relate Rothko's early and later work, Seitz observed, 'the thing that tied his early figures, his symbolic things, and his late things together was the backgrounds. It was as if he had removed the figures or swirling calligraphy, symbols, etc. and simplified the three toned-backgrounds.'[30] Rothko disagreed with Seitz, impressing on him his concept of the progression of his work: 'It was not that the figure had been removed, not that the figures had been swept away, but the symbols for the figures, and in turn the shapes in the later canvases were new substitutes for the figures My new areas have nothing whatever to do with the three tier backgrounds in the symbolic style.'[31]

Rothko considered his rectangular forms to be actual objects that he positioned on a stained field. His paintings are not arrangements of flat geometric forms that divide the picture plane, nor are they vast atmospheric backdrops. On the contrary, as he explained to Seitz, 'My new areas of color are things, I put them on the surface. They do not run to the edge, they stop before the edge These new shapes say . . . what the symbols said.'[32] He further commented 'I never was interested in Cubism . . . Abstract art never interested me; I have always painted realistically. My present paintings are realistic. When I thought symbols were [the best means of conveying my meaning] I used them. When I felt figures were, I used them.'[33]

Fearing insensitive viewers might misinterpret these pictures, Rothko cautiously selected the exhibitions to which he would loan and controlled the conditions under which the paintings would be seen. When Selden Rodman referred to Rothko as 'a master of color harmonies and relationships on a monumental scale,' in the late 1950s, Rothko denied this and, as reported by Rodman, once again insisted he was not an abstractionist and that he was not concerned with the relationships of color or form.[34] In an attempt to set Rodman straight he added: 'I'm interested only in expressing basic human emotions – tragedy, ecstasy, doom . . . And if you, as you say, are moved only by their color relationships, then you miss the point!'

Rothko noted in 'The Romantics Were Prompted' that modern man had few opportunities to achieve a transcendent experience, but his paintings, as he indicated to Rodman, succeeded in transporting the viewer to a spiritual realm. 'The people who weep before my pictures,' Rothko remarked, 'are having the same religious experience I had when I painted them.' The fact people cried when confronted with his pictures proved to him that he was communicating basic human emotions.

In a lecture delivered at Pratt University in 1958, reported on by Dore Ashton in *The New York Times*, Rothko paraphrased some of his early statements, and in recounting his journey from figurative painting to abstraction reiterated it was with 'the utmost reluctance that I found the figure could not serve my purposes.'[35] He still contended that painting was a valid conduit for ideas, once again indicating his 'interest in those elements in art that are dependent on the workings of intelligence rather than the senses alone.'

Toward the end of his life, when his canvases smoldered with somber tones of deep maroon, black and brown, Rothko not only thought it was possible to present his ideas through art but,

as he revealed to Katharine Kuh in an unpublished interview of the early 1960s, he was convinced he had come close to achieving his goal: 'If my later works are more tragic, they are more comprehensive, not more personal.'[36] Adamantly, he renounced to Kuh the interpretation of his paintings as reflecting his moods and emotions of a particular moment as this view was in opposition to all he believed.

Rothko's writings and statements reveal the philosophical nature of his work and the consistency of his aesthetic beliefs. He had established goals for his art early in his career that he was determined to resolve. Whether he used human figures, ancient symbols or abstract areas of color, Rothko single-mindedly tried to discover the most direct and vivid way to communicate his thoughts on the condition of mankind.

NOTES

[1] Letter to Barnett Newman, Summer 1950, on deposit at the Archives of American Art, Smithsonian Institution, Washington, D.C.

[2] During an interview on 22 January 1952 Rothko told William Seitz to write the following as a direct quote: 'One does not paint for design students or historians but for human beings, and the reaction in human terms is the only thing that is really satisfactory to the artist.' Transcript of interview with William Seitz on deposit at the Archives of American Art, Smithsonian Institution, Washington, D.C.

[3] Rothko's notes on education appear in a notebook preserved by Rothko's first wife Edith Sachar Carson (now in the George C. Carson family collection and on microfilm at the Archives of American Art, Smithsonian Institution, Washington, D.C.) A sketchbook on deposit at the National Gallery of Art, Washington, D.C. also includes notes on art education. Although both documents are undated, they probably were written in the late 1930s. As the notebook includes quotes from Wilhelm Viola, *Child Art and Franz Cizek* (Vienna, Austrian Red Cross) it would have to postdate the book's 1936 publication but predate Rothko's divorce from Edith Sachar in 1945. The notes in the National Gallery sketchbook were probably written between 1937 and 1939. Rothko wrote in the sketchbook, 'ten years ago when this school began progressive art methods were looked upon as suspicious innovations and experimentation.' Although the Center Academy's records no longer exist, some of its former teachers recall that the school began shortly before Rothko joined the faculty in 1929.

[4] Notes on art education, sketchbook, on deposit at The National Gallery of Art, Washington, D.C., *ibid.*

[5] Dore Ashton, 'Art: Lecture by Rothko,' *The New York Times*, 31 October 1958, p.26.

[6] Ashton, 'Art: Lecture by Rothko,' *ibid.*

[7] Lewis Browne, *The Graphic Bible*, MacMillan and Co., 1928. Rothko sued Lewis Browne and the MacMillan company for not giving him appropriate credit as the illustrator of *The Graphic Bible* and for not paying him his full fee. The trial was held at New York's Supreme Court, 26 December 1928 to 7 January 1929. The referee of the trial ruled against Rothko's claim.

In the transcript of the trial it is revealed that Rothko based many of his illustrations on images in handbooks of ornaments, drawings in Browne's earlier book *Stranger Than Fiction*, (1925) and symbols in Friedrich Delitzsch's book *Babel and Bible: A Lecture on the Significance of Assyriological Research for Religion* (1902). Rothko also informed the court that he had studied the Assyrian collection at the Metropolitan Museum of Art.

[8] Among the symbols in *The Graphic Bible* that Rothko used in his paintings of the early 1940s are: the eagle of the Roman empire (page 97) in 'Hierarchical Birds,' the snake that represents the invasion of Israel by Egypt (page 83) in the 1946 watercolor 'Vessels of Magic,' and thorns and thistles (page 82) in 'Untitled,' *c.*1942 (collection Neuberger Museum, Purchase, N.Y., Rothko Estate No. 3081.39). A multi-headed female figure in Rothko's painting, 'Untitled,' *c.*1942 (collection National Gallery of Art, Washington, D.C. Rothko Estate No. 3132.40) was modelled

after a drawing of a birth goddess statue on page 203 in *Babel and Bible*.

 See Bonnie Clearwater, 'Tragedy, Ecstasy, Doom: Clarifying Rothko's Theory on Art,' transcript of a lecture delivered at the College Art Association Annual Meeting, 13 February 1986, for a discussion of Rothko's use of symbols in *The Graphic Bible* and in his paintings of the early 1940s.

[9] Press Release, The Third Annual Exhibition of the Federation of Modern Painters and Sculptors, Inc. at the galleries of Wildenstein Company, 19 East 64th Street, New York City, from 2 June to 26 June 1943.

[10] Press Release, *ibid.*

[11] Edward Alden Jewell, 'Modern Painters Open Show Today,' *The New York Times*, 2 June 1943, p.28.

[12] Transcript of interview with Adolph Gottlieb conducted by Martin Friedman, August 1962; on deposit at the Adolph and Esther Gottlieb Foundation, New York.

[13] Edward Alden Jewell, 'The Realm of Art: A New Platform and other matters: "Globalism" Pops into View,' *The New York Times*, 13 June 1943, p.9. The letter Rothko and Gottlieb sent was dated 7 June 1943, and is on deposit at the Museum of Modern Art, New York.

[14] The drafts were preserved by Edith Sachar Carson, and now in the collection of the George C. Carson family and on microfilm at the Archives of American Art, Smithsonian Institution, Washington, D.C.

 See Clearwater, 'Shared Myths: Reconsideration of Rothko's and Gottlieb's letter to *The New York Times*,' *Archives of American Art Journal*, 24, no.1, 1984, pp.23–25, for discussion on the unpublished drafts.

[15] Rothko was quoted by William Seitz in an interview on 22 January 1952 as saying the 'letter to *The New York Times* was only a general point of view and that he would not back it up as a personal statement.' Seitz interview, 22 January 1952, *ibid.*

 Gottlieb, in a 1968 interview said he went along with Rothko's statement about the 'tragic and timeless' the way Rothko went along with Gottlieb's statements (transcript of interview conducted by Gladys Kashdin, 28 April 1965, on deposit at the Adolph and Esther Gottlieb Foundation, New York).

[16] 'The Portrait and the Modern Artist,' radio broadcast, Mark Rothko and Adolph Gottlieb, Art in New York, WNYC, 13 October 1943.

[17] 'The Portrait and the Modern Artist,' *ibid.*

[18] 'The Portrait and the Modern Artist,' *ibid.*

[19] 'Personal Statement,' in Washington, D.C., David Porter Gallery, *A Painting Prophecy – 1950*, February 1945.

[20] Transcript, Marcus Rothkowitz vs. Lewis Browne, and MacMillan and Co., *ibid.*

[21] 'The Portrait and the Modern Artist,' *ibid.*

[22] Quoted in notes taken by Clay Spohn from a lecture Rothko delivered at the California School of Arts, San Francisco, on deposit at the Archives of American Art, Smithsonian Institution, Washington, D.C. Spohn, who taught at the school, had prepared questions in advance of the lecture to ask Rothko, and had transcribed the answers. As Rothko taught at the school the summers of 1947 and 1949 and Spohn's notes are undated it is not clear which year the lecture was delivered.

[23] Alfred H. Barr, Jr., *Cubism and Abstract Art*, The Museum of Modern Art, New York, 1936, 1974 ed. p.15.

[24] Spohn, *ibid.* In 1948 Rothko organized with Robert Motherwell, Newman, William Baziotes, and David Hare a school they called the Subjects of the Artists. The instruction at the school was to encourage students to investigate subject matter in their work.

[25] Draft for letter to Jewell, *ibid.*

[26] 'Statement on his Attitude in Painting,' *Tiger's Eye*, 1, no.9, October 1949, p.114.

[27] 'The Romantics Were Prompted,' *Possibilities I*, Winter 1947/48, p.84.

[28] 'The Romantics Were Prompted,' *ibid.*

[29] Interview with William Seitz, 22 January 1952, *ibid.* Two additional interviews took place on 25 March 1953 and 1 April the same year (also on file at the Archives of American Art).

 Seitz incorporated some of the information from these interviews in 'Abstract-Expressionist Painting in America: An Interpretation Based on the Work and Thought of Six Key Figures,' Ph.D. dissertation, Princeton University, 1955; Cambridge, Mass., Harvard University Press, 1983.

[30] Seitz, interview on 22 January 1952, *ibid.*

[31] Seitz, interview on 22 January 1952, *ibid.*

[32] Seitz, interview on 22 January 1952, *ibid.*

[33] Seitz, interview on 22 January 1952, *ibid.*

[34] Selden Rodman, *Conversations With Artists*, New York, Devin-Adair, 1957, pp.93–94.

[35] Dore Ashton, 'Art: Lecture by Rothko,' *ibid.*

[36] Interview with Katharine Kuh, *c.*1961 on deposit at the Archives of American Art, Smithsonian Institution, Washington, D.C.

Writings by Mark Rothko

A new academy is playing the old comedy of attempting to create something by naming it. Apparently the effort enjoys a certain popular success, since the public is beginning to recognize an 'American art' that is determined by non-aesthetic standards – geographical, ethnical, moral or narrative – depending upon the various lexicographers who bestow the term. In this battle of words the symbol of the silo is in ascendency in our Whitney museums of modern American art. The TEN remind us that the nomenclature is arbitrary and narrow.

For four years THE TEN have been exhibiting as an articulate entity; their work has been shown at the Montross Gallery, The New School for Social Research, Georgette Passedoit, the Municipal Gallery and at the Galerie Bonaparte in Paris. They have been called expressionist, radical, cubist and experimentalist. Actually, they are experimenters by the very nature of their approach, and, consequently, strongly individualistic. Their association has arisen from this community of purpose rather than from any superficial similarity in their work. As a group they are homogeneous in their consistent opposition to conservatism, in their capacity to see objects and events as though for the first time, free from the accretions of habit and divorced from the conventions of a thousand years of painting. They are heterogeneous in their diverse intellectual and emotional interpretations of the environment.

A public which has had 'contemporary American art' dogmatically defined for it by museums as a representational art preoccupied with local color has a conception of an art only provincially American and contemporary only in the strictly chronological sense. This is aggravated by a curiously restricted chauvinism which condemns the occasional influence of the cubist and abstractionist innovators while accepting or ignoring the obvious imitations of Titian, Degas, Breughel and Chardin.

The title of this exhibition is designed to call attention to a significant section of art being produced in America. Its implications are intended to go beyond one museum and beyond one particular group of dissenters. It is a protest against the reputed equivalence of American painting and literal painting.

Bernard Braddon and Mark Rothko from catalogue of *The Ten: Whitney Dissenters*, Mercury Gallery, 4 E 8th St, New York, November 1938

Mr Edward Alden Jewell June 7, 1943
Art Editor, New York Times
229 West 43 Street
New York, N.Y.

Dear Mr Jewell:

To the artist, the workings of the critical mind is one of life's mysteries. That is why, we suppose, the artist's complaint that he is misunderstood, especially by the critic, has become a noisy commonplace. It is therefore, an event when the worm turns and the critic of the TIMES quietly yet publicly confesses his 'befuddlement', that he is 'non-plussed' before our pictures at the Federation Show. We salute this honest, we might say cordial reaction towards our 'obscure' paintings, for in other critical quarters we seem to have created a bedlam of hysteria. And we appreciate the gracious opportunity that is being offered us to present our views.

We do not intend to defend our pictures. They make their own defense. We consider them clear statements. Your failure to dismiss or disparage them is prima facie evidence that they carry some communicative power.

We refuse to defend them not because we cannot. It is an easy matter to explain to the befuddled that 'The Rape of Persephone' is a poetic expression of the essence of the myth; the presentation of the concept of seed and its earth with all its brutal implications; the impact of elemental truth. Would you have us present this abstract concept with all its complicated feelings by means of a boy and girl lightly tripping?

It is just as easy to explain 'The Syrian Bull', as a new interpretation of an archaic image, involving unprecedented distortions. Since art is timeless, the significant rendition of a symbol, no matter how archaic, has as full validity today as the archaic symbol had then. Or is the one 3000 years old truer?

But these easy program notes can help only the simple-minded. No possible set of notes can explain our paintings. Their explanation must come out of a consummated experience between picture and onlooker. The appreciation of art is a true marriage of minds. And in art, as in marriage, lack of consummation is ground for annulment.

The point at issue, it seems to us, is not an 'explanation' of the paintings but whether the intrinsic ideas carried within the frames of these pictures have significance.

We feel that our pictures demonstrate our aesthetic beliefs, some of which we, therefore, list:

1 To us art is an adventure into an unknown world, which can be explored only by those willing to take the risks.
2 This world of the imagination is fancy-free and violently opposed to common sense.
3 It is our function as artists to make the spectator see the world our way – not his way.
4 We favor the simple expression of the complex thought. We are for the large shape because it has the impact of the unequivocal. We wish to reassert the picture plane. We are for flat forms because they destroy illusion and reveal truth.

5 *It is a widely accepted notion among painters that it does not matter what one paints as long as it is well painted. This is the essence of academicism. There is no such thing as good painting about nothing. We assert that the subject is crucial and only that subject matter is valid which is tragic and timeless. That is why we profess spiritual kinship with primitive and archaic art.*

Consequently if our work embodies these beliefs, it must insult anyone who is spiritually attuned to interior decoration; pictures for the home; pictures for over the mantle; pictures of the American scene; social pictures; purity in art; prize-winning potboilers; the National Academy; the Whitney Academy, the Corn Belt Academy; buckeyes; trite tripe; etc.

Sincerely yours,

Adolph Gottlieb
Marcus Rothko

130 State Street
Brooklyn, New York

New York Times, 13 June 1943, partially drafted by Barnett Newman

THE PORTRAIT AND THE MODERN ARTIST

ADOLPH GOTTLIEB: We would like to begin by reading part of a letter that has just come to us:
 '*The portrait has always been linked in my mind with a picture of a person. I was therefore surprized to see your paintings of mythological characters, with their abstract rendition, in a portrait show, and would therefore be very much interested in your answers to the following –'*
 Now, the questions that this correspondent asks are so typical and at the same time so crucial that we feel that in answering them we shall not only help a good many people who may be puzzled by our specific work but we shall best make clear our attitude as modern artists concerning the problem of the portrait, which happens to be the subject of today's talk. We shall therefore, read the four questions and attempt to answer them as adequately as we can in the short time we have. Here they are:
 1 *Why do you consider these pictures to be portraits?*
 2 *Why do you as modern artists use mythological characters?*
 3 *Are not these pictures really abstract paintings with literary titles?*
 4 *Are you not denying modern art when you put so much emphasis on subject matter?*

Now, Mr Rothko, would you like to tackle the first question? Why do you consider these pictures to be portraits?
MR ROTHKO: The word portrait cannot possibly have the same meaning for us that it had for past generations. The modern artist has, in varying degrees, detached himself from appearance in

nature, and therefore, a great many of the old words, which have been retained as nomenclature in art have lost their old meaning. The still life of Braque and the landscapes of Lurcat have no more relationship to the conventional still life and landscape than the double images of Picasso have to the traditional portrait. New Times! New Ideas! New Methods!

Even before the days of the camera there was a definite distinction between portraits which served as historical or family memorials and portraits that were works of art. Rembrandt knew the difference; for, once he insisted upon painting works of art, he lost all his patrons. Sargent, on the other hand, never succeeded in creating either a work of art or in losing a patron – for obvious reasons.

There is, however, a profound reason for the persistence of the word 'portrait' because the real essence of the great portraiture of all time is the artist's eternal interest in the human figure, character and emotions – in short in the human drama. That Rembrandt expressed it by posing a sitter is irrelevant. We do not know the sitter but we are intensely aware of the drama. The Archaic Greeks, on the other hand used as their models the inner visions which they had of their gods. And in our day, our visions are the fulfillment of our own needs.

It must be noted that the great painters of the figure had this in common. Their portraits resemble each other far more than they recall the peculiarities of a particular model. In a sense they have painted one character in all their work. This is equally true of Rembrandt, the Greeks or Modigliani, to pick someone closer to our own time. The Romans, on the other hand, whose portraits are facsimiles of appearance never approached art at all. What is indicated here is that the artist's real model is an ideal which embraces all of human drama rather than the appearance of a particular individual.

Today the artist is no longer constrained by the limitation that all of man's experience is expressed by his outward appearance. Freed from the need of describing a particular person, the possibilities are endless. The whole of man's experience becomes his model, and in that sense it can be said that all of art is a portrait of an idea.

MR GOTTLIEB: That last point cannot be overemphasized. Now, I'll take the second question and relieve you for a moment. The question reads 'Why do you as modern artists use mythological characters?'

I think that anyone who looked carefully at my portrait of Oedipus, or at Mr Rothko's Leda will see that this is not mythology out of Bulfinch. The implications here have direct application to life, and if the presentation seems strange, one could without exaggeration make a similar comment on the life of our time.

What seems odd to me, is that our subject matter should be questioned, since there is so much precedent for it. Everyone knows that Grecian myths were frequently used by such diverse painters as Rubens, Titian, Veronese and Velasquez, as well as by Renoir and Picasso more recently.

It may be said that these fabulous tales and fantastic legends are unintelligible and meaningless today, except to an anthropologist or student of myths. By the same token the use of any subject matter which is not perfectly explicit either in past or contemporary art might be considered obscure. Obviously this is not the case since the artistically literate person has no difficulty in

grasping the meaning of Chinese, Egyptian, African, Eskimo, Early Christian, Archaic Greek or even pre-historic art, even though he has but a slight acquaintance with the religious or super-stitious beliefs of any of these peoples.

The reason for this is simply, that all genuine art forms utilize images that can be readily apprehended by anyone acquainted with the global language of art. That is why we use images that are directly communicable to all who accept art as the language of the spirit, but which appear as private symbols to those who wish to be provided with information or commentary.

And now Mr Rothko you may take the next question. Are not these pictures really abstract paintings with literary titles?

MR ROTHKO: Neither Mr Gottlieb's painting nor mine should be considered abstract paintings. It is not their intention either to create or to emphasize a formal color – space arrangement. They depart from natural representation only to intensify the expression of the subject implied in the title – not to dilute or efface it.

If our titles recall the known myths of antiquity, we have used them again because they are the eternal symbols upon which we must fall back to express basic psychological ideas. They are the symbols of man's primitive fears and motivations, no matter in which land or what time, changing only in detail but never in substance, be they Greek, Aztec, Icelandic, or Egyptian. And modern psychology finds them persisting still in our dreams, our vernacular, and our art, for all the changes in the outward conditions of life.

Our presentation of these myths, however, must be in our own terms, which are at once more primitive and more modern than the myths themselves – more primitive because we seek the primeval and atavistic roots of the idea rather than their graceful classical version; more modern than the myths themselves because we must redescribe their implications through our own experience. Those who think that the world of today is more gentle and graceful than the primeval and predatory passions from which these myths spring, are either not aware of reality or do not wish to see it in art. The myth holds us, therefore, not thru its romantic flavor, not thru the remembrance of the beauty of some bygone age, not thru the possibilities of fantasy, but because it expresses to us something real and existing in ourselves, as it was to those who first stumbled upon the symbols to give them life.

And now Mr Gottlieb, will you take the final question? Are you not denying modern art when you put so much emphasis on subject matter?

MR GOTTLIEB: It is true that modern art has severely limited subject matter in order to exploit the technical aspects of painting. This has been done with great brilliance by a number of painters, but it is generally felt today that this emphasis on the mechanics of picture making has been carried far enough. The surrealists have asserted their belief in subject matter but to us it is not enough to illustrate dreams.

While modern art got its first impetus thru discovering the forms of primitive art, we feel that its true significance lies not merely in formal arrangements, but in the spritual meaning under-lying all archaic works.

That these demonic and brutal images fascinate us today, is not because they are exotic, nor do they make us nostalgic for a past which seems enchanting because of its remoteness. On the contrary, it is the immediacy of their images that draws us irresistibly to the fancies, the superstitions, the fables of savages and the strange beliefs that were so vividly articulated by primitive man.

If we profess a kinship to the art of primitive men, it is because the feelings they expressed have a particular pertinence today. In times of violence, personal predilections for niceties of color and form seem irrelevant. All primitive expression reveals the constant awareness of powerful forces, the immediate presence of terror and fear, a recognition and acceptance of the brutality of the natural world as well as the eternal insecurity of life.

That these feelings are being experienced by many people thruout the world today is an unfortunate fact, and to us an art that glosses over or evades these feelings, is superficial or meaningless. That is why we insist on subject matter, a subject matter that embraces these feelings and permits them to be expressed.

Adolph Gottlieb and Mark Rothko, 'The Portrait and the Modern Artist', typescript of a broadcast on 'Art in New York,' Radio WNYC, 13 October 1943.

The theme here (The Omen of the Eagle) is derived from the Agamemnon Trilogy of Aeschylus. The picture deals not with the particular anecdote, but rather with the Spirit of Myth, which is generic to all myths at all times. It involves a pantheism in which man, bird, beast and tree – the known as well as the knowable – merge into a single tragic idea.

Mark Rothko, 1943

from Sydney Janis, *Abstract and Surrealist Art in America*, New York, 1944, p.118

PERSONAL STATEMENT

I adhere to the material reality of the world and the substance of things. I merely enlarge the extent of this reality, extending to it coequal attributes with experiences in our more familiar environment. I insist upon the equal existence of the world engendered in the mind and the world engendered by God outside of it. If I have faltered in the use of familiar objects, it is because I refuse to mutilate their appearance for the sake of an action which they are too old to serve; or for which, perhaps, they had never been intended.

I quarrel with surrealist and abstract art only as one quarrels with his father and mother, recognizing the inevitability and function of my roots, but insistent upon my dissension: I, being both they, and an integral completely independent of them.

The surrealist has uncovered the glossary of the myth and has established a congruity between the phantasmagoria of the unconscious and the objects of everyday life. This congruity constitutes the exhilarated tragic experience which for me is the only source book for art. But I love both the object and the dream far too much to have them effervesced into the insubstantiality of memory and hallucination. The abstract artist has given material existence to many unseen worlds and tempi. But i repudiate his denial of the anecdote just as I repudiate the denial of the material existence of the whole of reality. For art to me is an anecdote of the spirit, and the only means of making concrete the purpose of its varied quickness and stillness.

Rather be prodigal than niggardly. I would sooner confer anthropomorphic attributes upon a stone, than dehumanize the slightest possibility of consciousness.

Mark Rothko

David Porter Gallery, Washington, 1945

CLYFFORD STILL

It is significant that Still, working out West, and alone, has arrived at pictorial conclusions so allied to those of the small band of Myth Makers who have emerged here during the war. The fact that his is a completely new facet of this idea, using unprecedented forms and completely personal methods, attests further to the vitality of this movement.

Bypassing the current preoccupation with genre and the nuance of formal arrangements, Still expresses the tragic-religious drama which is generic to all Myths at all times, no matter where they occur. He is creating new counterparts to replace the old mythological hybrids who have lost their pertinence in the intervening centuries.

For me, Still's pictorial dramas are an extension of the Greek Persephone Myth. As he himself has expressed it his paintings are 'of the Earth, the Damned, and of the Recreated.'

Every shape becomes an organic entity, inviting the multiplicity of associations inherent in all living things. To me they form a theogony of the most elementary consciousness, hardly aware of itself beyond the will to live – a profound and moving experience.

Art of this Century, Clyfford Still, February 1946

A picture lives by companionship, expanding and quickening in the eyes of the sensitive observer. It dies by the same token. It is therefore a risky and unfeeling act to send it out into the world. How often it must be permanently impaired by the eyes of the vulgar and the cruelty of the impotent who would extend their affliction universally!

from *Tiger's Eye*, No.2, 1947, p.44

The romantics were prompted to seek exotic subjects and to travel to far off places. They failed to realize that, though the transcendental must involve the strange and unfamiliar, not everything strange or unfamiliar is transcendental.

The unfriendliness of society to his activity is difficult for the artist to accept. Yet this very hostility can act as a lever for true liberation. Freed from a false sense of security and community, the artist can abandon his plastic bank-book, just as he has abandoned other forms of security. Both the sense of community and of security depend on the familiar. Free of them, transcendental experiences become possible.

I think of my pictures as dramas; the shapes in the pictures are the performers. They have been created from the need for a group of actors who are able to move dramatically without embarrassment and execute gestures without shame.

Neither the action nor the actors can be anticipated, or described in advance. They begin as an unknown adventure in an unknown space. It is at the moment of completion that in a flash of recognition, they are seen to have the quantity and function which was intended. Ideas and plans that existed in the mind at the start were simply the doorway through which one left the world in which they occur.

The great cubist pictures thus transcend and belie the implications of the cubist program.

The most important tool the artist fashions through constant practice is faith in his ability to

produce miracles when they are needed. Pictures must be miraculous: the instant one is completed, the intimacy between the creation and the creator is ended. He is an outsider. The picture must be for him, as for anyone experiencing it later, a revelation, an unexpected and unprecedented resolution of an eternally familiar need.

On shapes:
They are unique elements in a unique situation.
They are organisms with volition and a passion for self-assertion.
They move with internal freedom, and without need to conform with or to violate what is probable in the familiar world.
They have no direct association with any particular visible experience, but in them one recognizes the principle and passion of organisms.

The presentation of this drama in the familiar world was never possible, unless everyday acts belonged to a ritual accepted as referring to a transcendent realm.

Even the archaic artist, who had an uncanny virtuosity found it necessary to create a group of intermediaries, monsters, hybrids, gods and demi-gods. The difference is that, since the archaic artist was living in a more practical society than ours, the urgency for transcendent experience was understood, and given an official status. As a consequence, the human figure and other elements from the familiar world could be combined with, or participate as a whole in the enactment of the excesses which characterize this improbable hierarchy. With us the disguise must be complete. The familiar identity of things has to be pulverized in order to destroy the finite associations with which our society increasingly enshrouds every aspect of our environment.

Without monsters and gods, art cannot enact our drama: art's most profound moments express this frustration. When they were abandoned as untenable superstitions, art sank into melancholy. It became fond of the dark, and enveloped its objects in the nostalgic intimations of a half-lit world. For me the great achievements of the centuries in which the artist accepted the probable and familiar as his subjects were the pictures of the single human figure – alone in a moment of utter immobility.

But the solitary figure could not raise its limbs in a single gesture that might indicate its concern with the fact of mortality and an insatiable appetite for ubiquitous experience in face of this fact. Nor could the solitude be overcome. It could gather on beaches and streets and in parks only through coincidence, and, with its companions, form a tableau vivant *of human incommunicability.*

I do not believe that there was ever a question of being abstract or representational. It is really a matter of ending this silence and solitude, of breathing and stretching one's arms again.

from *Possibilities*, No.1, Winter 1947/8, p.84

The progression of a painter's work, as it travels in time from point to point, will be toward clarity: toward the elimination of all obstacles between the painter and the idea, and between the idea and the observer. As examples of such obstacles, I give (among others) memory, history or geometry, which are swamps of generalization from which one might pull out parodies of ideas (which are ghosts) but never an idea in itself. To achieve this clarity is, inevitably, to be understood.

from *Tiger's Eye*, No.9, October 1949, p.114

Mr Rothko: I would like to say something about large pictures, and perhaps touch on some of the points made by the people who are looking for a spiritual basis for communion.

I paint very large pictures. I realize that historically the function of painting large pictures is something very grandiose and pompous. The reason I paint them however – I think it applies to other painters I know – is precisely because I want to be very intimate and human. To paint a small picture is to place yourself outside your experience, to look upon an experience as a stereopticon view or with a reducing glass. However you paint the larger picture, you are in it. It isn't something you command.

from *Interiors*, 10 May 1951. A Symposium

Mark Rothko
1288 6th Ave N.Y.C.
Dec. 20, 1952

Mr. Lloyd Goodrich
Whitney Museum

Dear Mr Goodrich

Betty Parsons has informed me that you have asked for two of my pictures to be sent before the holidays to be viewed by your purchasing committee. In view of the fact that I must decline the invitation, I hasten to get these remarks to you in due time.

I am addressing these remarks to you personally because we have already talked about related matters in regard to your present annual; and I feel therefore that there is some basis of under-standing. My reluctance to participate, then, was based on the conviction that the real and specific

meaning of the pictures was lost and distorted in these exhibitions. It would be an act of self deception for me to try to convince myself that the situation would be sufficiently different, in view of a possible purchase, if these pictures appeared in your permanent collection. Since I have a deep sense of responsibility for the life my pictures will lead out in the world, I will with gratitude accept any form of their exposition in which their life and meaning can be maintained, and avoid all occasions where I think that this cannot be done.

I know the likelihood of this being viewed as arrogance. But I assure you that nothing could be further from my mood which is one of great sadness about this situation: for, unfortunately there are few existing alternatives for the kind of activity which your museum represents. Nevertheless, in my life at least, there must be some congruity between convictions and actions if I am to continue to function and work. I hope that I have succeeded in explaining my position.

Sincerely,

Mark Rothko

Sir:

Re Two Americans in Action (A.N. ANNUAL, '58): I reject that aspect of the article which classifies my work as 'Action Painting'. An artist herself, the author must know that to classify is to embalm. Real identity is incompatible with schools and categories, except by mutilation.

To allude to my work as Action Painting borders on the fantastic. No matter what modifications and adjustments are made to the meaning of the word action. Action Painting is antithetical to the very look and spirit of my work. The work must be the final arbiter.

Mark Rothko
New York, N.Y.

letters to the Editor, *Art News*, Vol.56, No.8, December 1957 (p.5)

It was with the utmost reluctance that I found the figure could not serve my purposes But a time came when none of us could use the figure without mutilating it.

Excerpt from notes taken at a lecture by Mark Rothko at the Pratt Institute.
Published in an article by Dore Ashton in *The New York Times*, 31 October 1958

There is, however, a profound reason for the persistence of the word 'portrait' because the real essence of the great portraiture of all time is the artist's eternal interest in the human figure, character and emotions – in short in the human drama. That Rembrandt expressed it by posing a sitter is irrelevant. We do not know the sitter but we are intensely aware of the drama. The Archaic Greeks, on the other hand used as their models the inner visions which they had of their gods. And in our day, our visions are the fulfillment of our own needs.

It must be noted that the great painters of the figure had this in common. Their portraits resemble each other far more than they recall the peculiarities of a particular model. In a sense they have painted one character in all their work. What is indicated here is that the artist's real model is an ideal which embraces all of human drama rather than the appearance of a particular individual.

Today the artist is no longer constrained by the limitation that all of man's experience is expressed by his outward appearance. Freed from the need of describing a particular person, the possibilities are endless. The whole of man's experience becomes his model, and in that sense it can be said that all of art is a portrait of an idea.

Neither Mr Gottlieb's painting nor mine should be considered abstract paintings. It is not their intention either to create or to emphasize a formal color-space arrangement. They depart from natural representation only to intensify the expression of the subject implied in the title – not to dilute or efface it.

'There are some artists who want to tell all, but I feel it is more shrewd to tell little. My paintings are sometimes described as facades, and, indeed, they are facades.'

[Some of the 'ingredients' listed by Rothko as his 'recipe' for art]

'A clear preoccupation with death. All art deals with intimations of mortality.'

'Sensuality, the basis for being concrete about the world.'

'Tension: conflict or desire which in art is curbed at the very moment it occurs.'

'Irony: a modern ingredient. (The Greeks didn't need it.) A form of self-effacement and self-examination in which a man can for a moment escape his fate.'

'Wit, humor.'

'A few grams of the ephemeral, a chance.'

'About 10 per cent of hope If you need that sort of thing; the Greeks never mentioned it.'

'I paint large pictures because I want to create a state of intimacy. A large picture is an immediate transaction; it takes you into it.'

Excerpt from notes taken at a lecture by Mark Rothko at the Pratt Institute.
Published in an article by Dore Ashton in *Cimaise*, December 1958

Suggestions from Mr Mark Rothko regarding installation of his Paintings at the Whitechapel Gallery 1961

WALL COLOR: *Walls should be made considerably off-white with umber and warmed by a little red. If the walls are too white, they are always fighting against the pictures which turn greenish because of the predominance of red in the pictures.*

LIGHTING: *The light, whether natural or artificial, should not be too strong: the pictures have their own inner light and if there is too much light, the color in the picture is washed out and a distortion of their look occurs. The ideal situation would be to hang them in a normally lit room – that is the way they were painted. They should not be over-lit or romanticized by spots; this results in a distortion of their meaning. They should either be lighted from a great distance or indirectly by casting lights at the ceiling or the floor. Above all, the entire picture should be evenly lighted and not strongly.*

HANGING HEIGHT FROM THE FLOOR: *The larger pictures should all be hung as close to the floor as possible, ideally not more than six inches above it. In the case of the small pictures, they should be somewhat raised but not 'skyed' (never hung towards the ceiling). Again this is the way the pictures were painted. If this is not observed, the proportions of the rectangles become distorted and the picture changes.*

The exceptions to this are the pictures which are enumerated below which were painted as murals actually to be hung at a greater height. These are:

1 *Sketch for Mural, No. 1, 1958*

2 *Mural Sections 2, 3, 4, 5, and 7, 1958–9*

3 *White and Black on Wine, 1958*

The murals were painted at a height of 4′6″ above the floor. If it is not possible to raise them to that extent, any raising above three feet would contribute to their advantage and original effect.

GROUPING: *In the Museum of Modern Art's exhibition all works from the earliest in the show of 1949 inclusive were hung as a unit, the watercolors separated from the others. The murals were hung as a second unit, all together. The only exception to this grouping of the murals is the picture owned by Mr Rubin, 'White and Black on Wine' 1958, which could take its place, but with a raised hanging among the other works since it is a transitional piece between the earlier pictures of that year and the mural series. In the remaining works, it is best not to follow a chronological order but to arrange them according to their best effect upon each other. For instance, in the exhibition at the Museum the very light pictures were grouped together – yellows, oranges, etc. – and contributed greatly to the effect produced.*

In considering your installation, it might be of interest that with three murals (Mural Section No.3, 1959 in center, Mural Section No.5, and Mural Section No.7, each on flanking walls) were hung in a separate gallery in our Museum. The dimensions of this gallery were $16\frac{1}{2}′ \times 20′$ which Rothko felt were very good proportions and gave an excellent indication of the way in which the murals were intended to function. If a similar room could be devised, it would be highly desirable.

Notes drafted and sent by the Museum of Modern Art, New York

COMMEMORATIVE ESSAY

I would like to say a few words about the greatness of Milton Avery.

This conviction of greatness, the feeling that one was in the presence of great events, was immediate on encountering his work. It was true for many of us who were younger, questioning, and looking for an anchor. This conviction has never faltered. It has persisted, and has been reinforced through the passing decades and the passing fashions.

I cannot tell you what it meant for us during those early years to be made welcome in those memorable studios on Broadway, 72nd Street, and Columbus Avenue. We were, there, both the subjects of his paintings and his idolatrous audience. The walls were always covered with an endless and changing array of poetry and light.

The instruction, the example, the nearness in the flesh of this marvelous man – all this was a significant fact – one which I shall never forget.

Avery is first a great poet. His is the poetry of sheer loveliness, of sheer beauty. Thanks to him this kind of poetry has been able to survive in our time.

This – alone – took great courage in a generation which felt that it could be heard only through clamor, force and a show of power. But Avery had that inner power in which gentleness and silence proved more audible and poignant.

From the beginning there was nothing tentative about Avery. He always had that naturalness, that exactness and that inevitable completeness which can be achieved only by those gifted with magical means, by those born to sing.

There have been several others in our generation who have celebrated the world around them, but none with that inevitability where the poetry penetrated every pore of the canvas to the very last touch of the brush. For Avery was a great poet-inventor who had invented sonorities never seen nor heard before. From these we have learned much and will learn more for a long time to come.

What was Avery's repertoire? His living room, Central Park, his wife Sally, his daughter March, the beaches and mountains where they summered; cows, fish heads, the flight of birds; his friends and whatever world strayed through his studio: a domestic, unheroic cast. But from these there have been fashioned great canvases, that far from the casual and transitory implications of the subjects, have always a gripping lyricism, and often achieve the permanence and monumentality of Egypt.

I grieve for the loss of this great man. I rejoice for what he has left us.

Mark Rothko

7 January 1965

from Milton Avery, National Collection of Fine Arts, Smithsonian Institution, Washington, D.C. December 1969–January 1970

1 **Interior** 1932

2 **Woman Sewing** mid 1930s

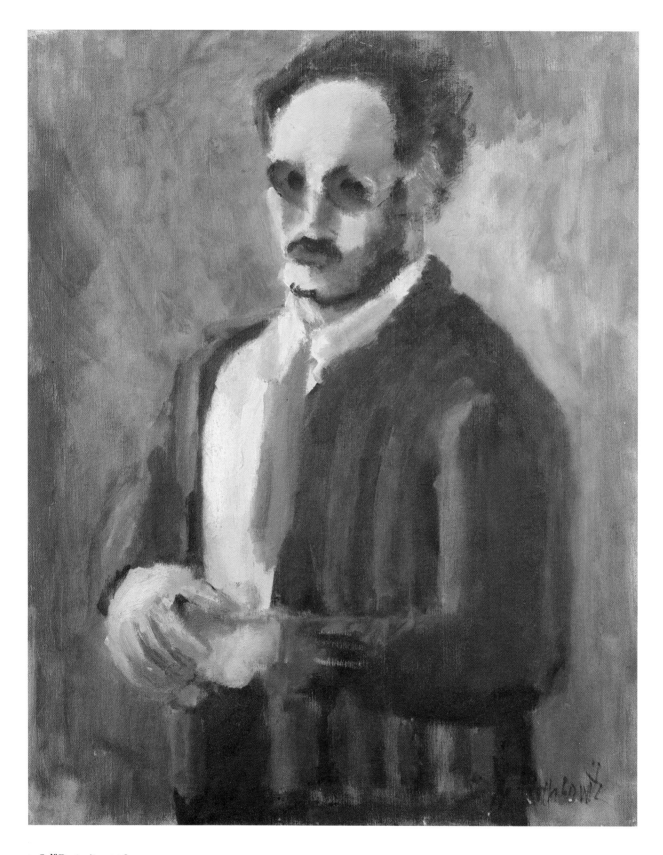

3 Self Portrait 1936

4 **Subway** 1930s

5 Untitled 1936

6 **Untitled** 1938

7 **Subway Scene** 1938

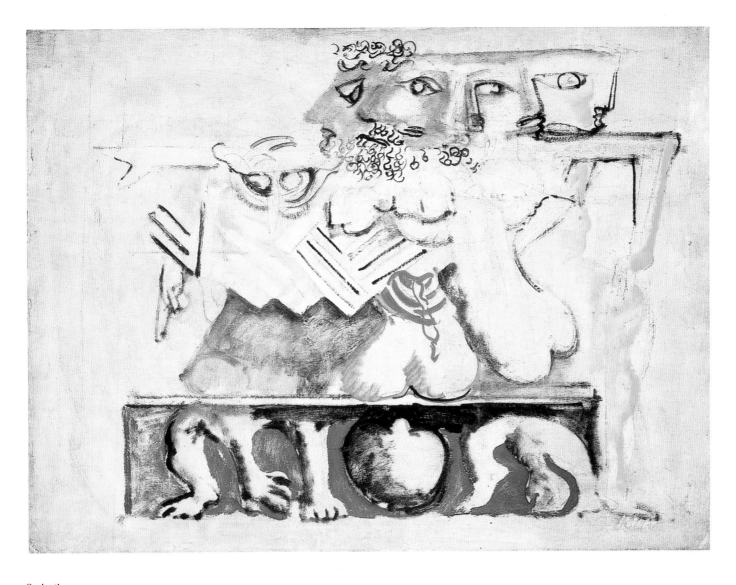

8 Antigone 1941

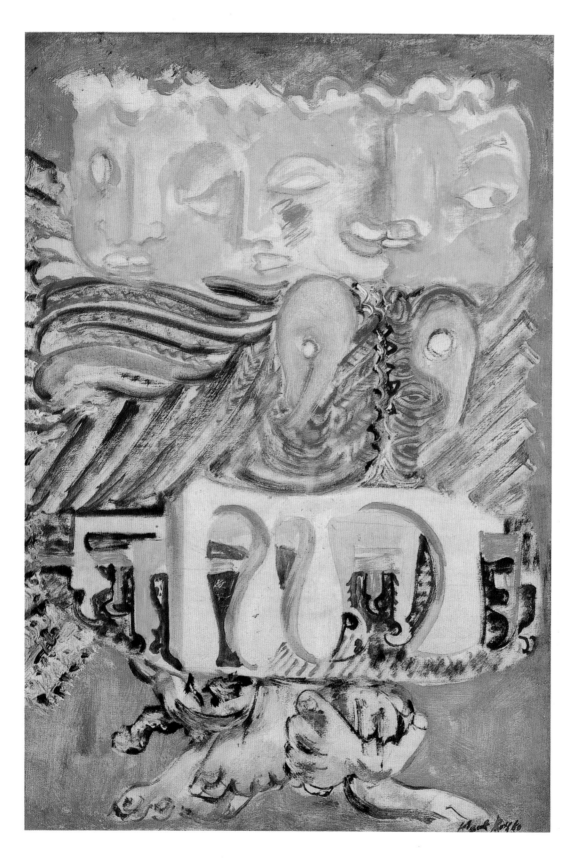

9 **The Omen of the Eagle** 1942

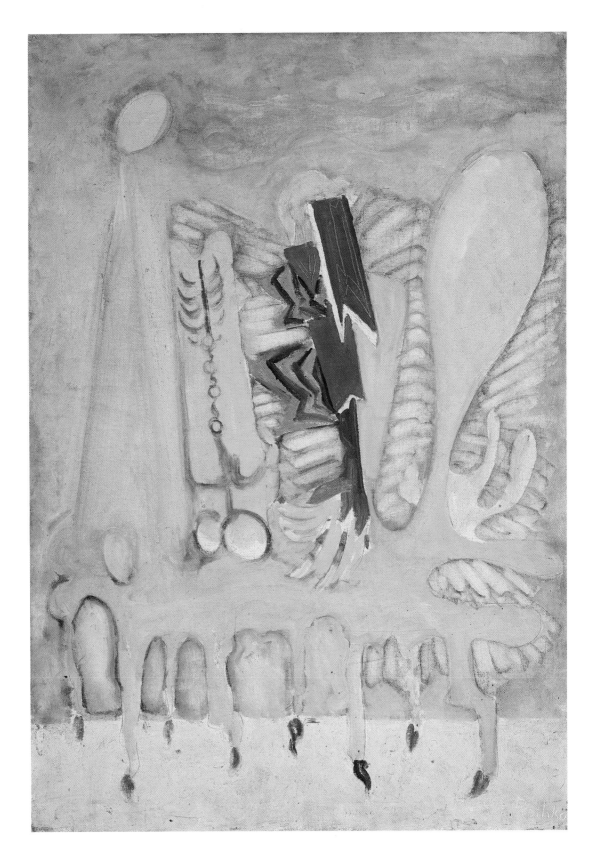

10 The Syrian Bull 1943

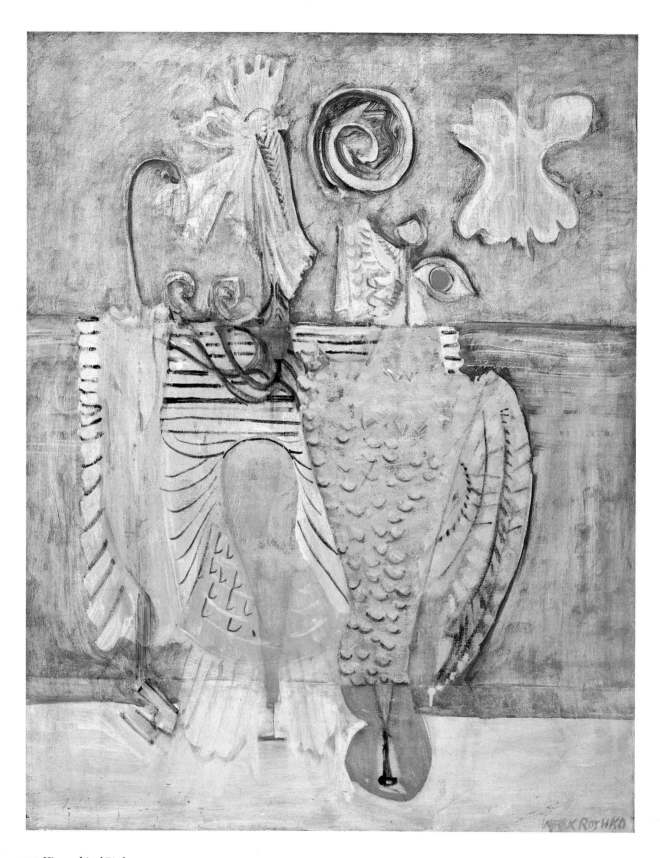

11 **Hierarchical Birds** 1944

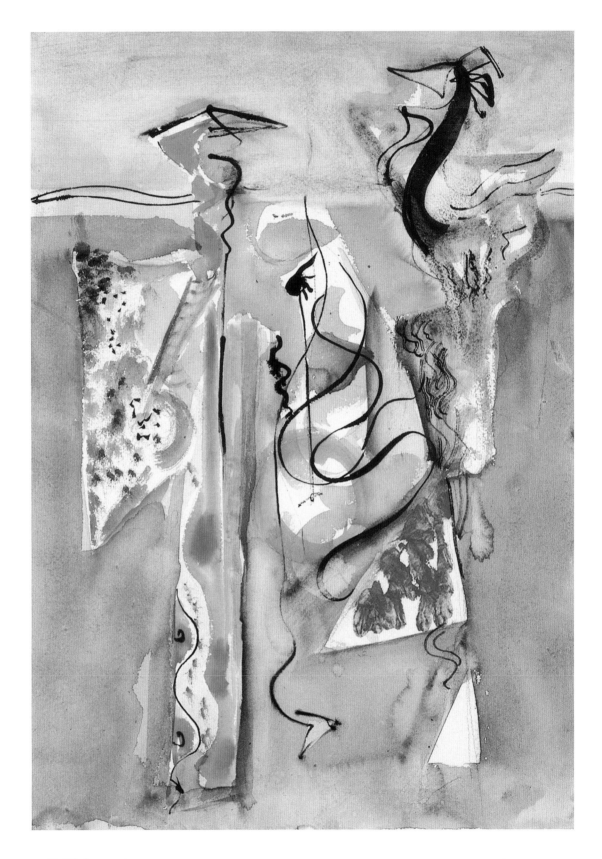

12 Untitled *c.*1944

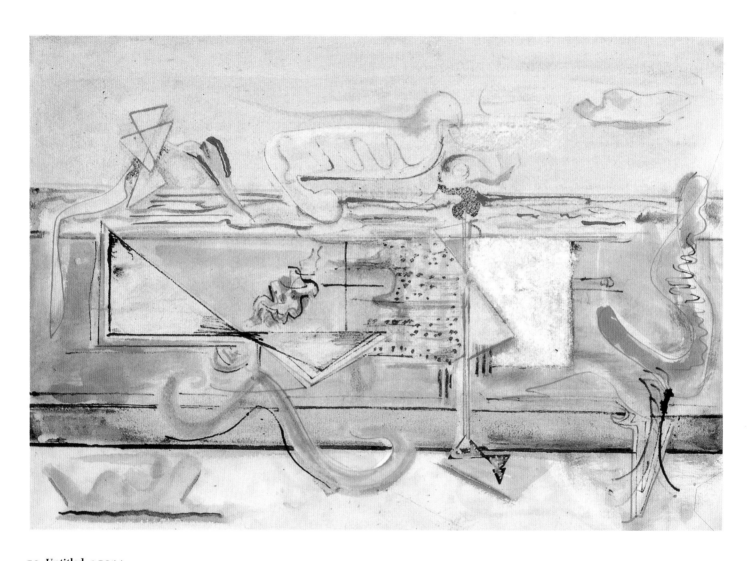

13 Untitled *c.*1944

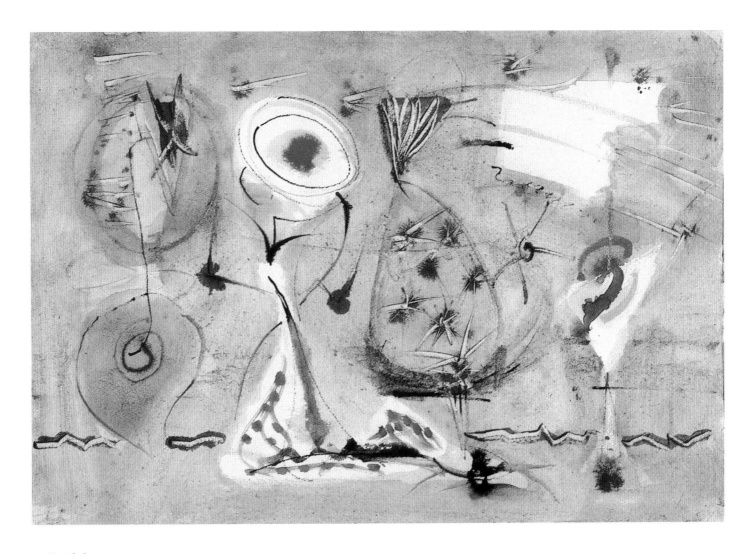

14 Untitled *c.*1944

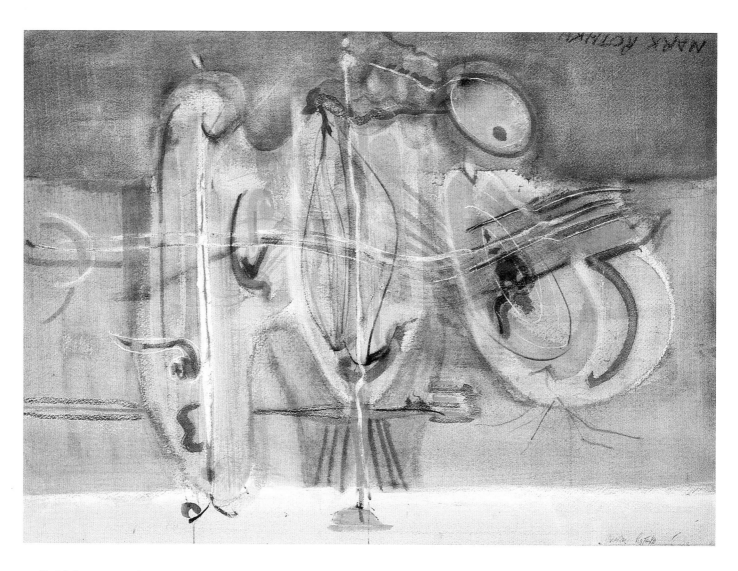

15 Untitled c.1944–46

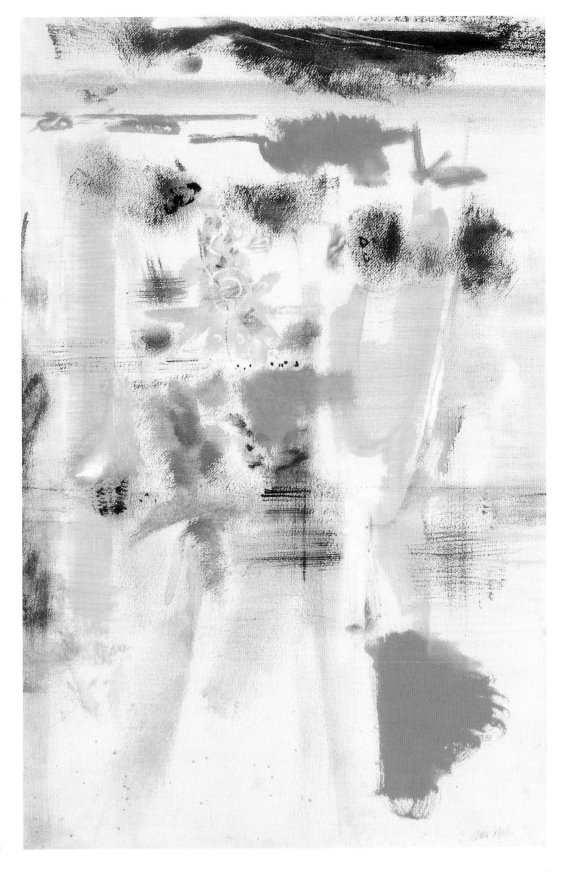

16 Untitled 1944–46

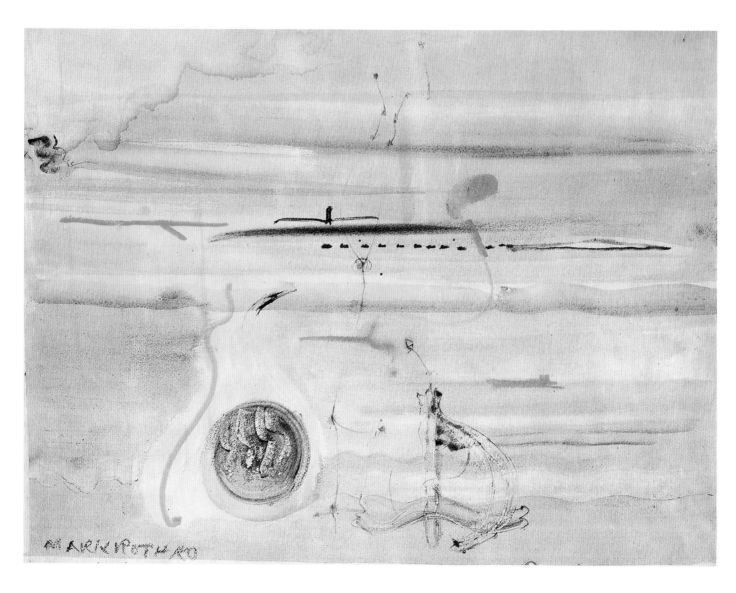

17 Untitled 1944–46
reverse of exhibited work

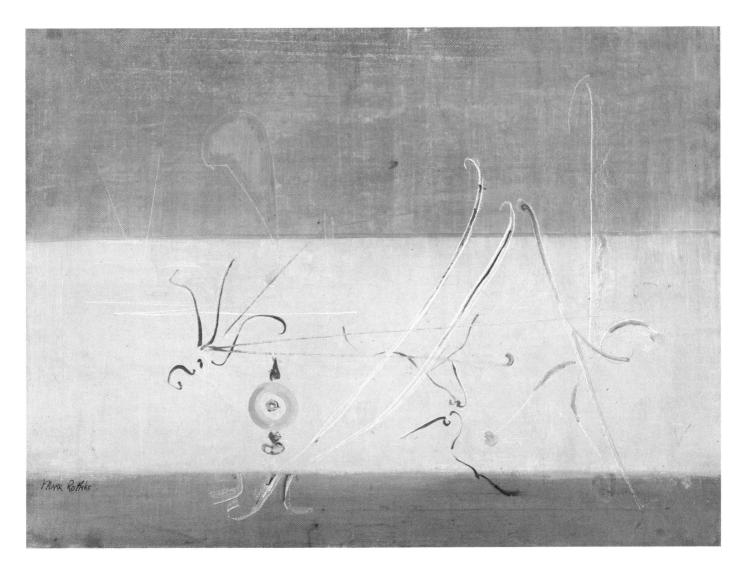

18 Untitled 1945

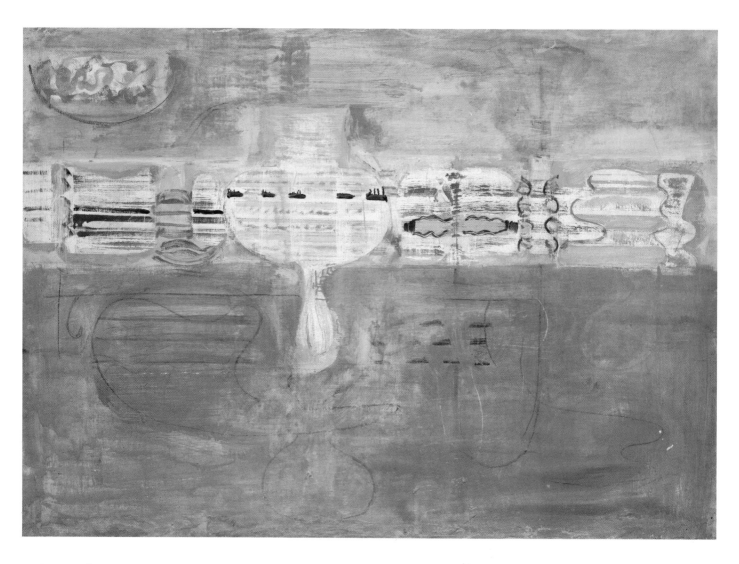

19 Horizontal Vision 1946

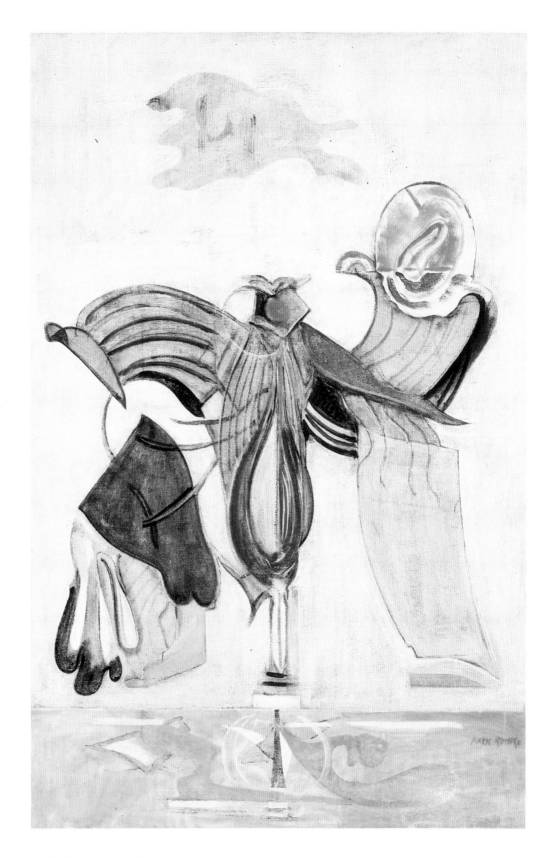

20 Gethsemane 1946

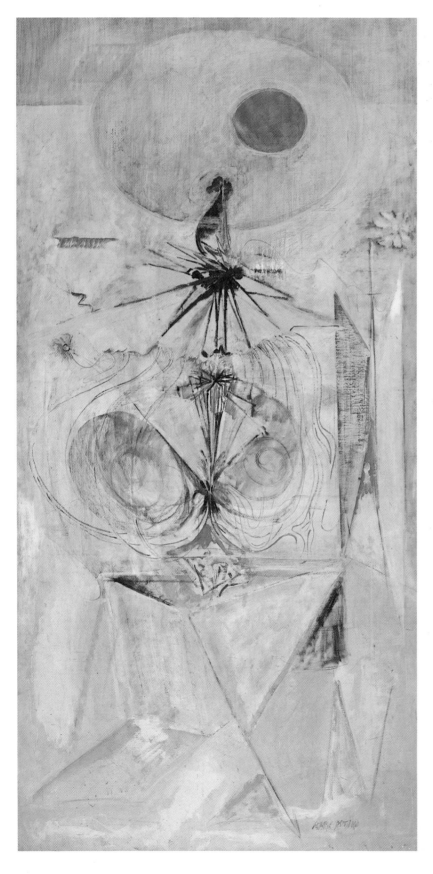

21 Tiresias 1946

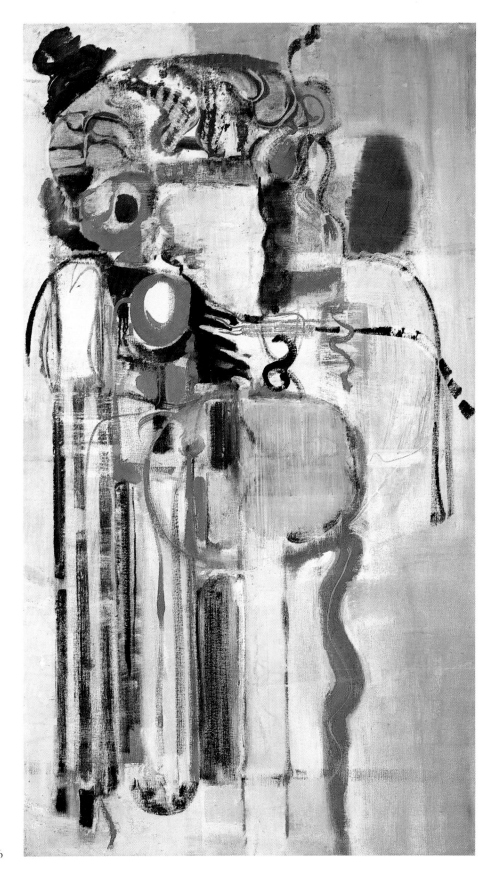

22 Personage Two 1946

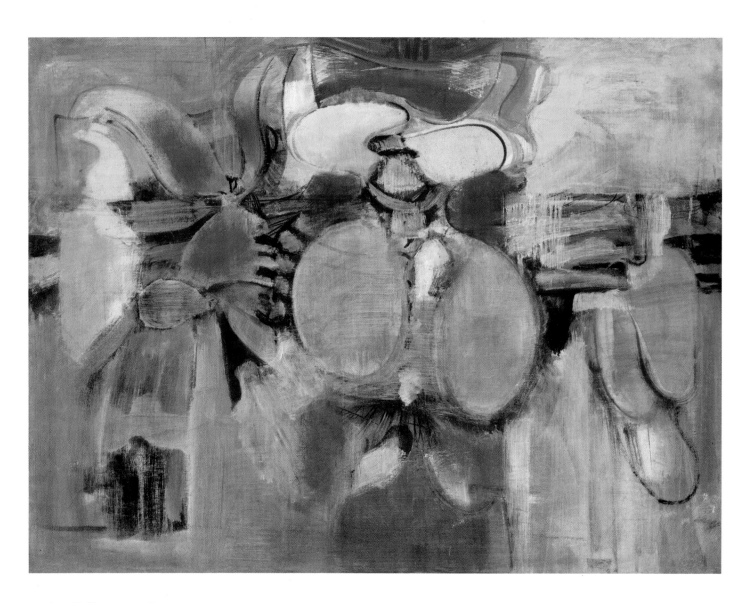

23 Aquatic Drama 1946

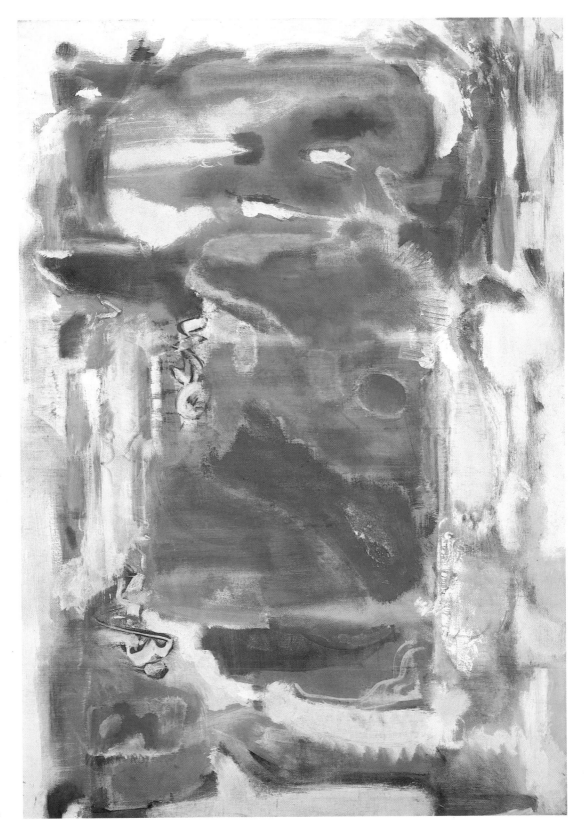

24 Number 18 1947

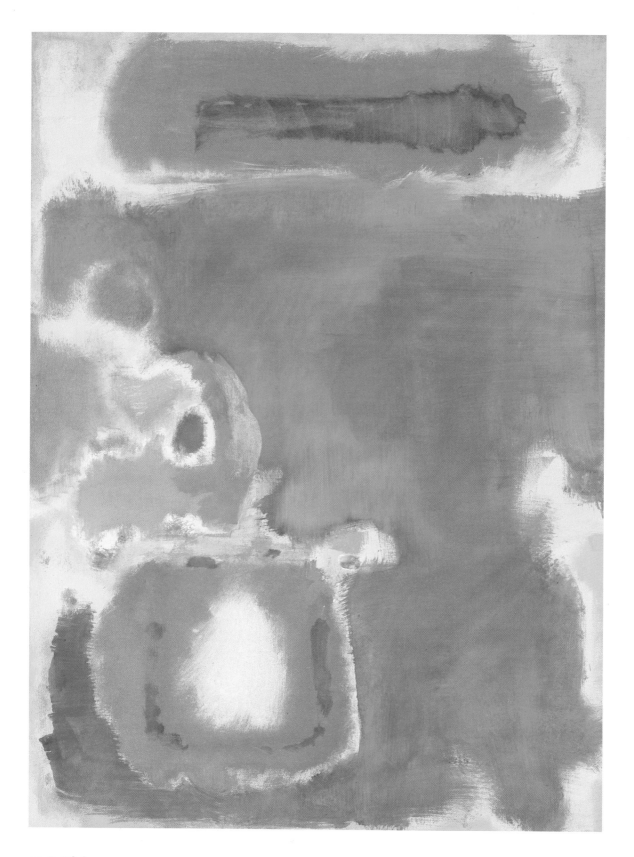

25 Untitled 1947

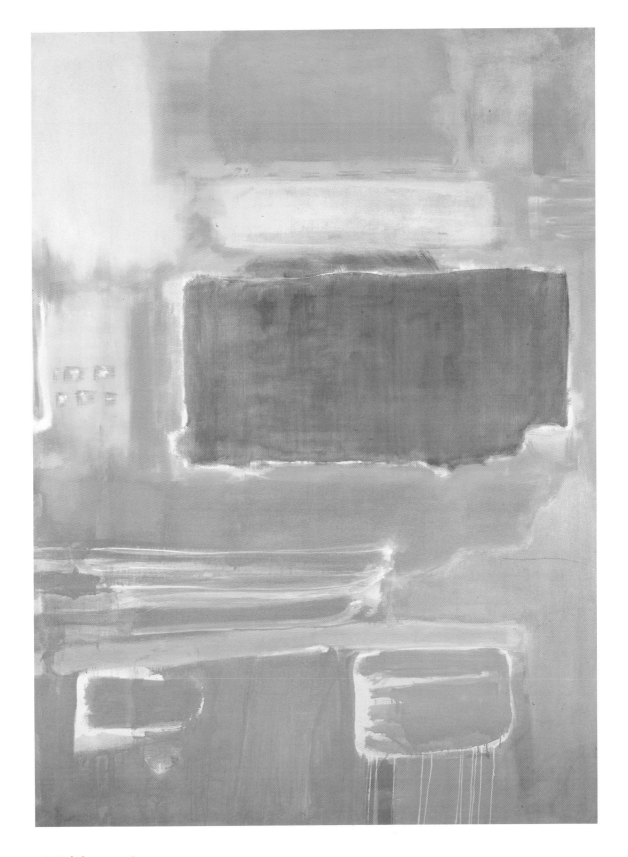

26 Multiform 1948

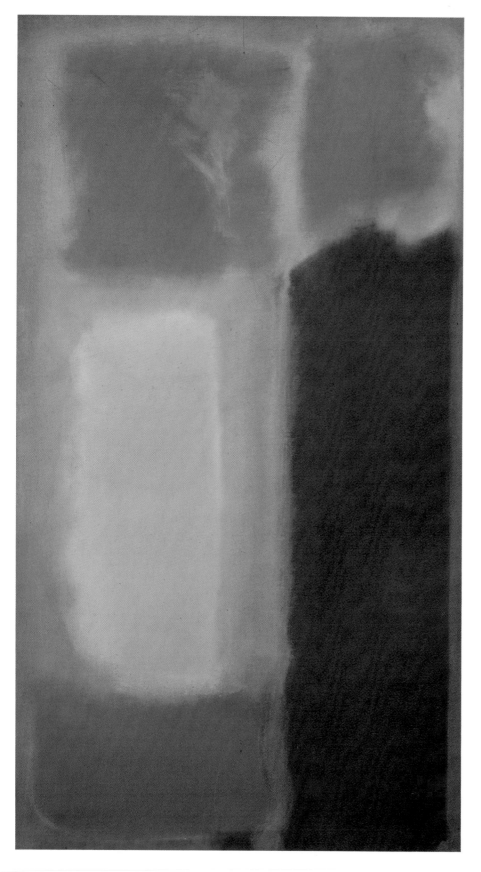

27 Number 15 1948

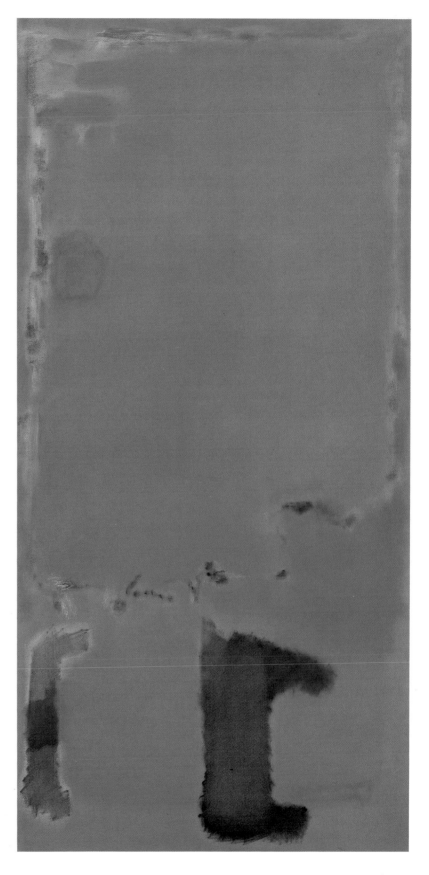

28 Untitled 1949

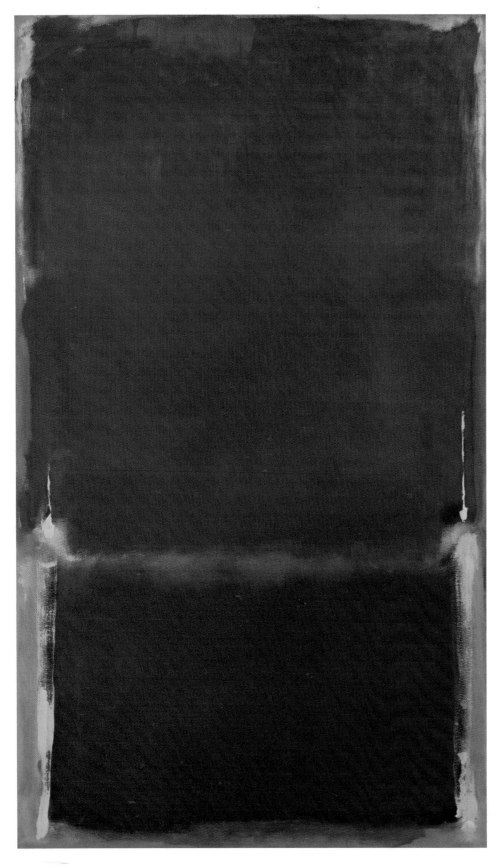

29 Untitled 1949

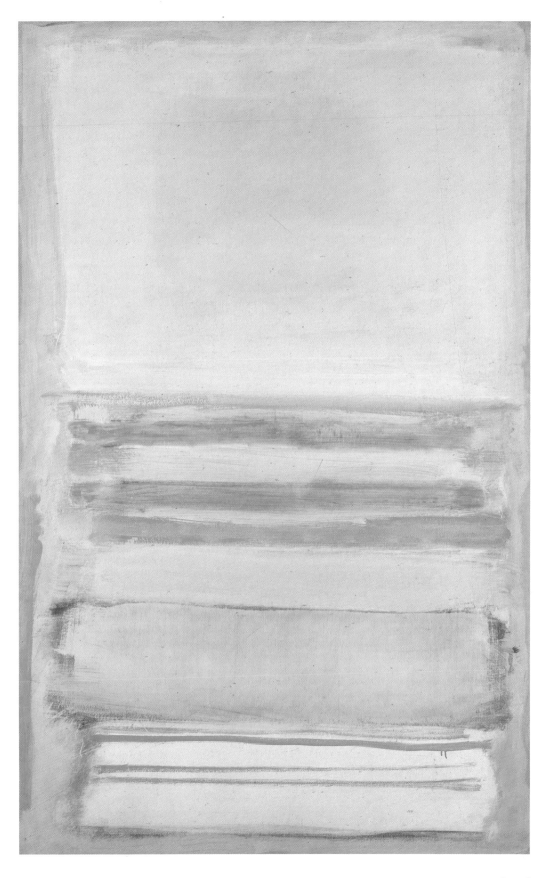

30 Number 11 1949

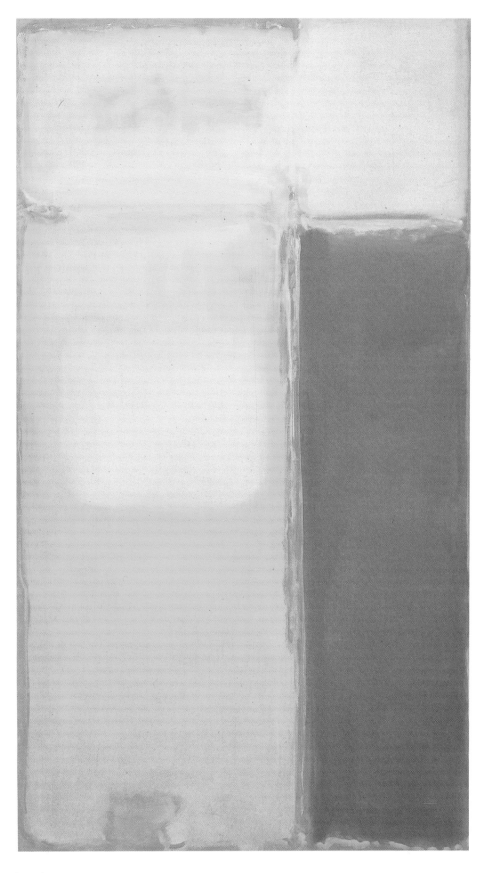

31 Untitled 1949

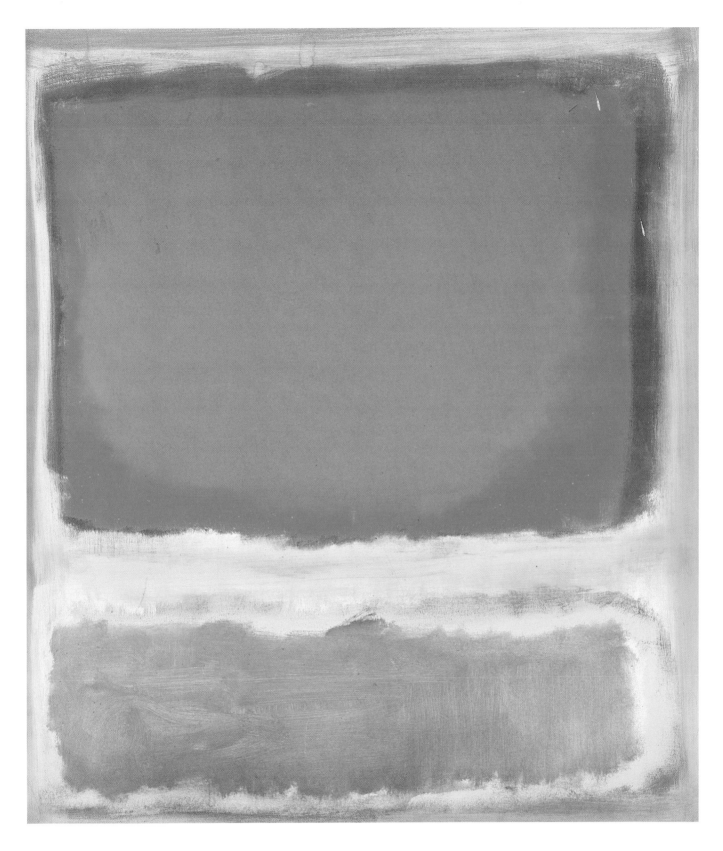

32 Untitled 1949

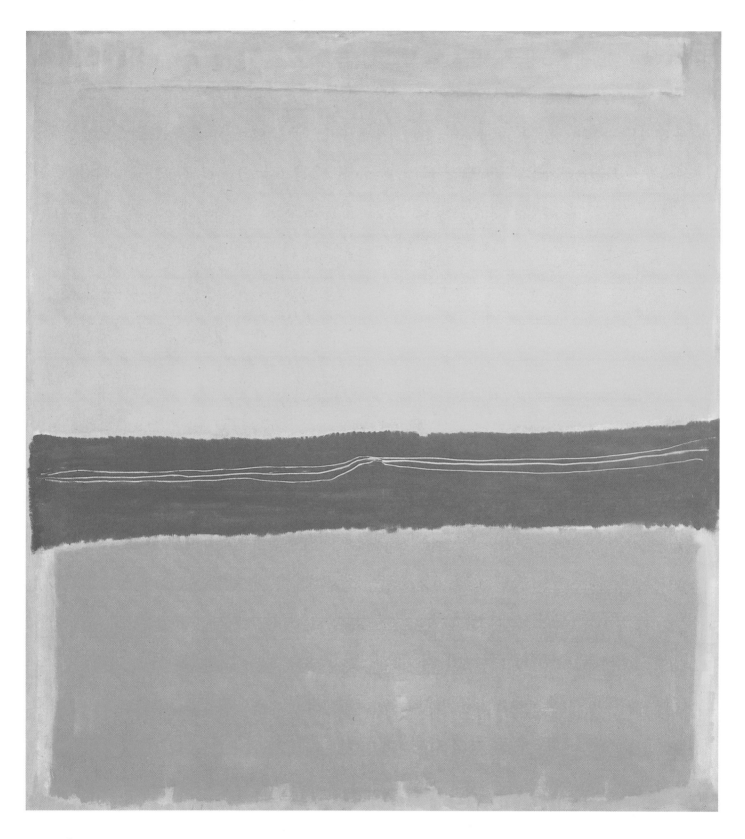

33 **Number 22** 1949

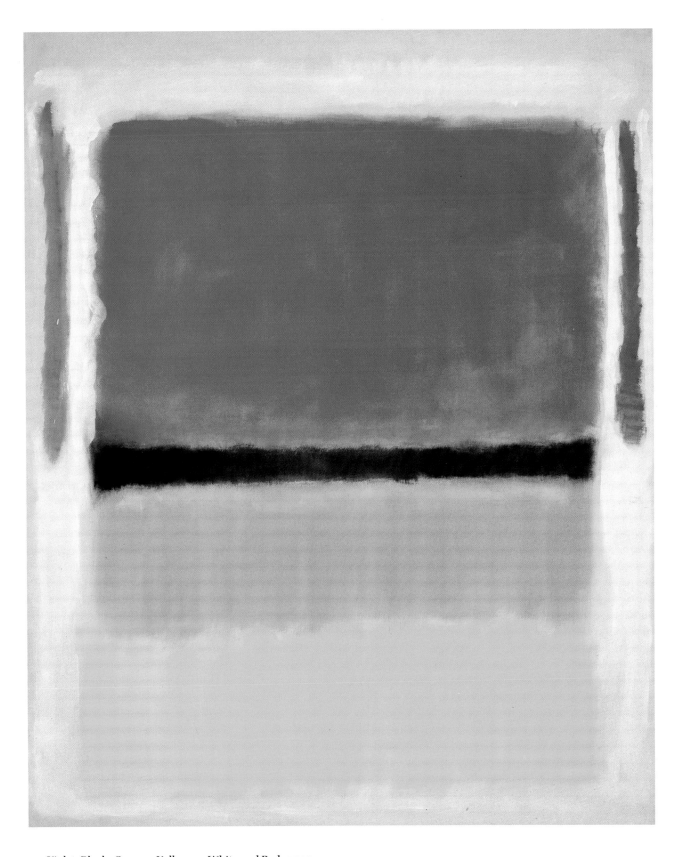

34 Violet, Black, Orange, Yellow on White and Red 1949

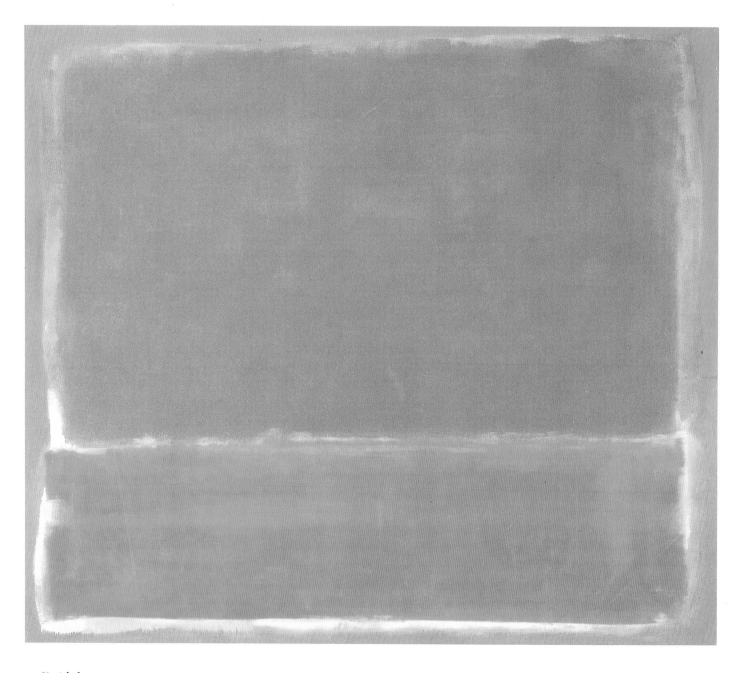

35 Untitled 1951

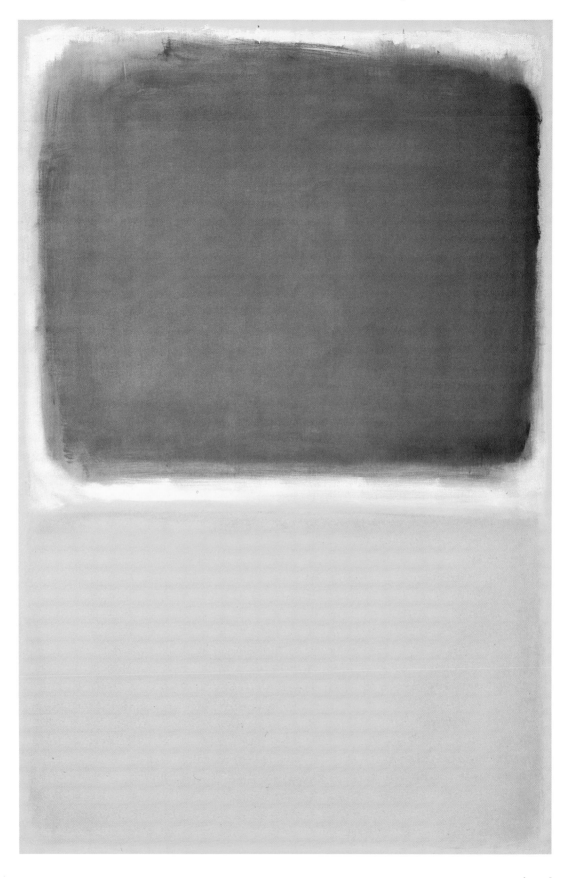

36 Green, White and
Yellow on Yellow 1951

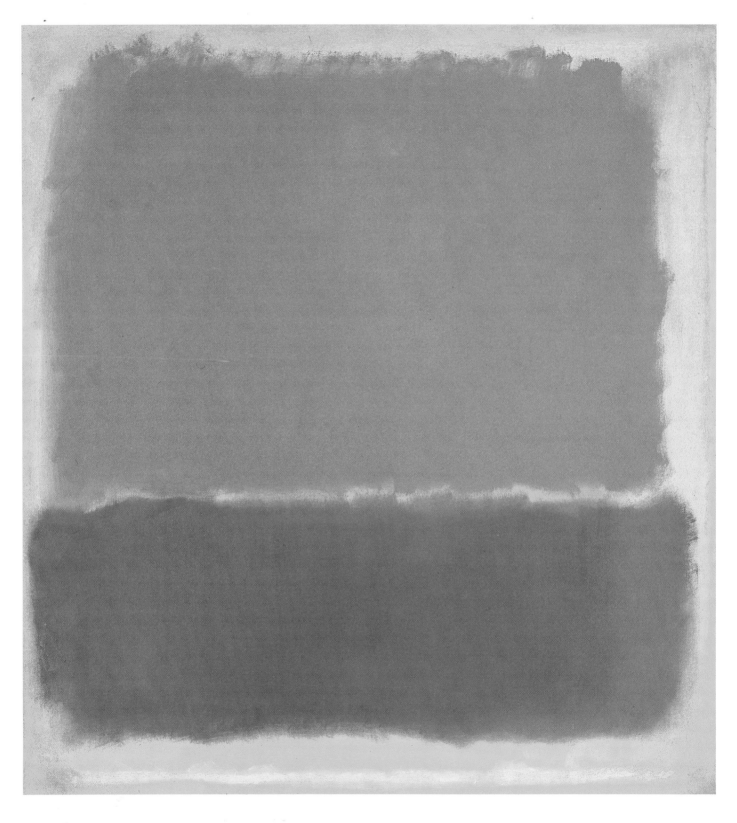

37 Number 12 1951

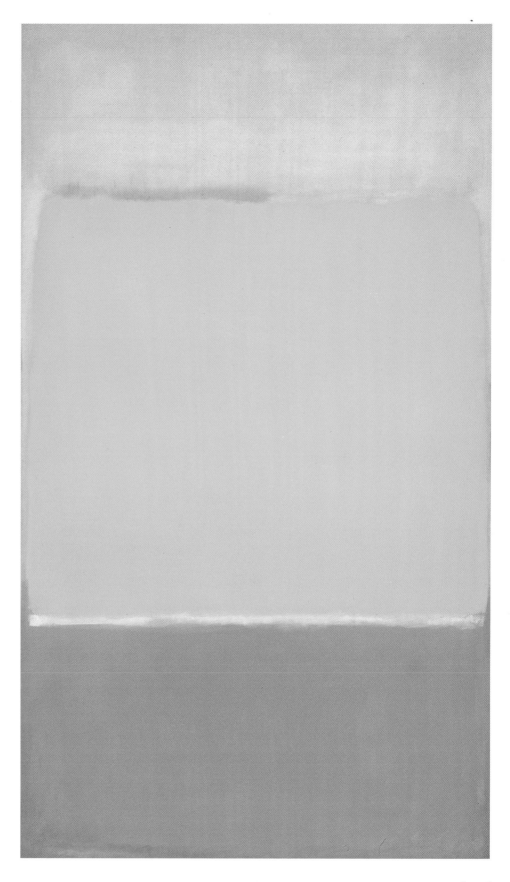

38 Number 7 1951

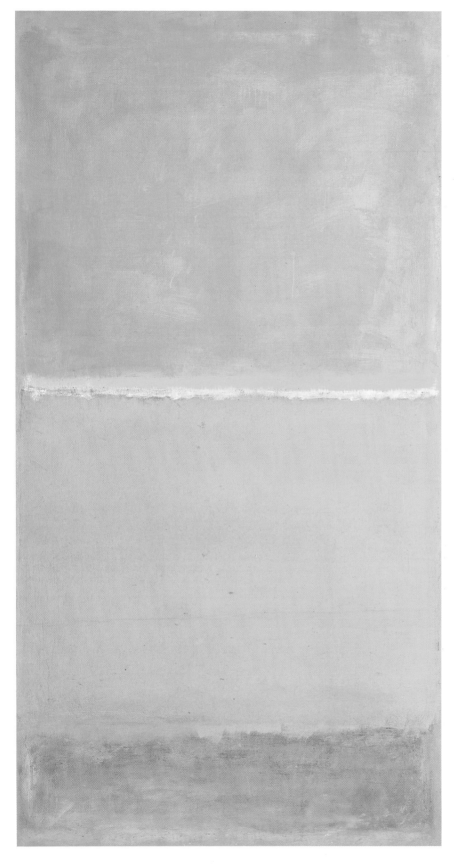

39 Untitled *c*.1951–52

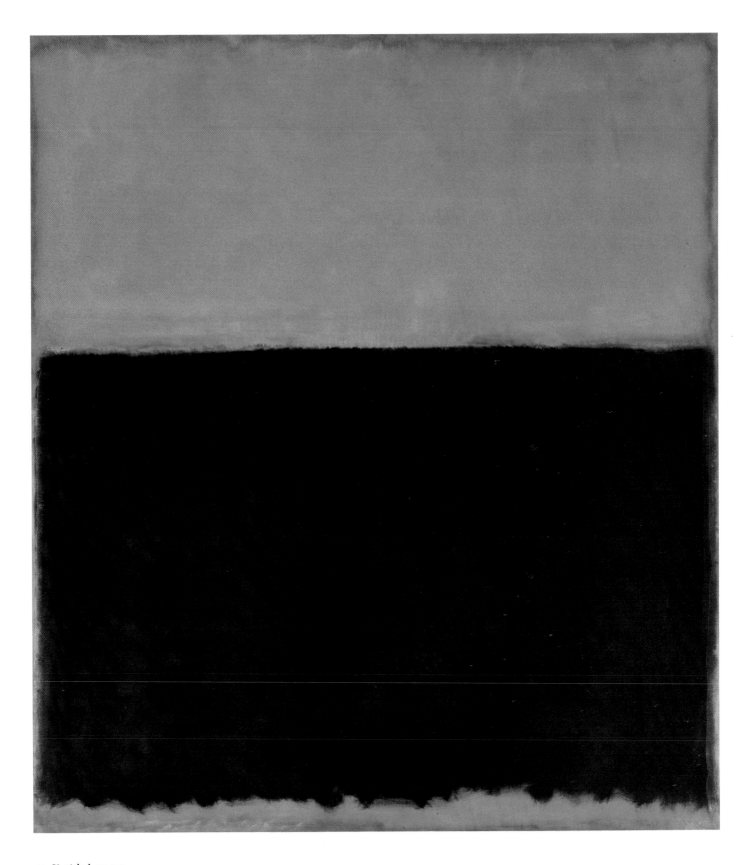

40 Untitled 1953

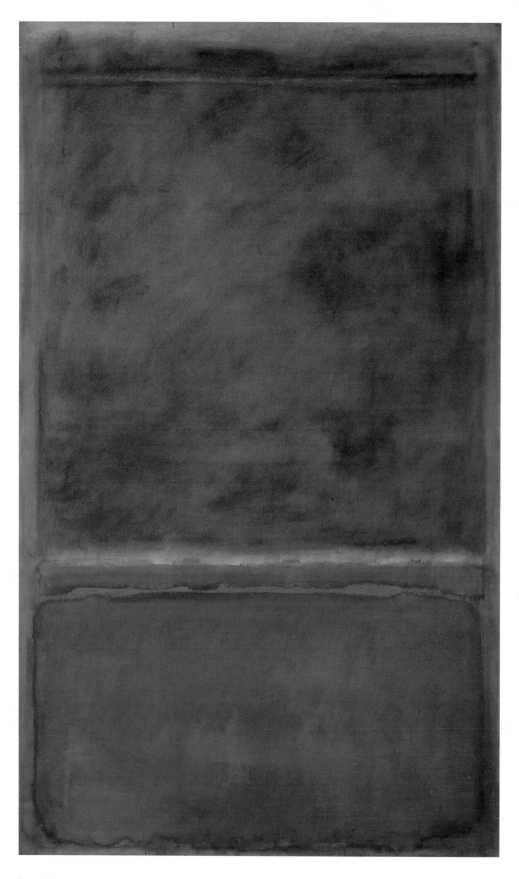

41 Green and Maroon 1953

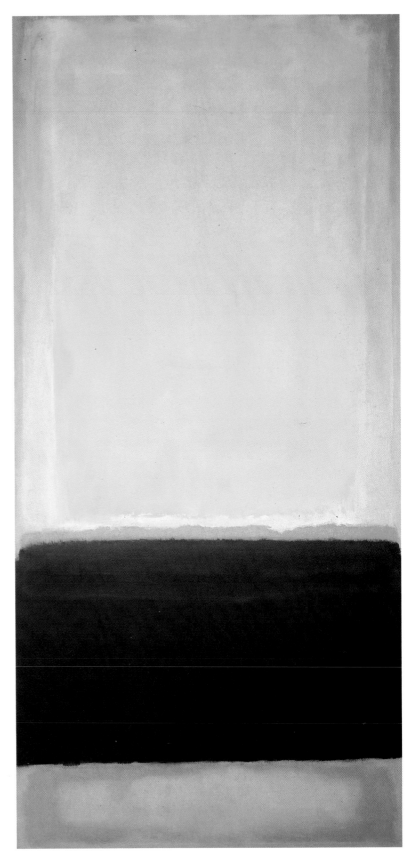

42 Untitled 1953

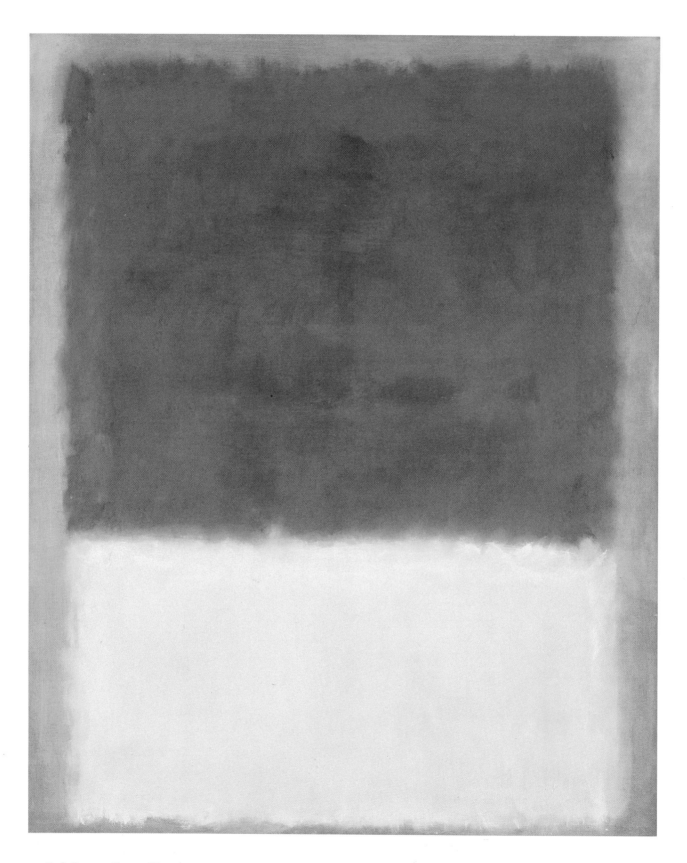

43 Red, Orange, Tan and Purple 1954

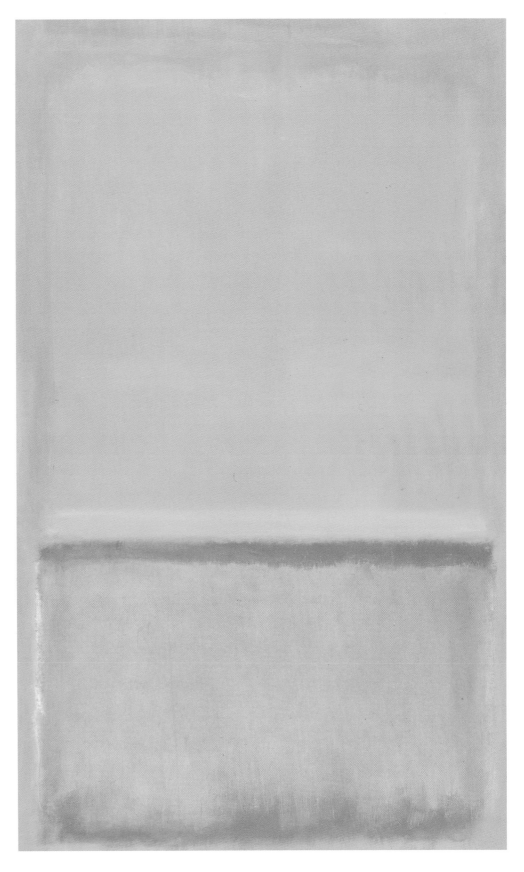

44 Untitled 1954

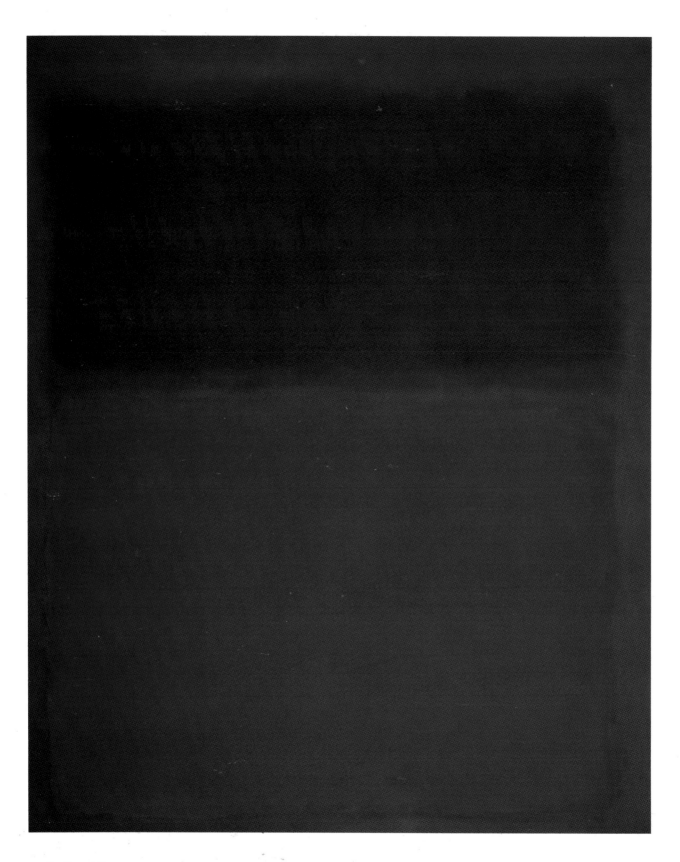

45 Earth and Green 1955

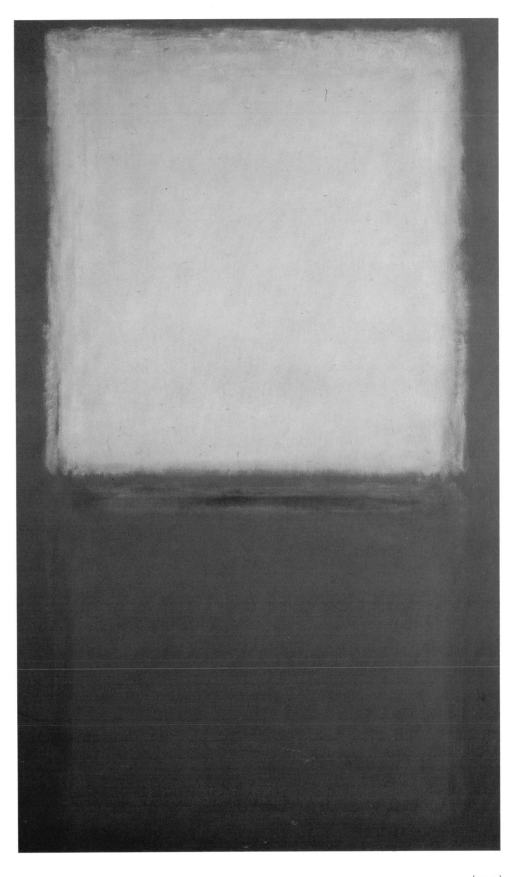

46 Untitled 1954

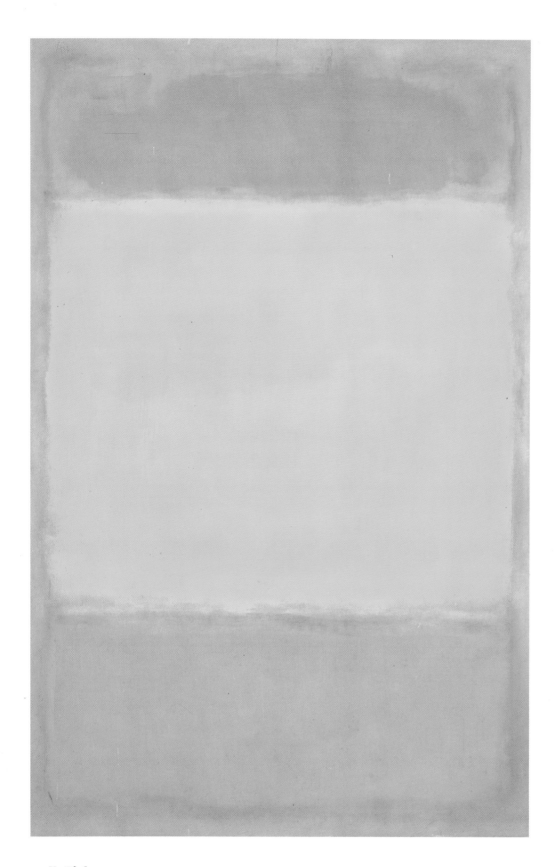

47 Untitled 1954

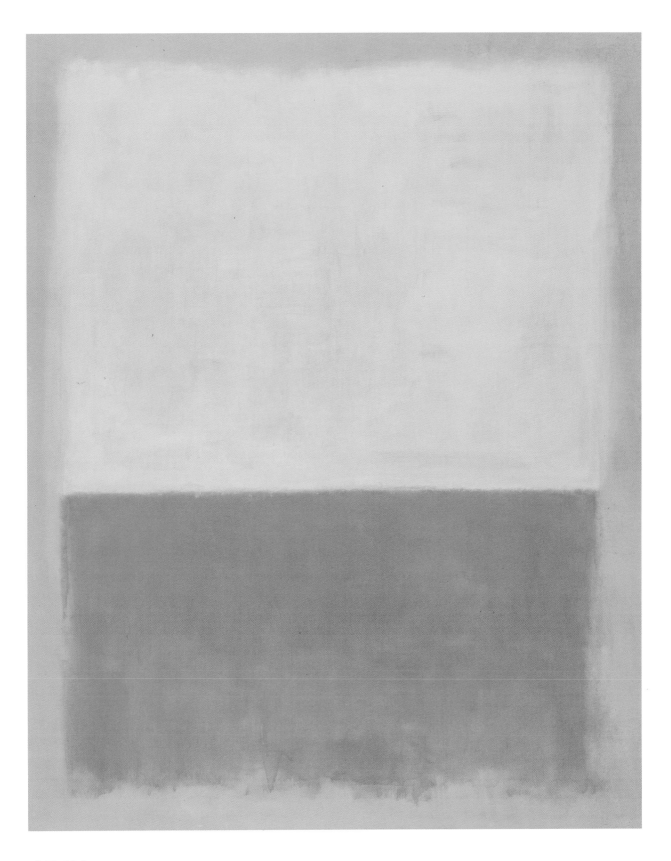

48 Untitled 1954

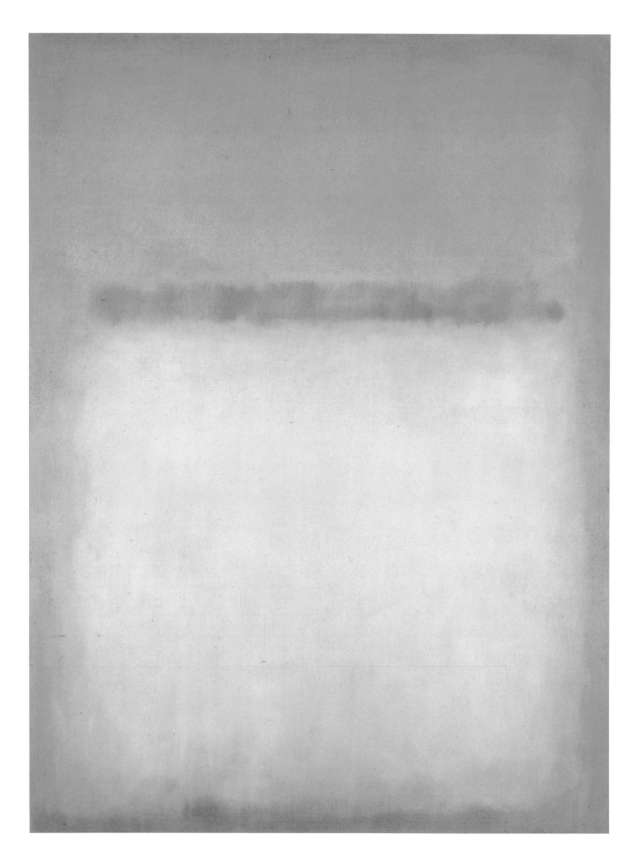

49 Untitled 1955

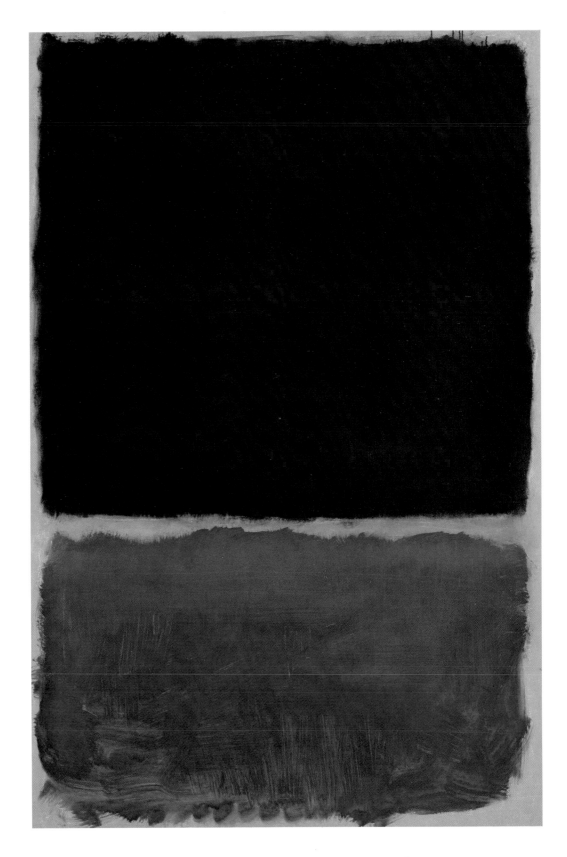

50 Untitled 1955

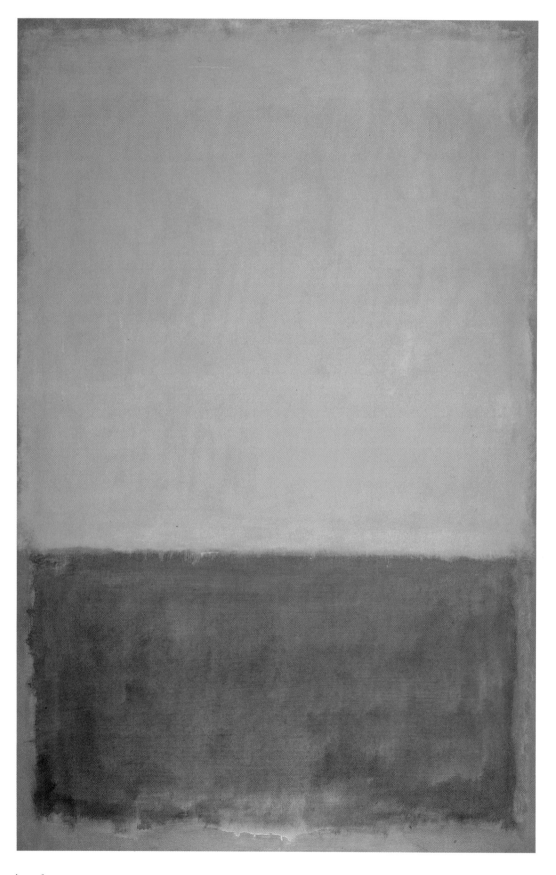

51 Yellow Blue on Orange 1955

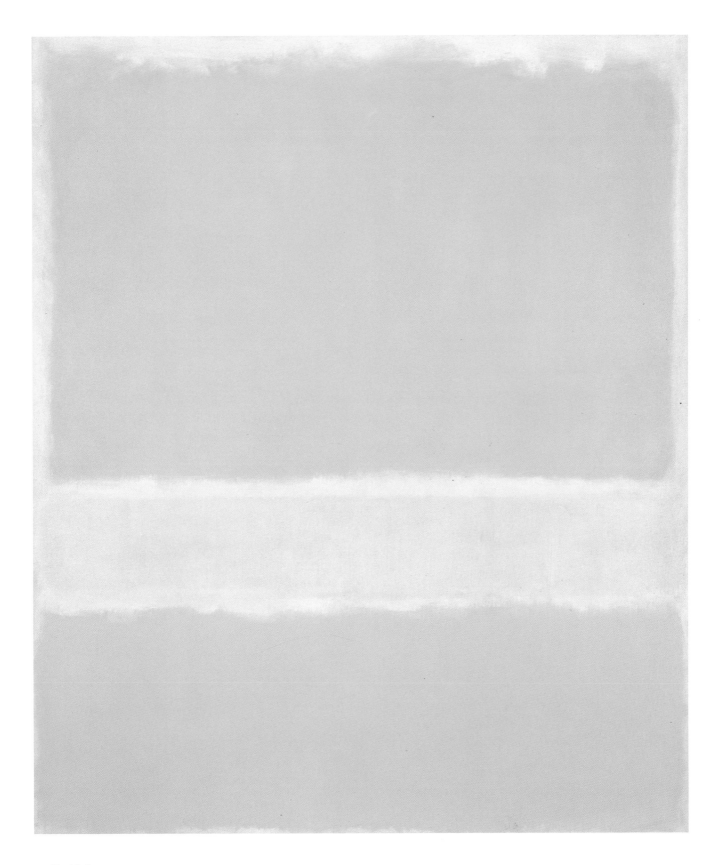

52 Untitled 1955

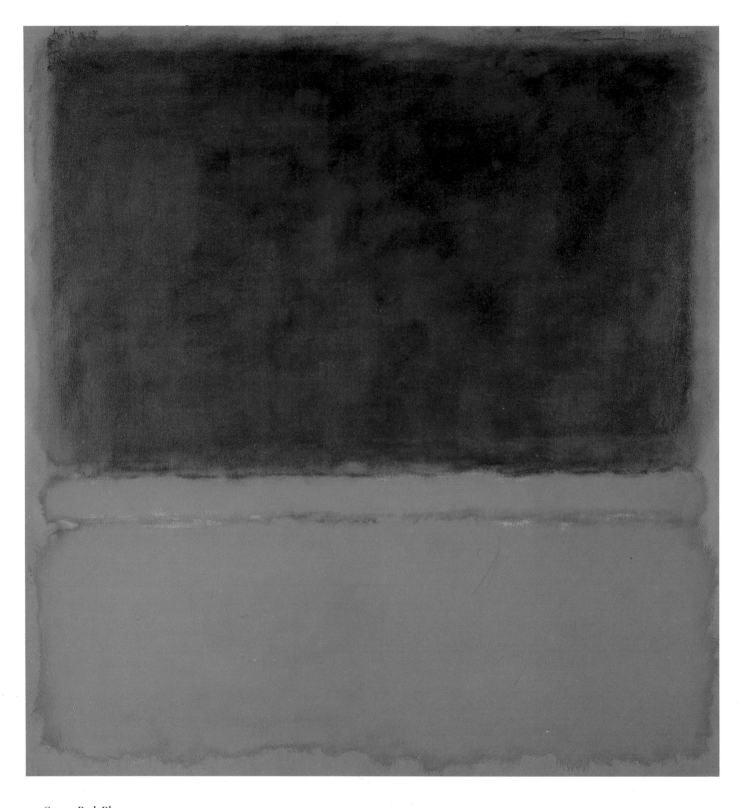

53 Green, Red, Blue 1955

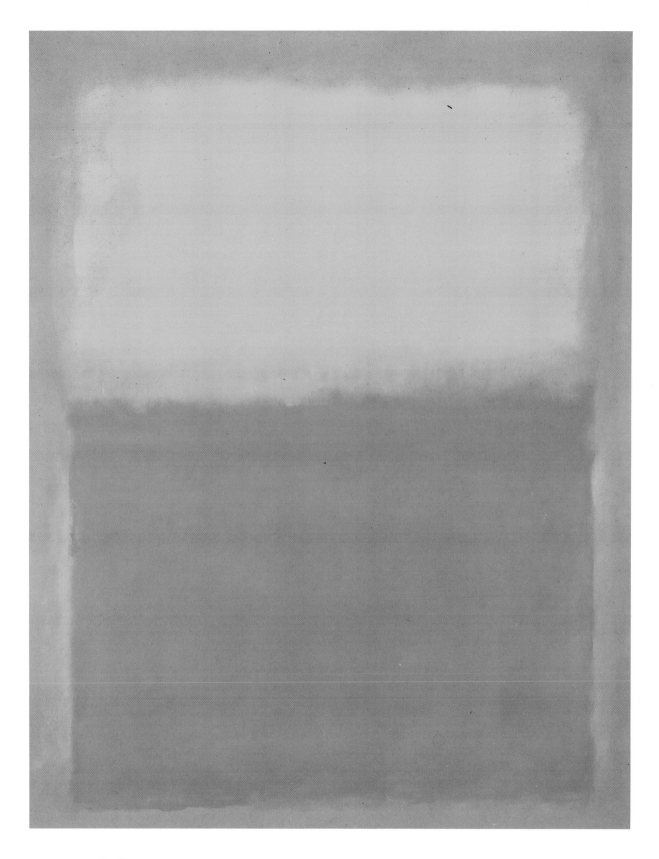

54 Orange and Yellow 1956

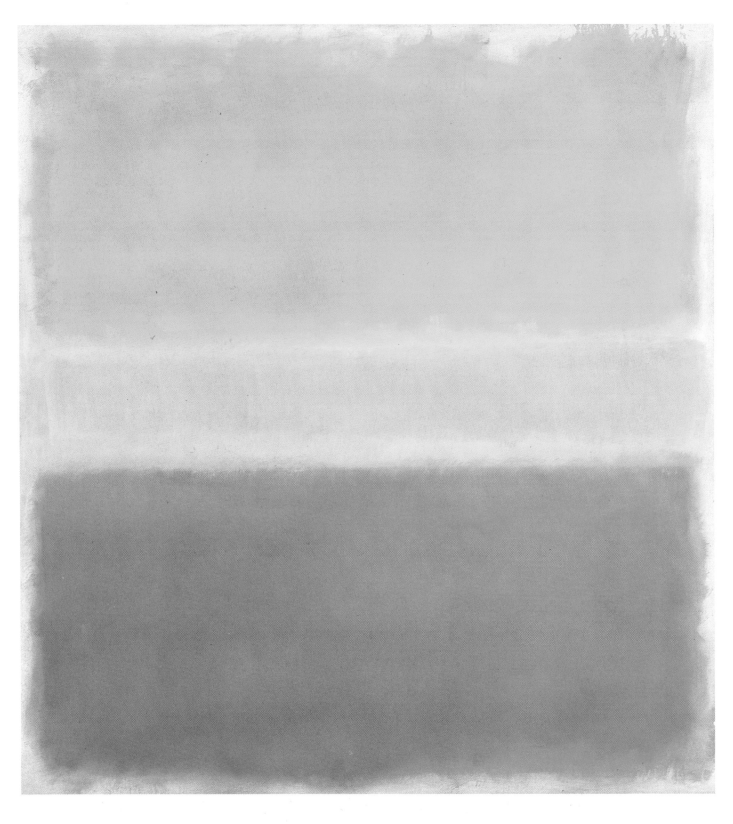

55 Yellow and Gold 1956

56 Untitled 1956

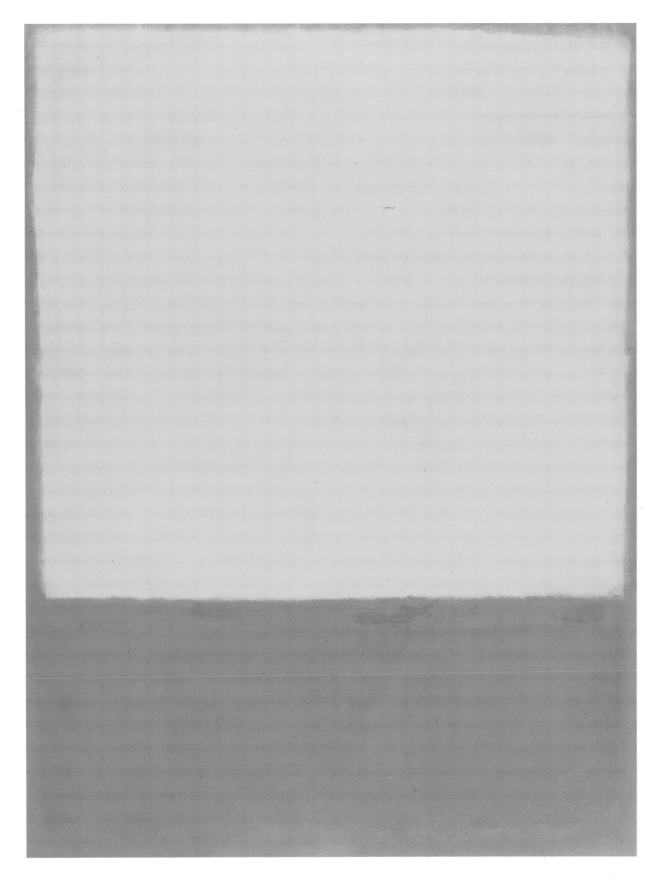

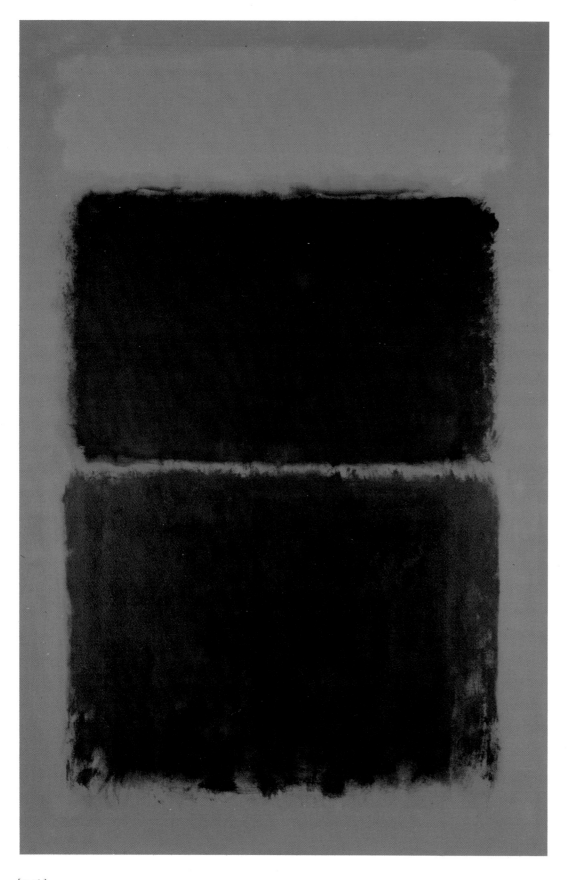

57 Light Red over Black 1957

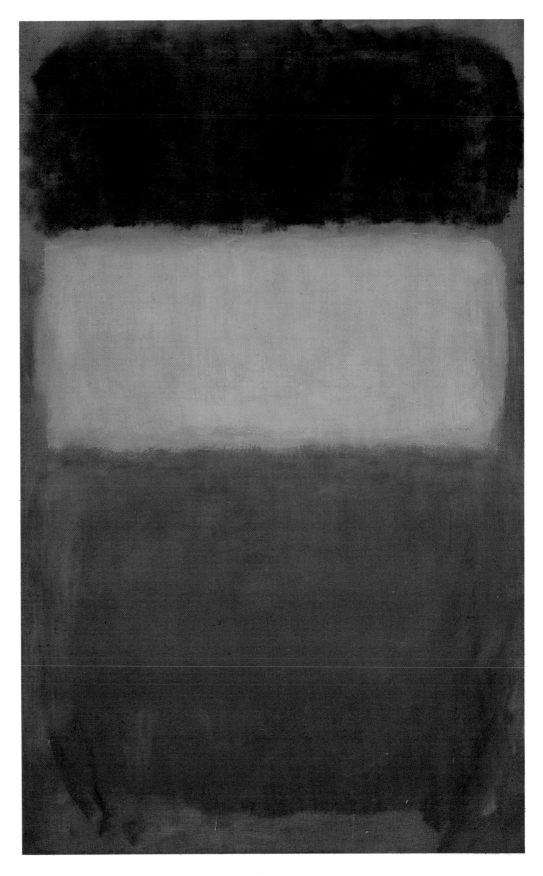

58 Orange and Chocolate 1957

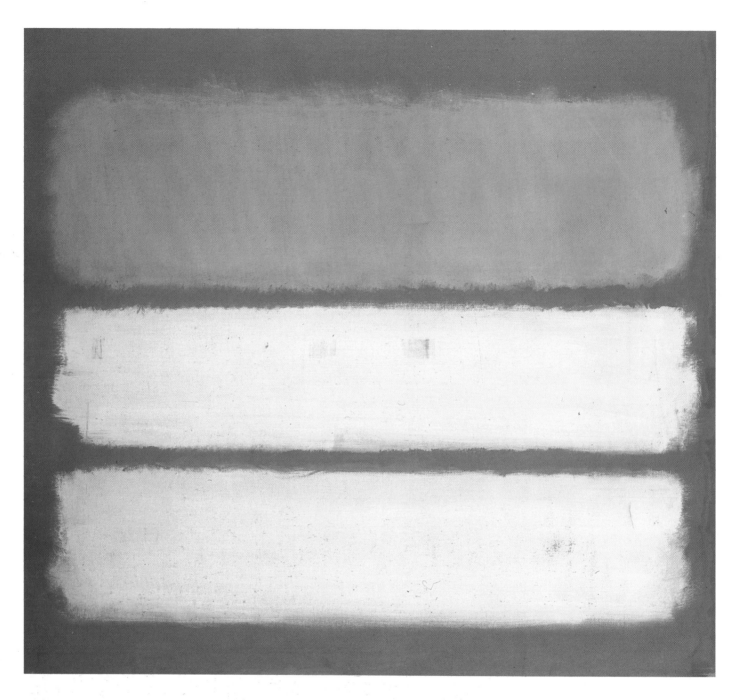

59 Untitled 1958

60 Brown and Black in Reds 1958

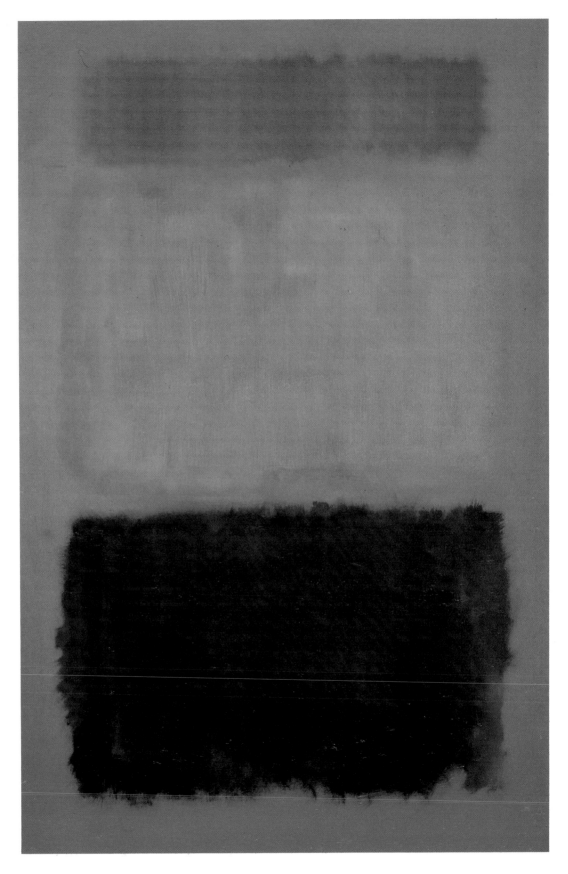

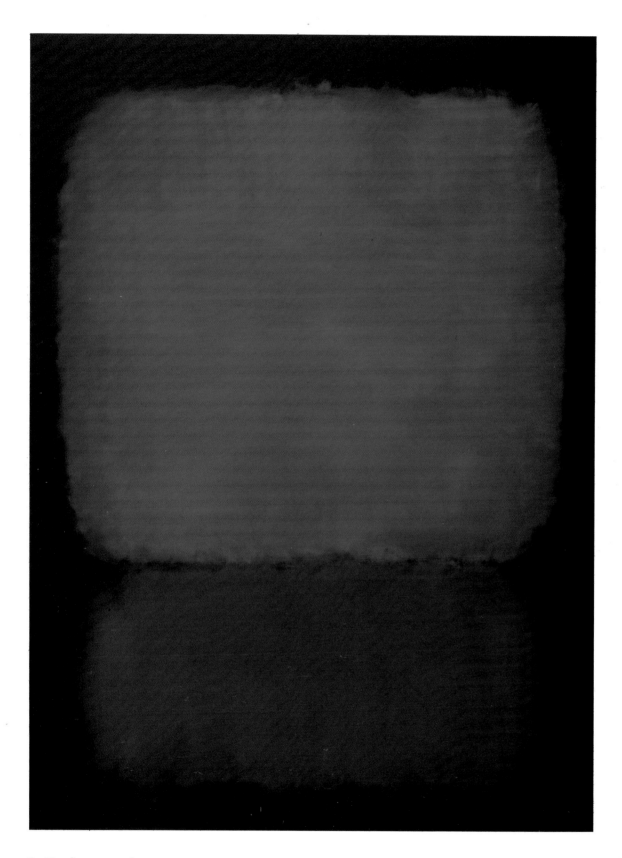

61 **Number 10** 1958

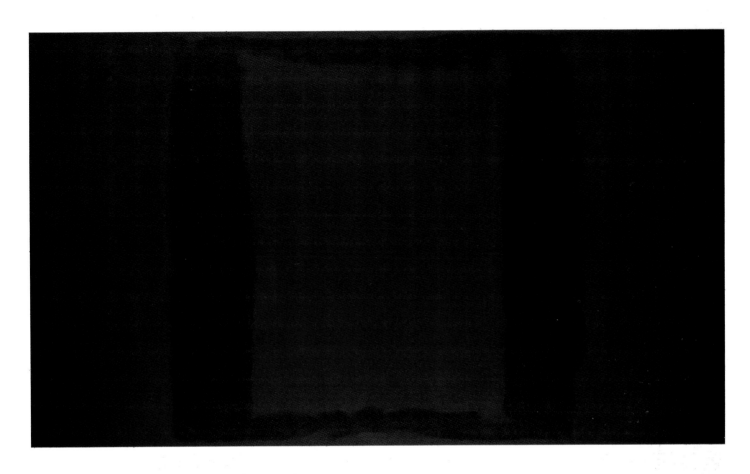

62 Black on Maroon 1958

63 **Black on Maroon** 1958

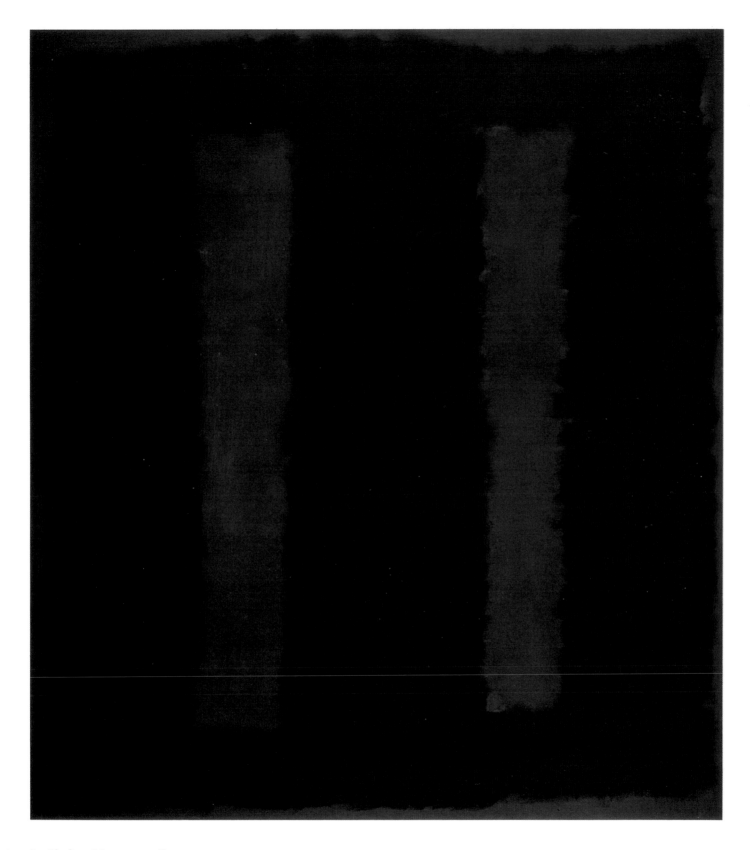

64 Black on Maroon 1958

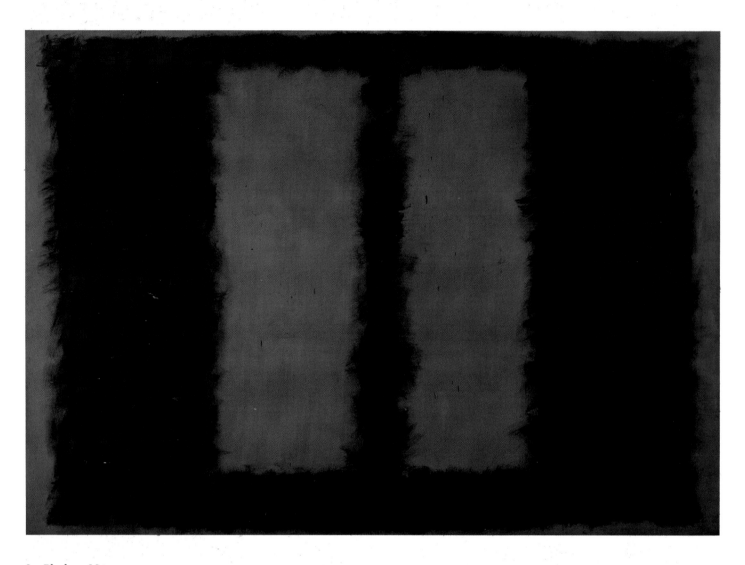

65 Black on Maroon 1959

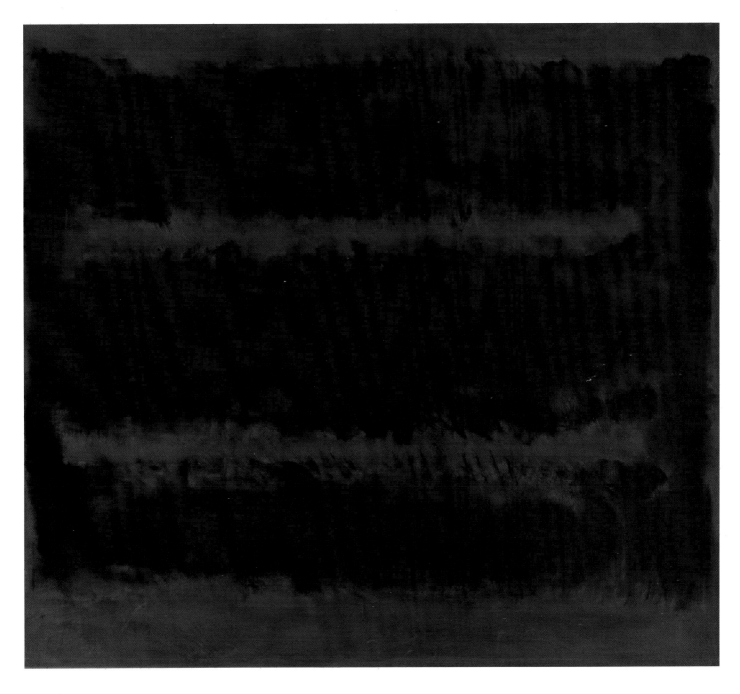

66 **Black on Maroon** 1959

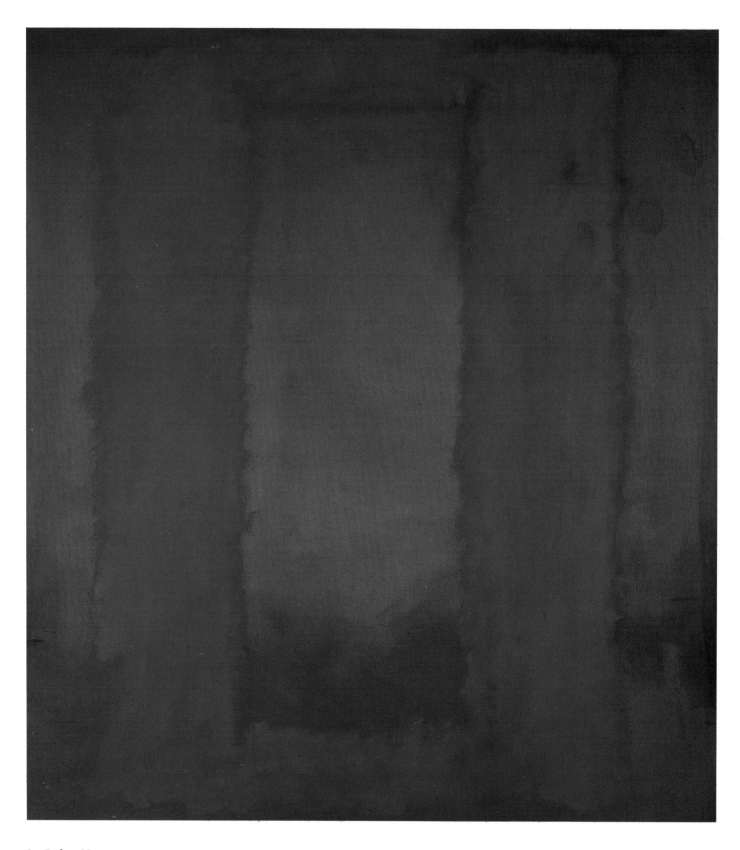

67 Red on Maroon 1959

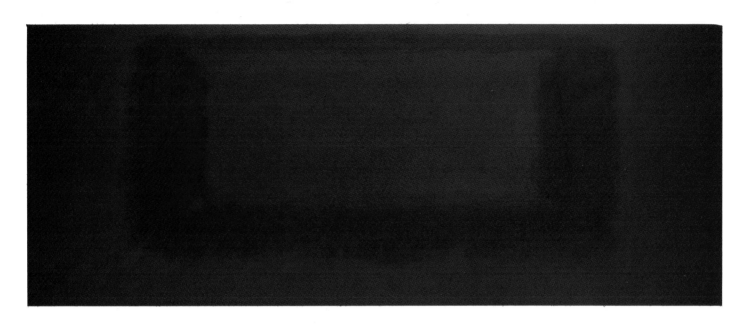

68 Red on Maroon 1959

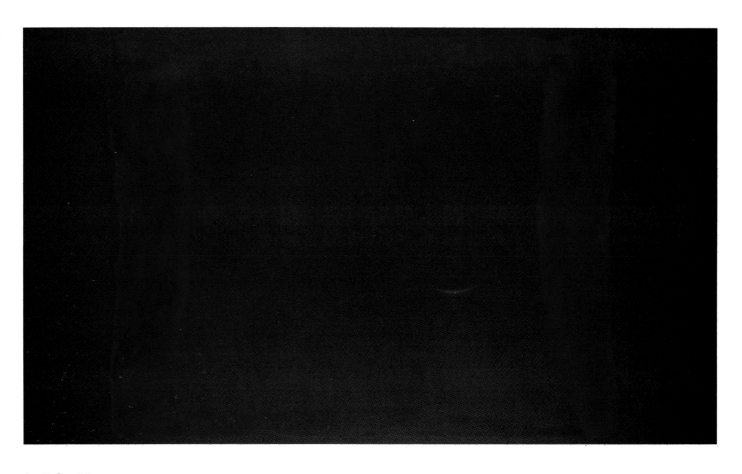

69 Red on Maroon 1959

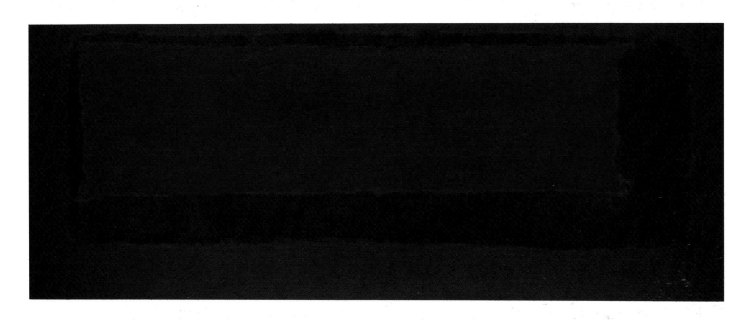

70 Red on Maroon 1959

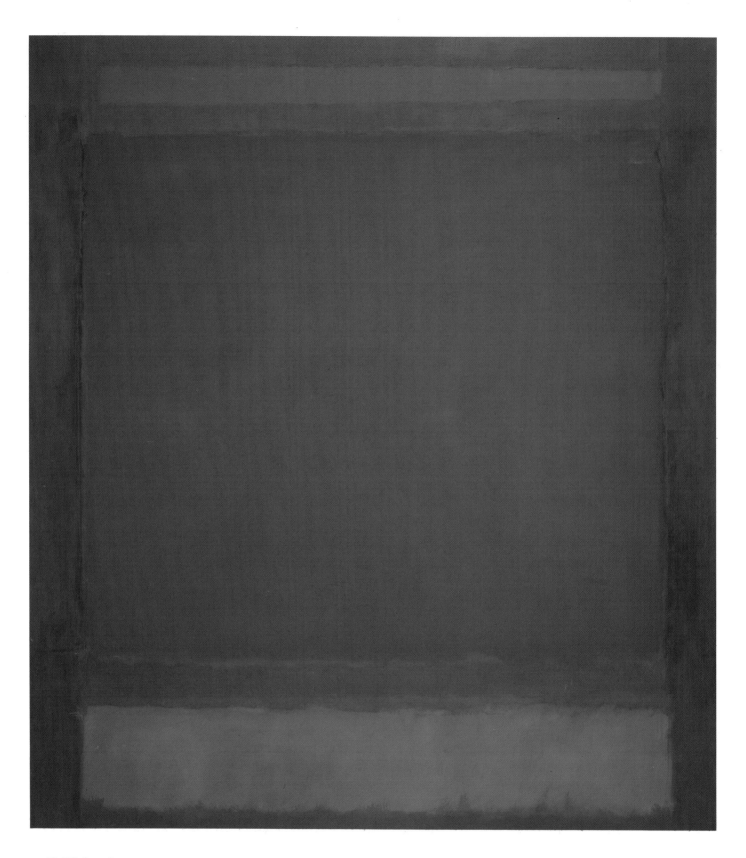

71 Untitled 1960

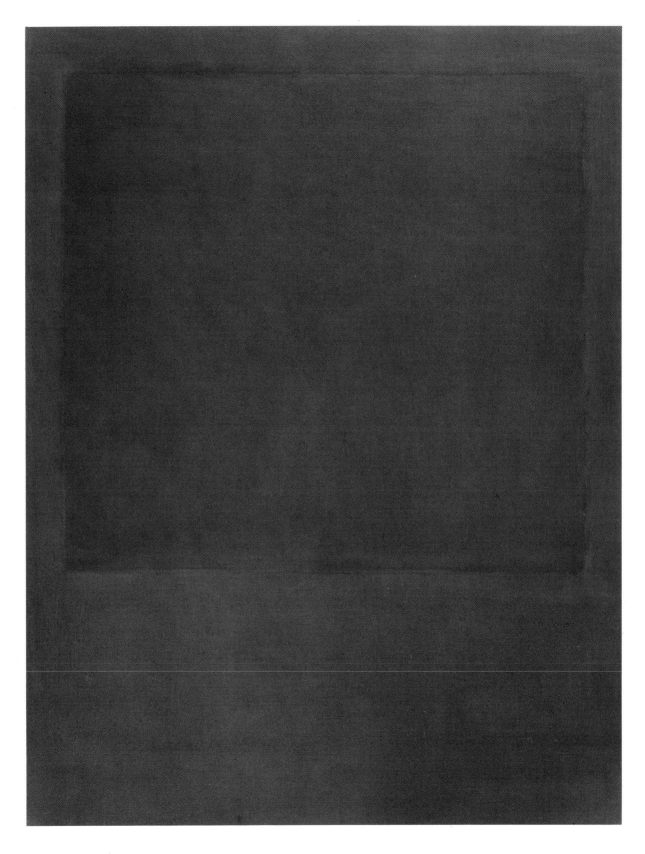

72 Untitled 1960

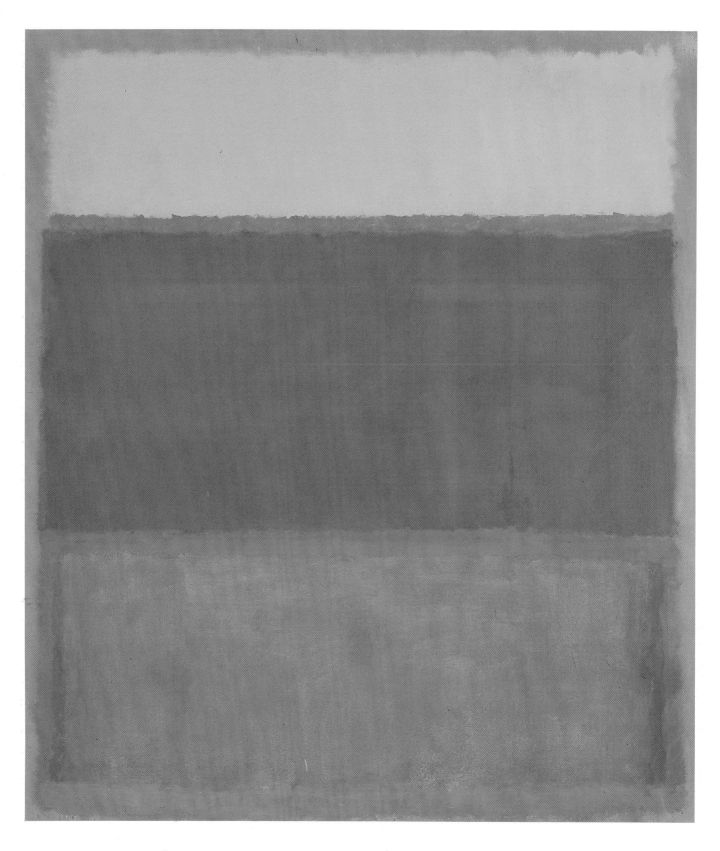

73 Orange, Wine, Gray on Plum 1961

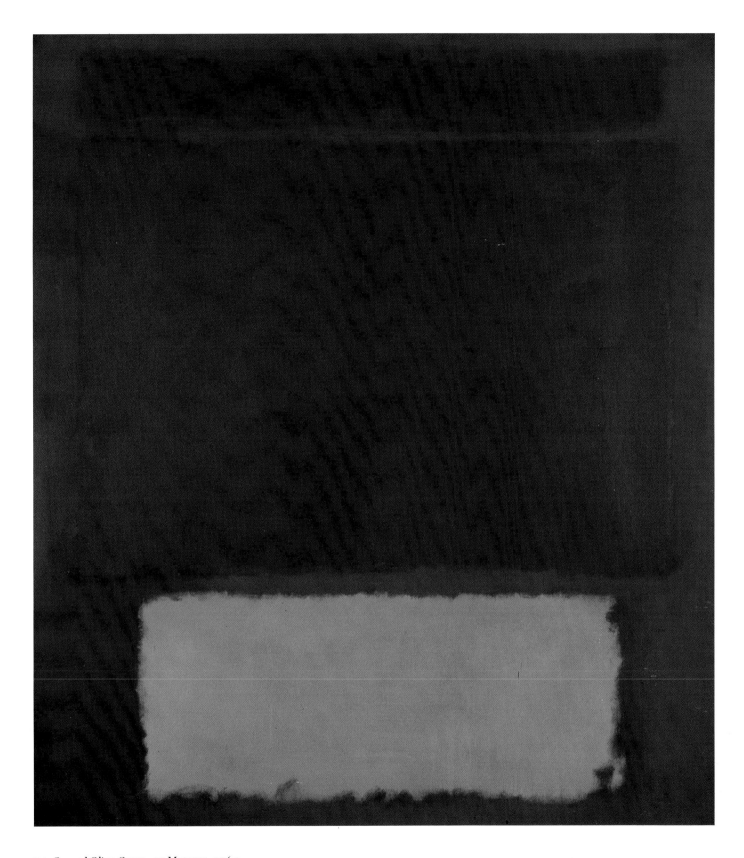

74 Grayed Olive Green, on Maroon 1961

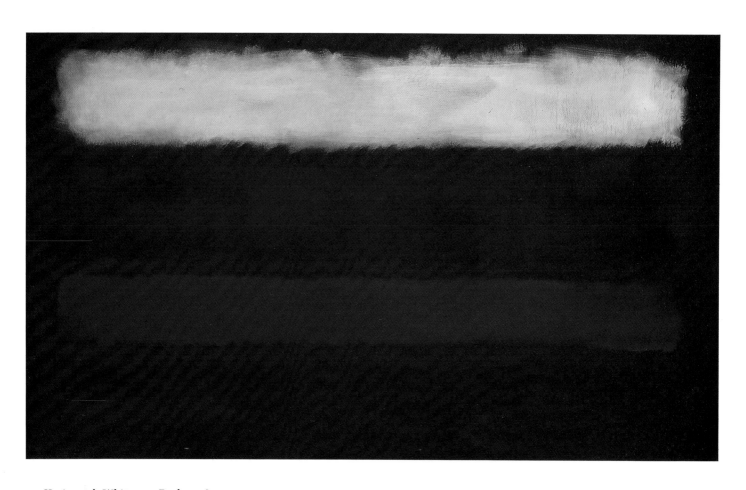

75 Horizontals White over Dark 1961

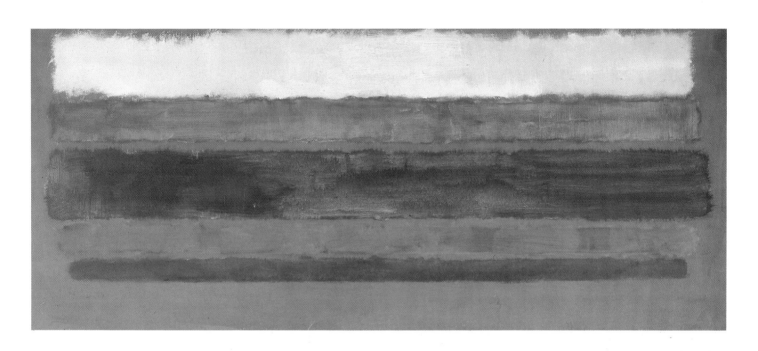

76 Pink, Brown, Wine and Black 1962

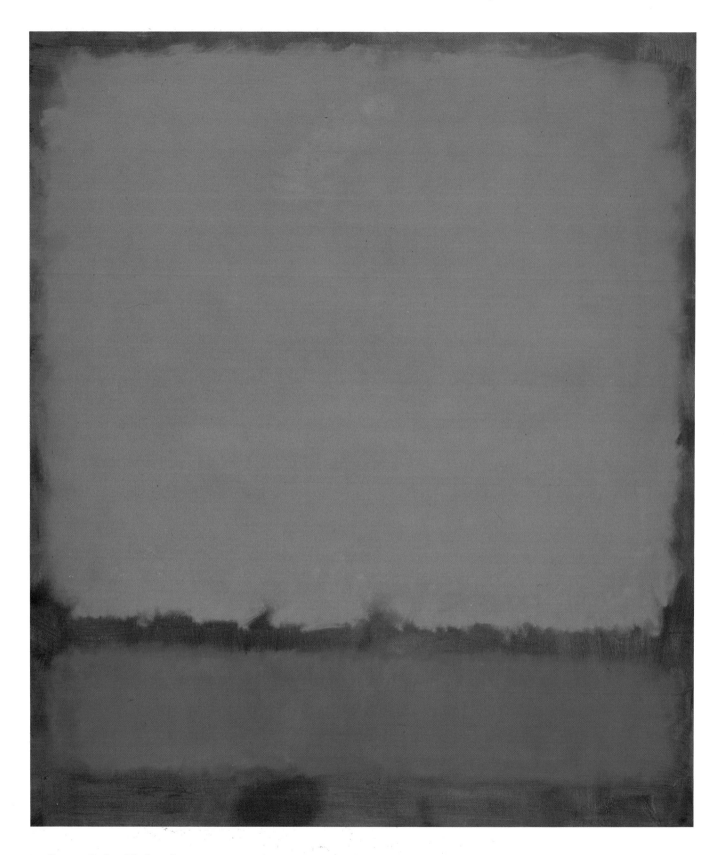

77 **Orange, Red and Red** 1962

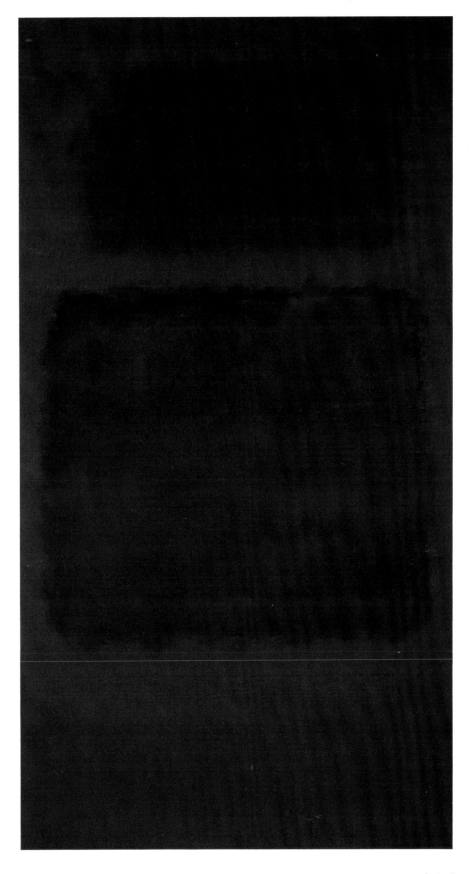

78 Dark Gray tone on Maroon 1963

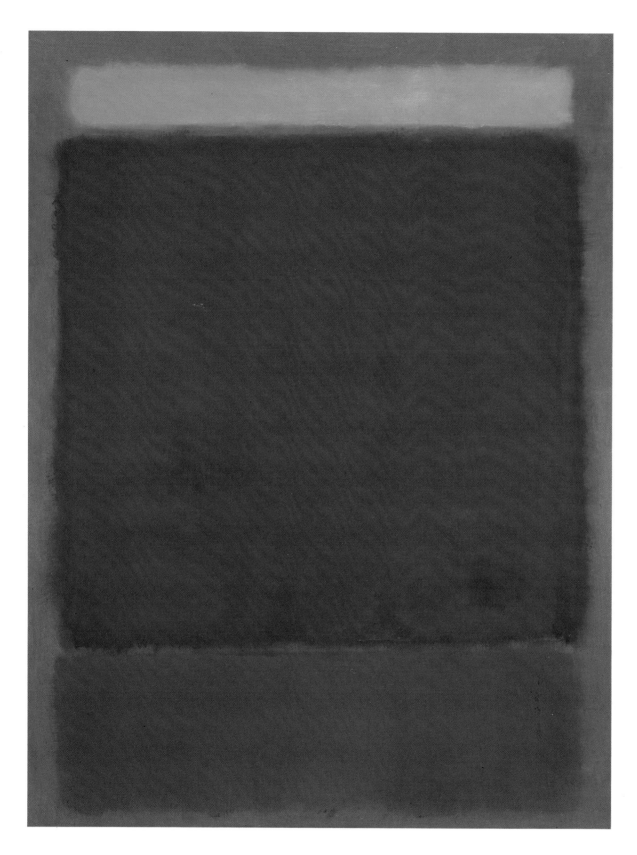

79 Untitled 1963

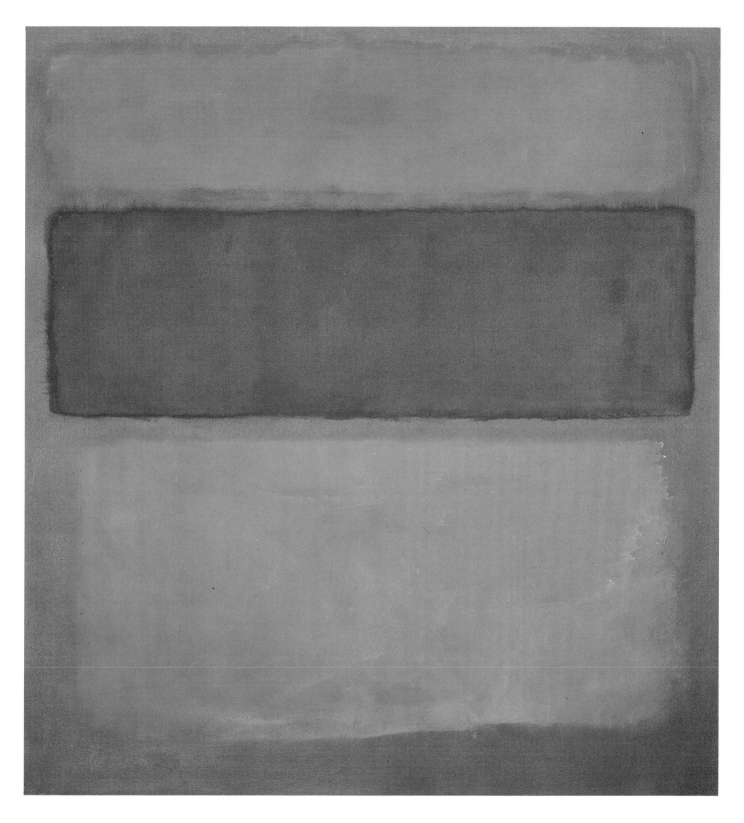

80 Untitled 1963

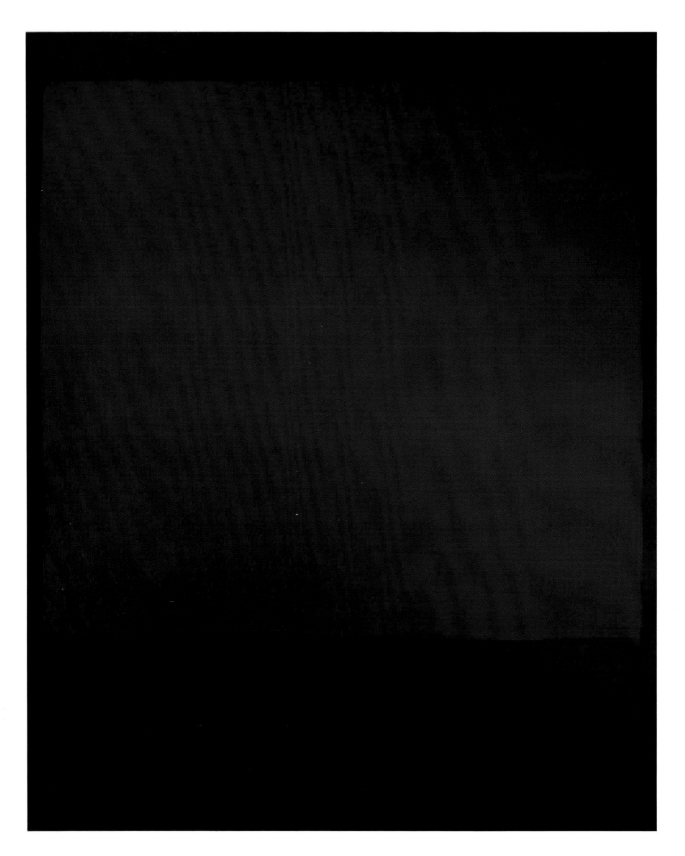

81 Black on Black 1964

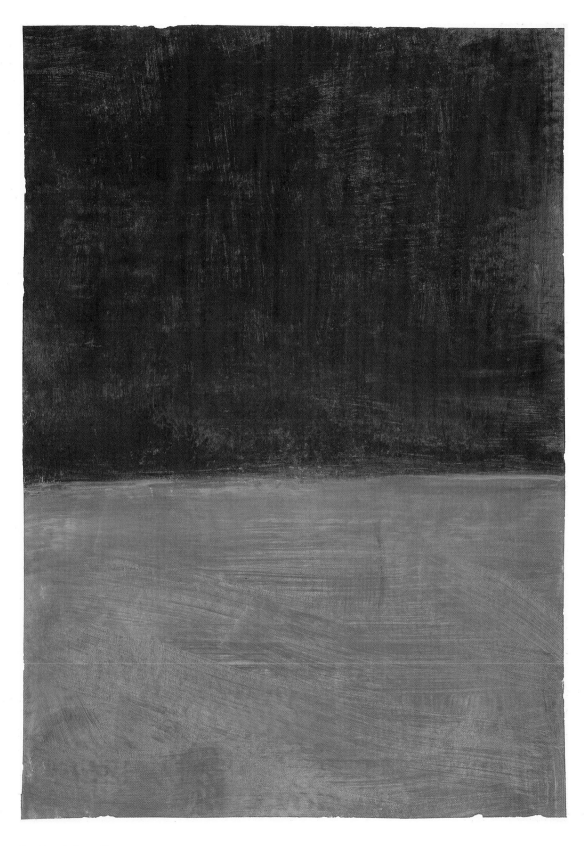

82 Untitled 1968

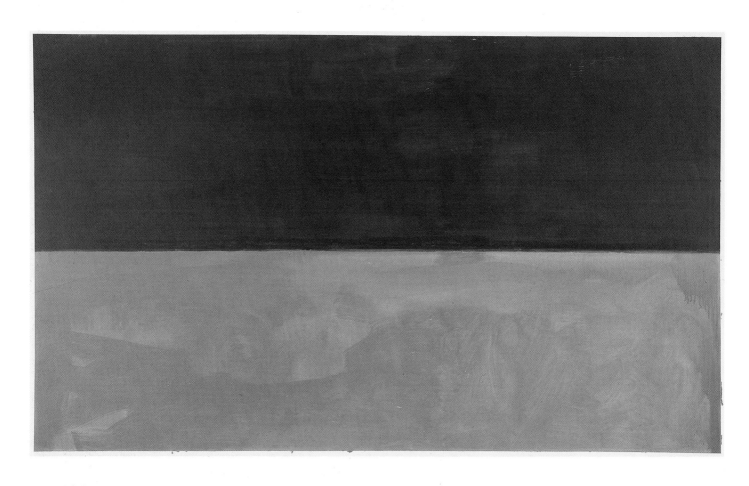

83 Untitled 1969

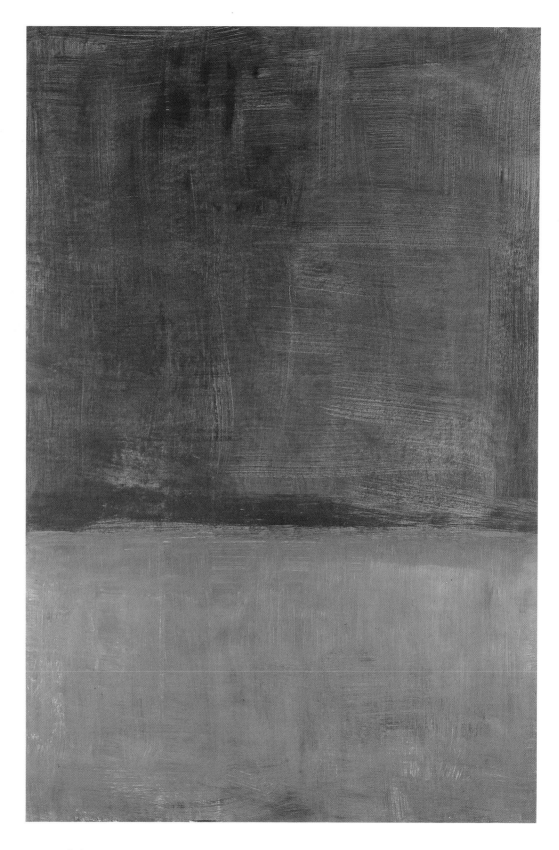

84 Untitled 1969

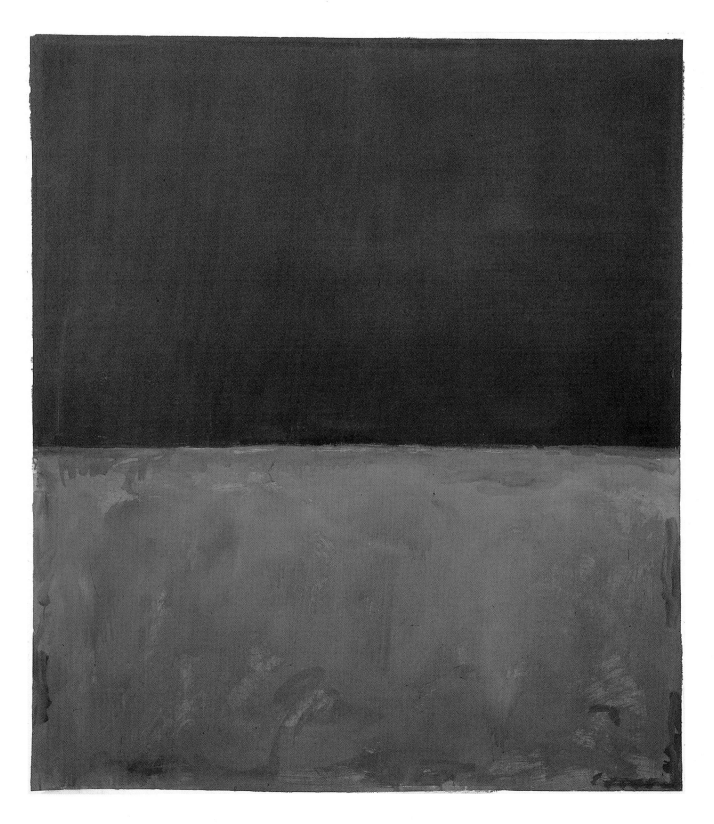

85 Untitled 1969

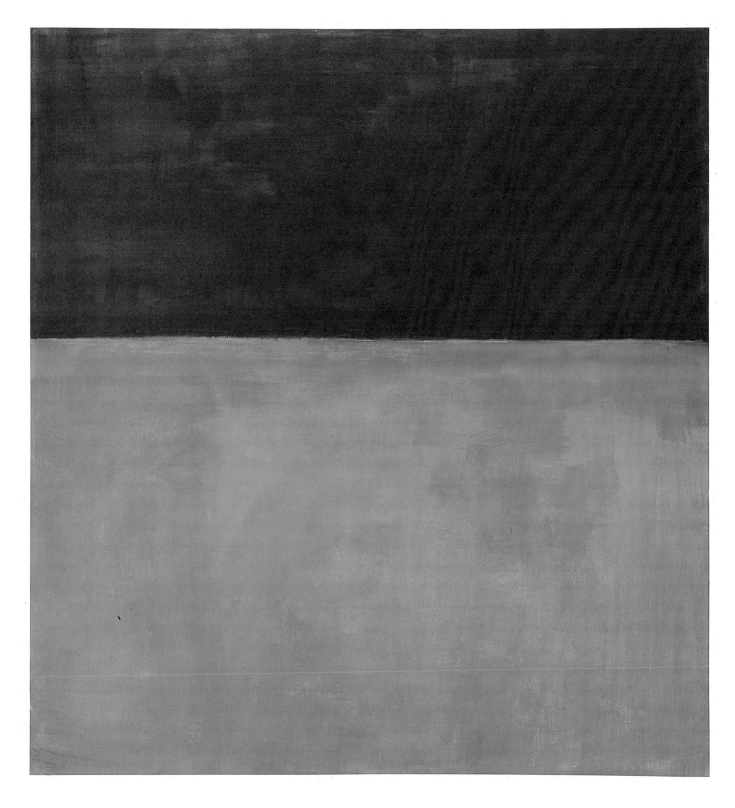

86 Untitled 1969

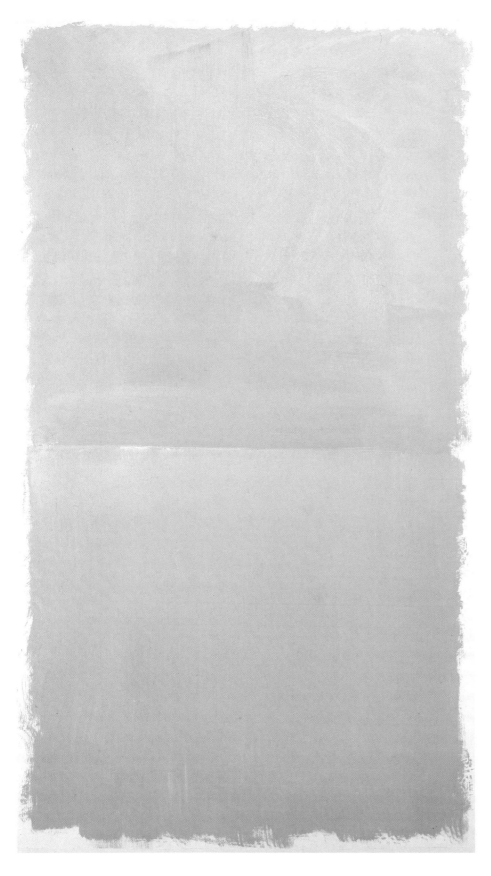

87 Untitled 1969

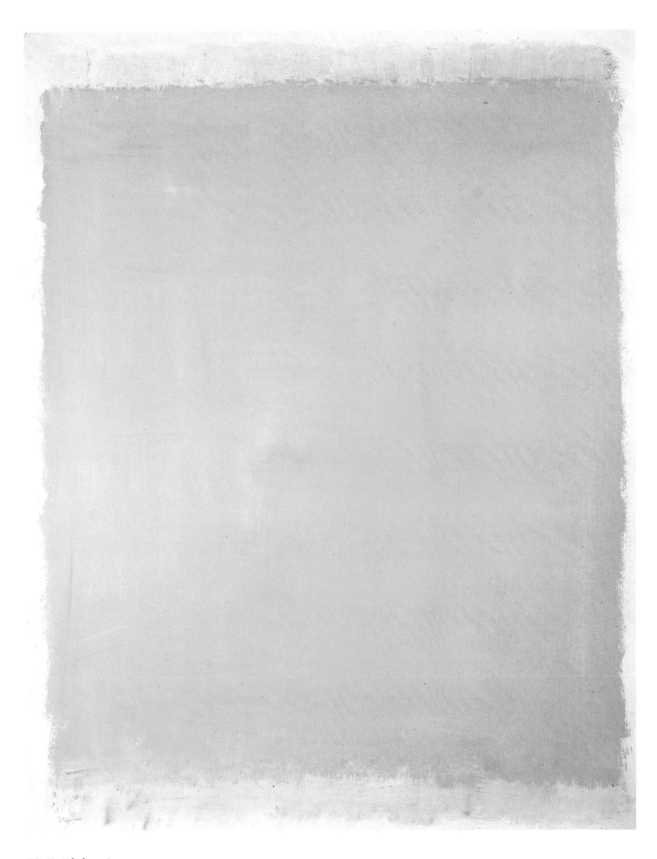

88 Untitled 1969

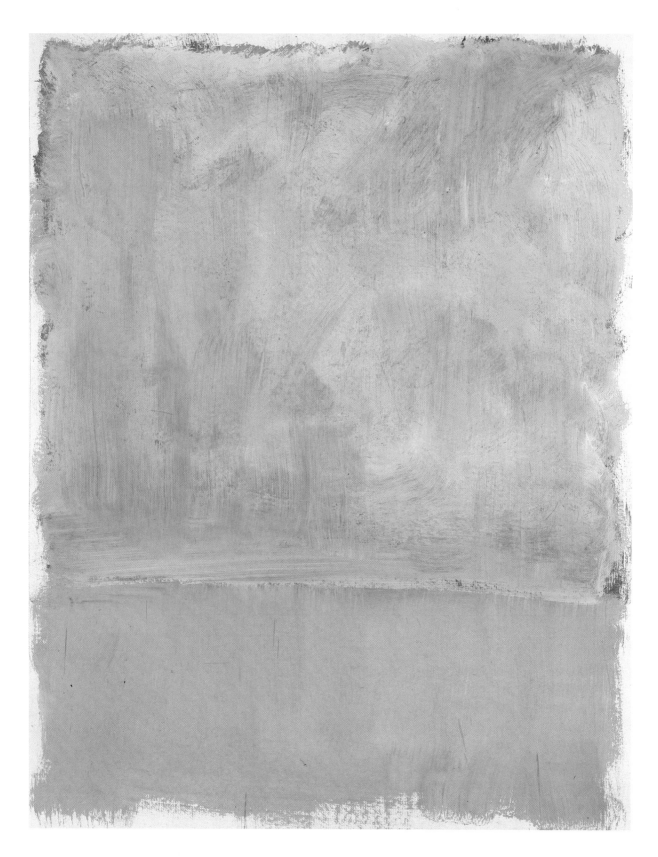

89 Untitled 1969

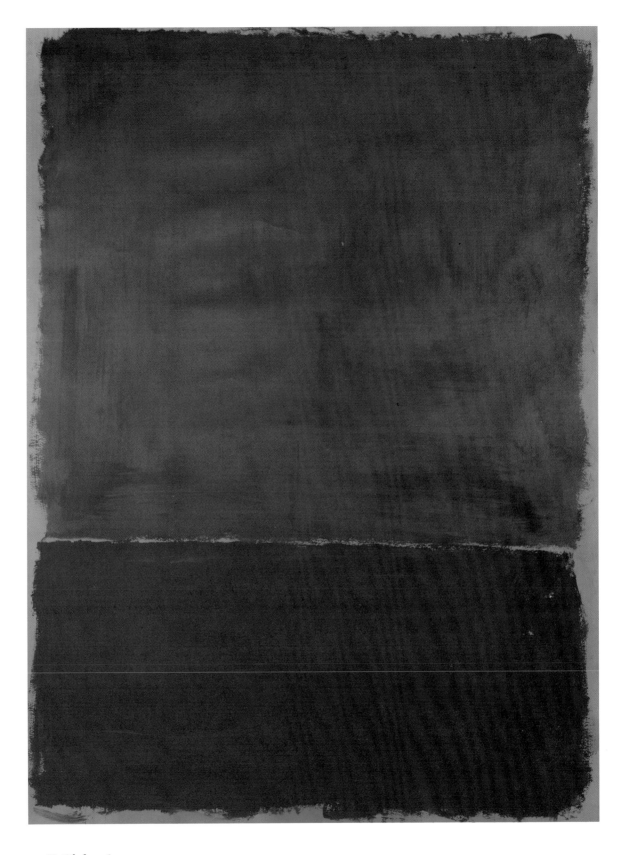

90 Untitled 1969

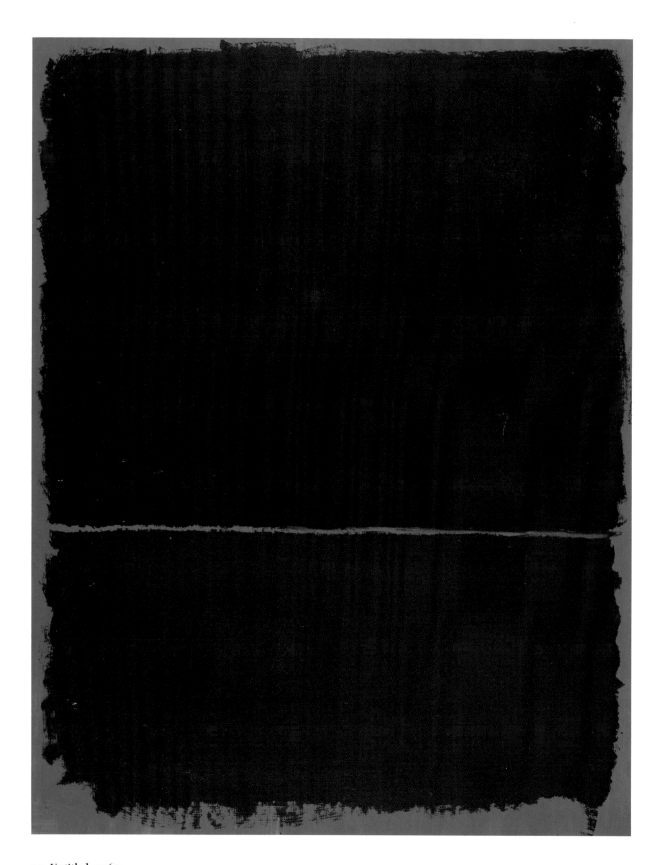

91 Untitled 1969

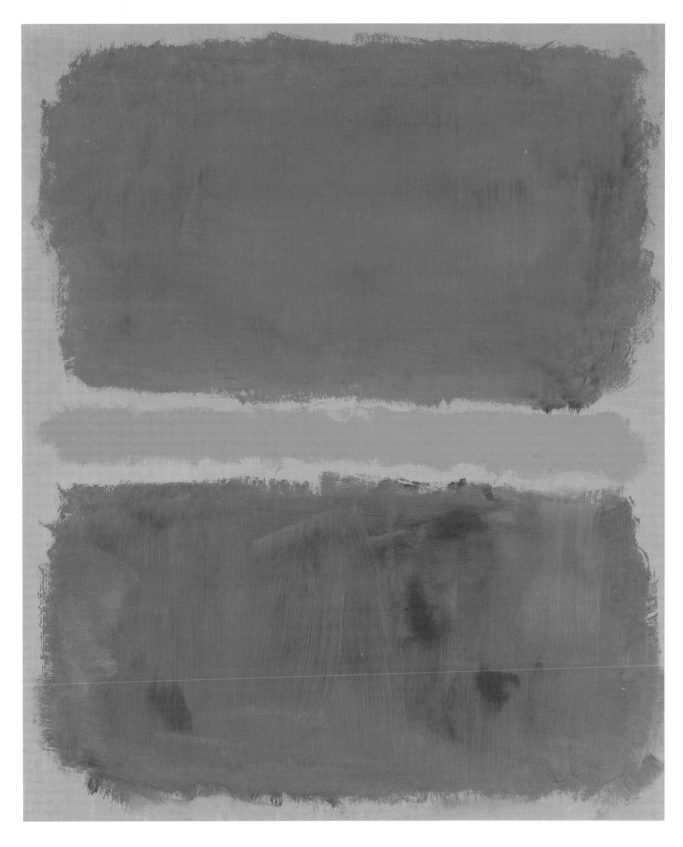

92 Untitled 1969

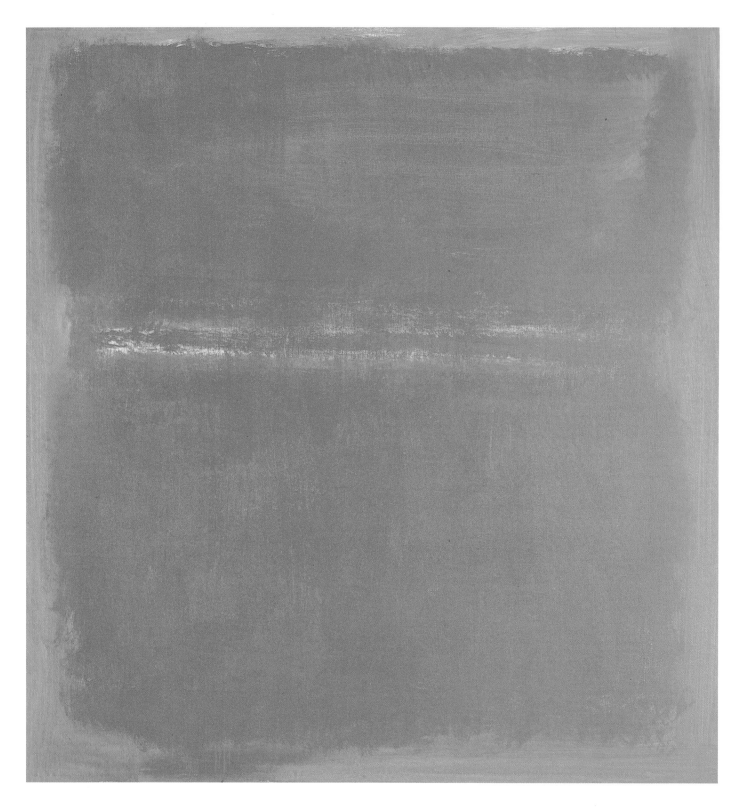

93 Untitled 1969

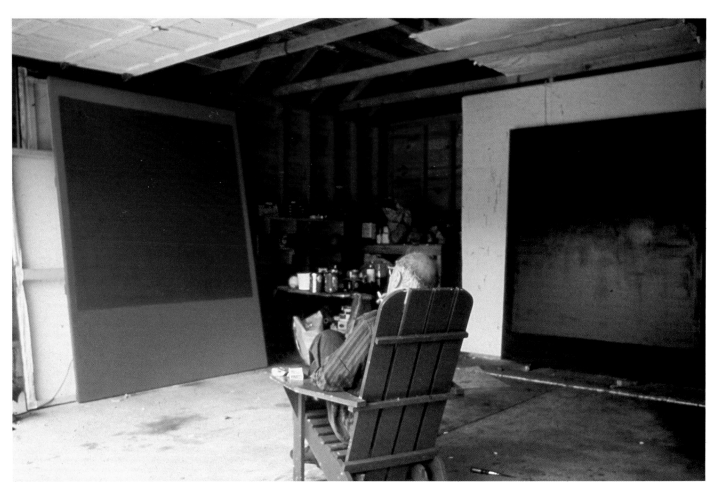

Rothko in his studio, *c.* 1964

List of Works

1 **Interior** 1932
Oil on masonite $23\frac{7}{8} \times 18$ (60×45.7)
National Gallery of Art, Washington;
Gift of The Mark Rothko Foundation Inc.
3069.32

2 **Woman Sewing** mid 1930s
Oil on hardboard $28 \times 36\frac{1}{16}$
(71.1×91.5)
National Gallery of Art, Washington;
Gift of The Mark Rothko Foundation Inc.
3074.32

3 **Self Portrait** 1936
Oil on canvas $32\frac{1}{4} \times 26$ (82×66)
Christopher Rothko and Kate Rothko Prizel
3266.36

4 **Subway** 1930s
Oil on canvas $34\frac{5}{16} \times 46\frac{1}{2}$ (87×118)
National Gallery of Art Washington;
Gift of The Mark Rothko Foundation Inc.
3261.30

5 **Untitled** 1936
Oil on canvas $36 \times 24\frac{1}{4}$ ($91\frac{1}{4} \times 61\frac{1}{4}$)
Christopher Rothko and Kate Rothko Prizel
3267.36

6 **Untitled** 1938
Oil on canvas $49\frac{3}{4} \times 37$ (126.5×94)
Estate of Mark Rothko
3019.38

7 **Subway Scene** 1938
Oil on canvas $35 \times 47\frac{1}{4}$ (89×120)
Estate of Mark Rothko
3241.38

8 **Antigone** 1941
Oil on canvas $34 \times 45\frac{3}{4}$ (86.5×116.2)
National Gallery of Art, Washington;
Gift of The Mark Rothko Foundation Inc.
3240.38

9 **The Omen of the Eagle** 1942
Oil and pencil on canvas $25\frac{3}{4} \times 17\frac{3}{4}$
(65.5×45)
National Gallery of Art, Washington;
Gift of The Mark Rothko Foundation Inc.
3223.40

10 **The Syrian Bull** 1943
Oil on canvas $39\frac{1}{2} \times 27\frac{1}{2}$ (100.5×70)
Mrs Barnett Newman

11 **Hierarchical Birds** 1944
Oil on canvas $39\frac{5}{8} \times 31\frac{3}{8}$ (100.5×80.5)
National Gallery of Art, Washington;
Gift of The Mark Rothko Foundation Inc.
3052.40

12 **Untitled** *c.*1944
Watercolour, tempera and ink on paper
$21\frac{1}{16} \times 15\frac{1}{16}$ (53×38.5)
Louisiana Museum of Art, Denmark
1143.40

13 **Untitled** *c.*1944
Watercolour, gouache and ink on paper
$14\frac{15}{16} \times 21\frac{1}{16}$ (38×53)
Philadelphia Museum of Art;
Gift of The Mark Rothko Foundation Inc.
1150.40

14 **Untitled** *c.*1944
Watercolour and ink on paper
$15\frac{1}{8} \times 21\frac{7}{16}$ (38.5×54.5)
Metropolitan Museum of Art, New York;
Gift of The Mark Rothko Foundation Inc.
1146.40

15 **Untitled** *c.*1944–46
Watercolour, tempera and ink on paper
$20\frac{7}{8} \times 29$ (52.7×73.7)
National Gallery of Art, Washington;
Gift of The Mark Rothko Foundation Inc.
1093.44

16 **Untitled** 1944–46
Watercolour, gouache, ink and pencil
on paper $39\frac{7}{8} \times 26$ (101.3×65.9)
Solomon R. Guggenheim Museum, New York;
Anonymous gift in memory of Mina Boehm Metzger

17 **Untitled** 1944–46
Watercolour and ink on paper $20\frac{9}{16} \times 27\frac{1}{8}$
(52.3×69)
National Gallery of Art, Washington;
Gift of The Mark Rothko Foundation Inc.
1156.40A

18 **Untitled** 1945
Oil on canvas 22×30 (56×76)
Estate of Mark Rothko
3189.45

19 **Horizontal Vision** 1946
Oil on canvas $39\frac{7}{8} \times 54\frac{1}{2}$
(101.2×138.5)
National Gallery of Art, Washington;
Gift of The Mark Rothko Foundation Inc.
3028.46

20 **Gethsemane** 1946
Oil on canvas $54\frac{3}{8} \times 35\frac{3}{8}$ (138×89.8)
Estate of Mark Rothko
3024.46

21 **Tiresias** 1946
Oil on canvas $79\frac{3}{4} \times 40$
(202.5×101.5)
Christopher Rothko and Kate Rothko Prizel
3262.46

22 **Personage Two** 1946
Oil on canvas $56\frac{1}{16} \times 32\frac{1}{4}$ (142.5×82)
National Gallery of Art, Washington;
Gift of The Mark Rothko Foundation Inc.
3033.46

23 **Aquatic Drama** 1946
Oil on canvas 36×48 (91.5×122)
National Gallery of Art, Washington;
Gift of The Mark Rothko Foundation Inc.
3029.46

24 **Number 18** 1947
Oil on canvas $61 \times 43\frac{1}{4}$ (155×110)
National Gallery of Art, Washington;
Gift of The Mark Rothko Foundation Inc.
4010.46

25 **Untitled** 1947
Oil on canvas $47\frac{3}{4} \times 35\frac{5}{8}$ (121.5×90.5)
Solomon R. Guggenheim Museum, New York;
Gift of The Mark Rothko Foundation Inc.
3244.47

26 **Multiform** 1948
Oil on canvas 89×65 (226×165)
Estate of Mark Rothko
5007.47

27 **Number 15** 1948
Oil on canvas 52×29 (132×73.7)
National Gallery of Art, Washington;
Gift of The Mark Rothko Foundation Inc.
5089.48

28 Untitled 1949
Oil, acrylic and powdered pigments on
canvas 80 × 39⅛ (203.2 × 100)
Metropolitan Museum of Art, New York;
Gift of The Mark Rothko Foundation Inc.
5199.49

29 Untitled 1949
Oil on canvas 56 1/16 × 32 15/16
(142.5 × 83.3)
Metropolitan Museum of Art, New York;
Gift of The Mark Rothko Foundation Inc.
5106.49

30 Number 11 1949
Oil on canvas 68 × 40 (172.3 × 101.5)
National Gallery of Art, Washington;
Gift of The Mark Rothko Foundation Inc.
5098.49

31 Untitled 1949
Oil on canvas 93½ × 53⅛ (237.5 × 135)
Estate of Mark Rothko
5014.49

32 Untitled 1949
Oil on canvas 49¼ × 43¼ (125 × 110)
Mr and Mrs Allen M. Turner, Chicago,
Illinois

33 Number 22 1949
Oil on canvas 117 × 107⅛ (297 × 272)
Museum of Modern Art, New York
Gift of the Artist, 1969

**34 Violet, Black, Orange, Yellow on White
and Red** 1949
Oil on canvas 81½ × 66 (207 × 167.5)
*Solomon R. Guggenheim Museum, New
York;*
Gift of Elaine and Werner Dannheisser and
The Dannheisser Foundation, 1978
3244.47

35 Untitled 1951
Oil on canvas 56½ × 65 (143.5 × 165)
Estate of Mark Rothko
5184.51

**36 Green, White and Yellow on
Yellow** 1951
Oil on canvas 67½ × 44½ (171.5 × 113)
Estate of Mark Rothko
5164.51

37 Number 12 1951
Oil on canvas 57½ × 52⅞ (146 × 138)
Christopher Rothko and Kate Rothko Prizel
5226.51

38 Number 7 1951
Oil on canvas 94 × 54½
(238.7 × 138.5)
*Sarah Campbell Blaffer Foundation,
Houston, Texas*

39 Untitled c.1951–52
Oil on canvas 74¾ × 39⅞ (189 × 100.8)
Tate Gallery;
Gift of The Mark Rothko Foundation Inc.

40 Untitled 1953
Oil on canvas 76½ × 67½
(194.3 × 171.5)
National Gallery of Art, Washington;
Gift of The Mark Rothko Foundation Inc.
5028.53

41 Green and Maroon 1953
Oil on canvas 91¼ × 54¾ (231 × 139)
Phillips Collection, Washington DC

42 Untitled 1953
Mixed media on canvas 105¾ × 50 5/16
(268.5 × 127.7)
*Whitney Museum of American Art, New
York;*
Gift of The Mark Rothko Foundation Inc.
5104.53

43 Red, Orange, Tan and Purple 1954
Oil on canvas 68½ × 84¼ (174 × 214.5)
Christopher Rothko and Kate Rothko Prizel
5233.54

44 Untitled 1954
Oil on unprimed canvas 93 × 56 1/16
(236.3 × 142.7)
Yale University Art Gallery, New Haven;
The Katharine Ordway Collection

45 Earth and Green 1955
Oil on canvas 91⅛ × 73⅝ (231.5 × 187)
Museum Ludwig, Cologne

46 Untitled 1954
Oil on canvas 93⅝ × 56¼ (237.7 × 143)
*Museum of Art, Rhode Island School of
Design, Providence, Rhode Island;*
*Purchased in honour of Daniel Robbins,
Museum Gifts and Collectors Acquisition
Fund: G.S. Aldritch Fund, Mary B. Jackson
Fund, The Walter H. Kimball Fund and The
Jesse H. Metcalf Fund*

47 Untitled 1954
Oil on canvas 91 × 59½ (231 × 151)
Estate of Mark Rothko
5154.54

48 Untitled 1954
Oil on canvas 115 × 90¾ (292 × 230.5)
Estate of Mark Rothko
5137.54

49 Untitled 1955
Oil on canvas 91¾ × 69 (233 × 175.3)
Mr and Mrs Graham Gund
5004.55

50 Untitled 1955
Oil on canvas 68 1/16 × 45½ (173 × 115.5)
Philadelphia Museum of Art;
Gift of The Mark Rothko Foundation Inc.
5159.55

51 Yellow Blue on Orange 1955
Oil on canvas 102¼ × 66¾
(259.7 × 169.5)
*Carnegie Museum of Art, Pittsburgh,
Pennsylvania;*
*Acquired through the Fellows of the
Museum of Art Fund, Women's
Committee, Museum of Art and Patrons
Art Fund, 1974*

52 Untitled 1955
Oil on canvas 80 × 68 (203.2 × 172.8)
Estate of Mark Rothko
5031.55

53 Green, Red, Blue 1955
Oil on canvas 81½ × 77¾ (207 × 197.5)
Milwaukee Art Museum Collection;
Gift of Mrs Harry Lynde Bradley, 1977

54 Orange and Yellow 1956
Oil on canvas 91 × 71 (231 × 180.3)
*Albright-Knox Art Gallery, Buffalo, New
York;*
Gift of Seymour H. Knox, 1956

55 Yellow and Gold 1956
Oil on canvas 67½ × 62¾
(170.5 × 159.4)
Museum of Modern Art, New York;
Gift of Philip Johnson, 1970

56 Untitled 1956
Oil on canvas 91½ × 68½ (232.5 × 174)
Estate of Mark Rothko
5156.56

57 Light Red over Black 1957
Oil on canvas 91⅝ × 60⅛
(232.7 × 152.7)
Tate Gallery

58 Orange and Chocolate 1957
Oil on canvas 70 × 44 (177.8 × 111.7)
Christopher Rothko and Kate Rothko Prizel
5236.57

59 **Untitled** 1958
Oil and acrylic on canvas 56½ × 62⅛
(143.5 × 157.7)
National Gallery of Art, Washington;
Gift of The Mark Rothko Foundation Inc.
5124.58

60 **Brown and Black in Reds** 1958
Oil on canvas 91½ × 60
(232.5 × 152.3)
Collection of Joseph E. Seagram & Sons,
Inc.

61 **Number 10** 1958
Oil on canvas 94 × 69¼
(238.7 × 175.7)
Collection of Leila and Melville Straus

62 **Black on Maroon** 1958
Oil on canvas 105 × 144
(266.7 × 365.8)
Tate Gallery;
Gift of the Artist

63 **Black on Maroon** 1958
Oil on canvas 95 × 105
(241.3 × 266.7)
Tate Gallery;
Gift of the Artist

64 **Black on Maroon** 1958
Oil on canvas 90 × 81½ (228.6 × 207)
Tate Gallery;
Gift of the Artist

65 **Black on Maroon** 1959
Oil on canvas 105 × 180
(266.7 × 457.2)
Tate Gallery;
Gift of the Artist

66 **Black on Maroon** 1959
Oil on canvas 90 × 105
(228.6 × 266.7)
Tate Gallery;
Gift of the Artist

67 **Red on Maroon** 1959
Oil on canvas 105 × 94
(266.7 × 238.8)
Tate Gallery;
Gift of the Artist

68 **Red on Maroon** 1959
Oil on canvas 72 × 180
(182.9 × 457.2)
Tate Gallery;
Gift of the Artist

69 **Red on Maroon** 1959
Oil on canvas 105 × 180
(266.7 × 457.2)
Tate Gallery;
Gift of the Artist

70 **Red on Maroon** 1959
Oil on canvas 72 × 180
(182.9 × 457.2)
Tate Gallery;
Gift of the Artist

71 **Untitled** 1960
Oil on canvas 116 × 104
(294.3 × 264.2)
Estate of Mark Rothko
5127.60

72 **Untitled** 1960
Oil on canvas 89¾ × 69 (228 × 175.3)
Estate of Mark Rothko
5013.60

73 **Orange, Wine, Gray on Plum** 1961
Oil on canvas 104½ × 92½
(265.5 × 235)
Estate of Mark Rothko
5130.61

74 **Grayed Olive Green, on Maroon** 1961
Oil on canvas 101⅝ × 89½
(258 × 227.2)
National Gallery of Art, Washington;
Gift of The Mark Rothko Foundation Inc.
5128.61

75 **Horizontals White over Dark** 1961
Oil on canvas 56½ × 93¼ (143.3 × 237)
Museum of Modern Art, New York;
The Sidney and Harriet Janis Collection
(fractional gift), 1967

76 **Pink, Brown, Wine and Black** 1962
Oil on canvas 45 × 105½ (114.3 × 268)
Christopher Rothko and Kate Rothko Prizel
5231.62

77 **Orange, Red and Red** 1962
Oil on canvas 93 × 80 (236.2 × 203.2)
Dallas Museum of Art, Texas;
Gift of Mr and Mrs Algur H. Meadows and
the Meadows Foundation Inc.

78 **Dark Gray tone on Maroon** 1963
Oil on canvas 134 × 74 (340.5 × 188)
National Gallery of Art, Washington;
Gift of The Mark Rothko Foundation Inc.
6020.63

79 **Untitled** 1963
Oil on canvas 90½ × 69 (230 × 175.2)
Estate of Mark Rothko
5003.63

80 **Untitled** 1963
Oil on canvas 69 × 64 (175.2 × 162.5)
Estate of Mark Rothko
5057.63

81 **Black on Black** 1964
Oil, acrylic and mixed media on canvas
93⅛ × 75⁵⁄₁₆ (236.5 × 191.5)
National Gallery of Art, Washington;
Gift of The Mark Rothko Foundation Inc.
5083.60

82 **Untitled** 1968
Acrylic on paper 68¼ × 48⅝
(173 × 123.5)
Tate Gallery;
Gift of The Mark Rothko Foundation Inc.

83 **Untitled** 1969
Acrylic on canvas 69¾ × 116⅝
(177 × 296.2)
Estate of Mark Rothko
5207.69

84 **Untitled** 1969
Acrylic on paper 72 × 48 (183 × 122)
Estate of Mark Rothko
2072.69

85 **Untitled** 1969
Acrylic on canvas 59⅝ × 62³⁄₁₆
(151.5 × 158)
National Gallery of Art, Washington;
Gift of The Mark Rothko Foundation Inc.
5212.69

86 **Untitled** 1969
Acrylic on canvas 81⅜ × 76¼
(206.5 × 193.7)
National Gallery of Art, Washington;
Gift of The Mark Rothko Foundation Inc.
5217.69

87 **Untitled** 1969
Acrylic on paper 72 × 41¼ (183 × 105)
Estate of Mark Rothko
2029.69

88 **Untitled** 1969
Acrylic on canvas 54 × 42
(137.2 × 106.7)
Estate of Mark Rothko
2069.69

89 **Untitled** 1969
Acrylic on paper 54⅛ × 42⁷⁄₁₆
(138 × 108)
National Gallery of Art, Washington;
Gift of The Mark Rothko Foundation Inc.
2049.69

90 **Untitled** 1969
Acrylic on paper $78\frac{1}{2} \times 58\frac{5}{8}$
(199.5 × 149.3)
Estate of Mark Rothko
2042.69

91 **Untitled** 1969
Acrylic on paper $54 \times 42\frac{3}{8}$
(137.2 × 107.7)
National Gallery of Art, Washington;
Gift of The Mark Rothko Foundation Inc.
2034.69

92 **Untitled** 1969
Acrylic on paper $50\frac{3}{8} \times 42\frac{1}{4}$
(128 × 107.2)
National Gallery of Art, Washington;
Gift of The Mark Rothko Foundation Inc.
2046.69

93 **Untitled** 1969
Acrylic on canvas 68 × 60
(172.7 × 152.5)
National Gallery of Art, Washington;
Gift of The Mark Rothko Foundation Inc.
X5.70

Painting Materials and Techniques of Mark Rothko: Consequences of an Unorthodox Approach

DANA CRANMER

Marcus Rothkowitz made art that would last. Mark Rothko did not. At about the time Rothko adopted the name by which we know him, he began experimenting with techniques and materials that would make his paintings both memorable and prized. However, the freedom he gained by abandoning conventional approaches to painting may also have jeopardized the permanence of his art. Like Leonardo da Vinci, Rothko cared more for the effect created by his materials than for their longevity.

Exploring the mutual relationship that develops between artist and material is particularly relevant and rewarding when applied to Rothko. The gradual metamorphosis of his work was the result of just such a dialogue. For more than forty years (c. 1925 – 70), Rothko persevered in developing his art, using painting materials and techniques as the vehicle for his explorations.

Typical of many artists born early in this century, Rothko pursued several stylistic movements before establishing his own singular voice. Summarizing the technical evolution in his painting career and highlighting his innovations may bring deeper appreciation for the artist. It may be possible to grasp more fully the difficulty of the task he undertook, the tenacity with which he persisted, and ultimately the profundity of his achievement.

Compared to his colleagues, Rothko can be assessed as a relatively conventional technician. Although largely self-taught, he adhered to most of the academic definitions of painting: he stretched canvas on wooden stretchers or strainers[1]; he applied paint using standard brushes; and when he painted, he worked standing up before the canvas. Contrasted with the experimental extremes of Jackson Pollock or even Willem de Kooning and Franz Kline, Rothko appears almost academic. However, Rothko's great innovations were focused not on methods but on the physical components and quality of the paint film itself and the variety of effects possible in the manipulation of the medium.

Although Rothko's best-known achievements were realized in his works on canvas, throughout his career he also worked on paper with water-based mediums. Often he applied what he developed in one medium to the other. At times, the works on paper appear to be in close stylistic harmony with the works on canvas, but on paper he experimented more freely, developing techniques and effects in advance of applying them to canvas. As he progressed in his career, the watercolor medium clearly became an important resource.

Rothko had but brief exposure to fine arts training. After two years of undergraduate study at Yale University, he came to New York and studied sporadically from 1924 to 1926 with

Max Weber at the Art Students League. Weber, a European artist, was familiar with the development of early twentieth-century art movements, particularly Cubism and the works of Paul Cézanne. Rothko's earliest works reflect exposure to his teacher's style. Generally, his early paintings (c. 1925–40) were executed using commercial tube oil paint on artist-primed cotton duck (fig. 1), attached with tacks to wooden strainers. According to Joseph Solmon, a colleague of Rothko's, all the students at that time were familiar with Max Doerner's book on artists' materials, although they might not have followed the recommended procedures with any rigor.[2]

In addition to canvas, Rothko painted on Masonite supports at this time. The paintings from the 'expressionist-realist' period are heavily impastoed, dense, and dark in tone and hue. The tacking margins of the canvases were extremely narrow, a characteristic of Rothko's paintings until the mural projects beginning in 1958. The canvas support often did not even extend beyond the edge of the wooden strainer, and there was so little fabric that it must have been with great difficulty that the canvas was pulled and tacked to the edge of the strainer. Rothko's effort to use every square inch of his canvas must have reflected his impoverished state. Even so, he did not economize by painting over previous compositions, a practice common to many artists. This ill-advised economy often leads to problems as the paint films mature.

Rothko continued to use tube oil paint on artist-primed canvas throughout his 'mytho-classical' and 'surrealist' periods, while he developed an ever-inventive and expanding vocabulary of brushworks and effects. In the mytho-classical period (c. 1941–44), he introduced a decorative and descriptive line. Texture of hair, feathers, and fabrics, all ingredients of the subject matter of these works, were depicted representationally, with new varieties of brushstrokes. There are indications of charcoal drawing incorporated into the

fig. 1 Rothko used army surplus cotton canvas duck as a detail of the reverse, top right corner, of a 1939 painting shows

composition. The treatment and quality of these surfaces was very direct, and they were allowed to dry with little or no glazing

The surfaces of the works from the subsequent surrealist period (c. 1944–46) differ from the previous styles in their display of Rothko's exploration and increasing mastery of glazing, scumbling, and scraffito techniques. During this period, a remarkable symbiosis occurred between the watercolors and the oils. Rothko approached the canvas support much as he did the white paper support of the watercolors. An intimate dialogue developed between Rothko and his composition, reflecting the surrealist technique of automatism. The brushwork was both spare and spontaneous. Rothko scraped and scratched back into the paint film to reveal the white or tinted surface beneath.

For artists in New York City after World War II, the atmosphere was exceptionally favorable to experimentation. Not only had many European artists settled in New York during and after the war, creating a charged international ambience in which to work, but there was also a range of new materials becoming commercially available. In the late 1940s, Rothko began to incorporate newly developed synthetic paint mediums into his works on canvas. Leonard Bocour, a paint-maker and artist, began to formulate synthetic mediums for his fellow artists, tailoring them to the individual's needs.[3] Bocour also became one of the first manufacturers and suppliers of synthetic paint mediums for fine artists at large. The use of these new paints corresponded with a stylistic change for Rothko. He began to compose nonobjective paintings, conventionally known as 'multiforms' or 'transitional.' Simultaneously, Rothko abandoned traditional preparation of his canvas supports. He began to 'stain' the cotton canvas duck with an initial glue size mixed with powdered pigments. Sometimes he used this background stain to set the tone of the painting or to serve as a contrasting foil for subsequent layers of synthetic or oil paint films. The tacking margin was intended to be a visible part of the painting's surface. While occasionally Rothko deliberately left the top and bottom edges unpainted, more often he painted all edges, and by doing so emphasized the painting as an object – no longer a traditional 'window.' Consequently the tacking margins are extremely delicate and vulnerable to abrasion and discolorations from handling. Many of the margins have been repainted (rarely, if ever, by the artist) or conventionally framed so that the edges are no longer visible. The paintings of the late 1940s with amorphous forms floating on a glowing field are the result of layers of dry-brushed areas of synthetic or oil paint. The predominantly pastel-colored surfaces of these works are extremely porous and dry, almost frescolike in appearance.

Around 1949, Rothko's work reveals a growing coalescence between method, materials and intention, resulting from twenty years of work and contact with the artistic community of his time. Other artists were also experimenting with new materials, borrowing from the industrial sector for application in fine arts. Franz Kline used house paint for his broad compositions; David Alfaro Siqueros, the Mexican mural painter, established a workshop that concentrated on developing resilient media durable enough for outdoor exposure.

As the decade drew to a close, Rothko began to double or triple the size of his canvases. At

the same time, his compositions became simplified and consolidated, increasingly symmetrical. Rothko's dexterity in manipulating paint films was increasing also. He found the greater scale liberating.

In the 1950s, Rothko continued to experiment with the physical components of the paint mixture. He added unbound powdered pigments and whole eggs to his paint formula and often diluted the paint film with solvent, so much so that the effect of the binding element in the paint mixture was compromised; the pigment particles were almost disassociated from the paint film, barely clinging to the surface. Rothko ignored the limits of physical coherence to achieve a translucency unique to his paintings. Light penetrated the attenuated paint film, striking the individual pigment particles and bouncing back to suffuse the surface and engulf the viewer in an aura of color. These films, brushed one on top of another, have an opalescent quality. Light seems to emanate from within the paint film itself. Physically, these surfaces are extremely delicate if not ephemeral. Similar to works composed of pastel, they are brittle and crack or powder easily (fig.2). They are readily affected by light and humidity, sometimes fading or otherwise altering in appearance. In his paintings of this era, Rothko explored various juxtapositions of color and density of films.

In 1958, Rothko commenced the first of three mural projects that would dominate the last decade of his life. He was asked to paint a mural for a room in Mies van der Rohe's newly constructed Seagram Building in New York City. The room, designed by Philip Johnson, measured 27 feet by 56 feet. As part of his work method, Rothko had part of his studio converted to a scale mockup of the room. It was the first time that Rothko worked to develop a series of related paintings to be viewed as an ensemble. In all, he produced three 'sets' of paintings, approximately thirty individual canvases altogether. At this time, he employed

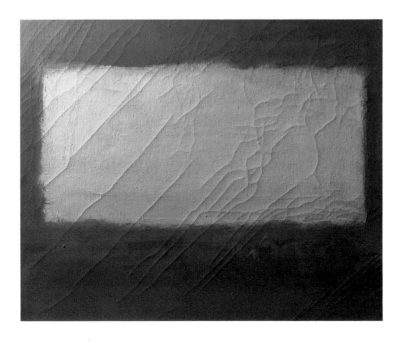

fig.2 This detail of a 1958 painting was photographed in raking light to emphasize the diagonal stress cracks that can appear in a brittle paint film

studio assistants to aid in the preparation of the paintings, some of which were nine by thirteen feet. The colors in the three series progressed from an initial fiery orange to a final deep plum and black.[4] The earliest paintings in the series were thinly painted, the later ones, thick and opaque.

Rothko prepared the stretched canvases for the Seagram murals with rabbit-skin glue and a powdered pigments mixture, adding subsequent layers of oil and synthetic paint films, sometimes with powdered pigments and eggs. In this series, Rothko abandoned his classic format of rectangular forms stacked on top of each other and created compositions with positive and negative forms, evocative of solids and voids, possibly an architectural metaphor – alluding to windows or portals. The 'background' stain conveyed matt and atmospheric effects while the 'foreground' possessed physical solidity with three-dimensional allusions.

The next mural series was painted for the Society of Fellows of Harvard University for a meetingroom in the penthouse of Holyoke Center, a new building on the Harvard campus, designed by José Luis Sert. Although the room eventually became a faculty diningroom, Rothko accepted the change and in 1961 produced a group of paintings with a similar architectonic format as in the Seagram murals with the addition of a distinctive 'nodule' at the center of the horizontal elements. The colors in the Harvard murals tend to be more varied and the surfaces more loosely brushed and glazed than the Seagram series. He painted at least seven paintings from which he selected five (one triptych and two individual works) for installation.

With the assistance of Wilder Green, who had aided Rothko in the installation of paintings in his one-man exhibition at the Museum of Modern Art in 1961, Rothko installed the five paintings in the Holyoke room. Prior to their hanging in Cambridge, the murals had been previewed in an exhibition at the Solomon R. Guggenheim Museum in New York from 9 April to 2 June 1963. Rothko and Green had complete discretion over the particulars of the installation of the room. They determined not only the placement of the paintings but also selected the wall and window coverings for the two large windows at either end of the room.

It was noted, less than ten years after they were painted, that the general appearance of the paintings had altered; they had faded and developed whitish streaks, most notably in the center panel of the triptych. In 1971, in an eloquent report on the history of the murals, Elizabeth Jones, chief conservator of the Fogg Art Museum, discussed the physical changes in the works.[5] Her report included reference to conversations with Rothko about his methods and materials. He had informed her that they were composed primarily of artist's oil paint but that he had run out once and had purchased paint from the local Woolworth's (a five-and-dime store). He also described his technique of applying isolating layers of egg white between layers of paint – a traditional technique alluded to in Cennino Cennini's fifteenth-century handbook and employed by Nicolas Poussin. Jones speculated about the wisdom of such a practice, given the thin films of Rothko's paintings; she feared that it might have contributed to the breakdown of the paintings' surfaces. She also mentioned that Rothko was adamantly opposed to her suggestion of applying a protective varnish. She concluded in the report that

the materials that Rothko used were innately fugitive and that the original brilliant canvases could never be retrieved.

Rothko's last mural series, now known as the Rothko Chapel in Houston, Texas, was his most ambitious project. Jean and Dominique de Menil had seen some of the paintings intended for the Seagram murals in Rothko's studio in 1960. They had also been inspired by the artist-designed chapels in France developed by Father Alain-Marie Couturier: the Matisse chapel in Vence and Le Corbusier's in Ronchamp. In 1964, the de Menils commissioned Rothko to paint murals for a chapel to be designed by Philip Johnson for the campus of the University of St Thomas in Houston. The design was ultimately assumed by Howard Barnstone and Eugene Aubrey.

For the chapel commission, Rothko again had a scale mockup constructed in his studio, which at that time was in a carriage house at 157 East 69th Street in New York. There, beneath a large skylight, he suspended a parachute to disperse and soften the light. He participated with the architects on the design of the interior, and he developed a scheme for a suite of fourteen paintings, painting at least six 'alternates.' Each work was approximately 10 by 15 feet. In addition to two triptychs with black geometric forms floating on a plum background, there were seven monochrome plum-colored paintings and one solitary painting with a black form on a plum background.

Rothko arrived at the ultimate proportions of the works only after much experimentation.[6] In one of the preliminary studies, which was the size of the actual painting, there were three different tacking margins indicating changes sometimes no more than $\frac{3}{4}$ inch on an overall format of some 9 by 13 feet. Rothko was also obsessed with perfecting the relationship of the interior black rectilinear shape to the overall dimensions of the painting.

He adopted a slightly new procedure in the preparation of the Houston chapel murals – a little more complicated with additions of new materials to the paint film. For the first time he delegated the actual painting to his assistants although they were always under his strict supervision. Unprimed cotton duck was stretched over the large strainers and then stained with rabbit-skin glue mixed with powdered pigments diluted with water. Next, a layer of powdered pigments mixed with acrylic polymer and water was applied with brushes. In all cases, Rothko insisted on having two people working at once so that the paint films would dry evenly. In the paintings with the black form, the black area was drawn in with charcoal over the plum background. After editing and altering, the shape was established and painted with a layer of tube oil paint diluted with turpentine. The final layer, which Rothko mixed in unmeasured amounts, consisted of tube oil paint, turpentine, whole eggs, and dammar resin.[7]

Rothko did not live to see the chapel completed; it opened in January 1971, a year after his death. Since that time some of the paintings have changed dramatically. In the two black-form triptychs, a whitening effect has developed with cleaving and some loss of the paint film. The underlying changes that Rothko made in the size of the black form are becoming visible on the surface of the shape.[8] Efforts to arrest their progressive alteration have been rigorous

though noninvasive. The humidity and temperature systems of the chapel have been improved and the skylight baffled, but the deterioration has continued despite efforts to stabilize the environment. A substantial degree of time and expertise has been invested to determine the physical composition of the murals with a view to their preservation.

Consideration of treatment of the paintings themselves has presented a dilemma for their caretakers. These paintings already look very different from when they left the Rothko studio, and there is always a possibility that treatment would further alter their appearance. Preserving the art may mean compromising the artist's original vision. With Rothko's paintings, it is the surface that is significant, the very element that has altered the most.

In his last series of paintings (1968–70), Rothko introduced new materials into his reductive style. After hospitalization in 1968 (for an aneurysm of the aorta), Rothko was restricted to painting on paper which was less of a physical strain than working on canvas. He instructed his assistant to trim sheets from a roll of paper approximately 48 inches wide.[9] The paper support was then taped to large, upright sheets of plywood which served as easels. Originally Rothko attached the paper support to the easels by stapling along the edges, but because removing the staples often tore the paper, he switched to masking tape to attach the works to the easels (fig. 3).

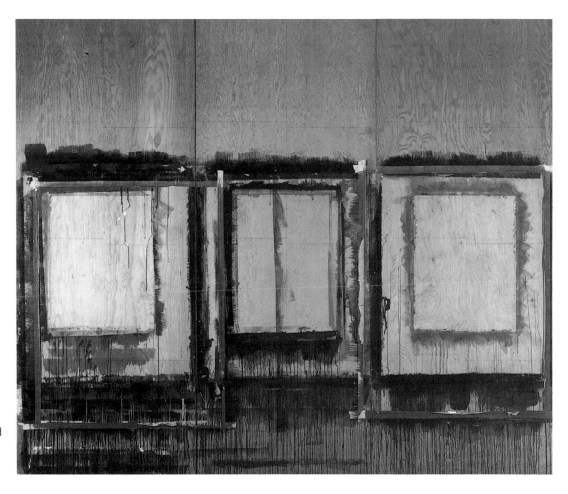

fig. 3 A surviving plywood easel for works on paper from Rothko's studio, 1968–70

The brilliant colors were painted with Pelikan brand ink, and subsequent layers of colors with Magna brand paint.[10] Many of these works were unusually large for works on paper, approximately 74 by 48 inches. As the masking tape was removed a stark white border appeared, a phenomenon that intrigued Rothko. Donald McKinney, a visitor to Rothko's studio during this time, later wrote of Rothko's response: 'And it was from his observation of this classic "studio accident" that he conceived doing the last major series of paintings – the Black and Gray acrylics on canvas.'[11] Rothko harvested this latest idea from his usual fertile source.

The compositions of these last works on canvas were extremely simplified, almost minimal. Each painting was divided into two areas, a dark black top and a gray bottom, separated by a horizontal seam which rose and fell from painting to painting. To duplicate the effect of the white border around the works on paper, Rothko had the stretched cotton duck primed with synthetic white gesso. A border of masking tape was attached along all four edges of the gessoed surface. The tape was sealed with a clear synthetic medium to prevent leakage under the tape when paint was applied to the body of the painting. After the top and bottom colors were painted and had dried, the tape was carefully removed, leaving the white border intact. The width of the border in each work differed, signifying borders determined by eye not ruler. Sometimes Rothko was dissatisfied with the width of a border and would then retape the painting and meticulously match colors and brushwork in the narrow strip of exposed gessoed ground to reduce the border's width.

The Black and Gray paintings have also changed in the two decades since their completion. The paint films were thinly applied; often the black top form has but one coat, very smoothly applied. The lower gray form, often including turgid brushwork, has no more than two to three layers of paint. Cracks have developed in the paint film, especially in the dark top form which is more brittle than the gray form, most likely because of its thin application. The cracks appear to be stress induced, some of them following the distinct outlines of numbers written on the reverse. The synthetic medium that was used to seal the tape on the white borders of the paintings had discolored, muting the stark effect they created.

Many artworks produced since World War II, including Rothko's paintings, cannot be approached with traditional conservation treatments. The delicate, underbound paint films, the unpredictable formulations of the paint medium, and the unconventional techniques of Rothko's paintings dictate new approaches to their care and maintenance. Established conservation procedures, such as wax-resin lining, when applied to works such as Rothko's, result in disaster. In such cases, the adhesive, heated wax-resin has penetrated from the reverse of the painting through the multiple, delicate striations of the paint film, inalterably transforming the physical structure of the film into an opaque sameness.

At the Mark Rothko Foundation, we began to indicate media as 'mixed' after determining that Rothko had used a widely varied combination of materials, including oil paint, synthetic paint, eggs, and other yet unidentified ingredients. The nature of the work was such that only extensive chemical analysis of each work could possibly yield, if then, an accurate

determination of the materials used for each painting. We used the term *mixed* as a reasonable alternative to publishing or otherwise disseminating false information which would also result in inappropriate treatment.

Of course, development in innovative approaches and materials for the treatment of these problematic works must be encouraged and nourished, but it should not be the only area of endeavor. There must be a corresponding commitment to preserving the art by taking preventative measures for its maintenance. The inherent fragility of these works must be recognized and heeded if our historic and aesthetic inheritance from this ingenious, though experimental age is to be preserved for others to ponder.

NOTES

1 'Strainers' and stretchers are both wooden sub-frames but a stretcher has a key or some similar device so that the canvas may be tensioned.

2 Joseph Solmon, telephone conversation with the author, February 1987, New York City; Max Doerner, *The Materials of the Artist and Their Use in Painting with notes on the Techniques of the Old Masters*; translated by Eugen Neuhaus (New York: Harcourt, Brace and World, 1934).

3 Leonard Bocour, conversation with the author, 24 May 1983, New York City.

4 Diane Waldman, *Mark Rothko: A Retrospective* (New York: Harry N. Abrams Inc., 1978), p. 276.

5 Elizabeth Jones, untitled and unpublished report to the director, Fogg Art Museum, Cambridge, Mass., 1971; telephone conversation with the author, 2 March 1987.

6 Carol Mancusi-Ungaro, 'Preliminary Studies for the Conservation of the Rothko Chapel Paintings: An Investigative Approach' (Paper delivered at the Ninth Annual Meeting of the American Institute for Conservation of Historic and Artistic Work, Philadelphia, Pa., 27–31 May 1981), pp.109–13.

7 *Ibid.*

8 *Ibid.*

9 Oliver Steindecker, conversation with the author, 10 May 1983, New York City.

10 *Ibid.*

11 Werner Haftmann, *Mark Rothko*, exhibition catalogue, translated by Margery Scharer (Zurich: Kunsthaus / New York: Marlborough Gallery / Boston: Book Art Co., 1971), p.xvi.

Select Bibliography 1978–1996

Compiled by Jane Savidge (to 1987); updated by Krzysztof Cieszkowski and Jane Henderson (1987–96).

An extensive bibliography of publications dating from before 1978 can be found in Waldman 1978 (the catalogue of the 1978–9 Guggenheim exhibition, see section 1 below).

Sections 1 and 2 are in alphabetical order, by author (for books) or town (for solo exhibition catalogues); sections 3 and 4 are arranged chronologically.

1 Books and solo exhibitions

Ashton, Dore. *About Rothko.* New York: Oxford University Press, 1983. 225p., illus.

Ashton, Dore. *About Rothko.* New York: Da Capo Press, 1994.

Barnes, Susan J. *The Rothko Chapel: an act of faith.* Houston: Rothko Chapel, 1989. 126p., illus.

Bersani, Leo, and Ulysse Dutoit. *Arts of impoverishment: Beckett, Rothko, Resnais.* Cambridge (MA), London: Harvard University Press, 1993. 229p., illus.

Blau, Daniel (hrsg.). *Mark Rothko: 'Multiforms': Bilder von 1947–1949.* [includes texts by Mark Stevens, David Anfam, Mark Rothko, Andreas Franzke, Siegfried Gohr]. Munich: Galerie Daniel Blau; Stuttgart: Verlag Gerd Hatje, 1993. 84p., illus.

Breslin, James E.B. *Mark Rothko: a biography.* Chicago, London: University of Chicago Press, 1993. 700p., illus.

Chave, Anna. *Mark Rothko's subject matter.* [Ph.D. dissertation, Yale University 1982]. 236p., illus. Distributed by UMI Dissertation Information Service.

Chave, Anna. *Mark Rothko: subjects.* Atlanta: High Museum of Art, 1983. 31p., illus. [published on the occasion of an exhibition, 15 Oct. 1983–26 Feb. 1984 (23 works)].

Chave, Anna C. *Mark Rothko: subjects in abstraction.* New Haven, London: Yale University Press, 1989. (Yale Publications in the History of Art, no.39). 224p., illus.

Chiba-shi, Kawamura Memorial Museum of Art. *Mark Rothko.* [exhibition catalogue, 23 Sept.–5 Nov. 1995; travelling to Marugame Genichiro-Inokuma Museum of Contemporary Art, 11 Nov.–24 Dec. 1995; Nagoya City Museum of Art, 4 Jan.–12 Feb. 1996; Museum of Contemporary Art, Tokyo, 17 Feb.–24 March 1996 (56 works)]. 226p., illus. Texts by David Anfam, Nobuyuki Hiromoto, Sumi Hayashi, Naaoko Seki.

Clearwater, Bonnie. *Mark Rothko: works on paper.* (with introduction by Dore Ashton). New York: Hudson Hills Press, 1984. 144p., illus [published on the occasion of an exhibition organised by the American Federation of Arts and The Mark Rothko Foundation, circulated May 1984–Sept. 1986, opening at National Gallery of Art, Washington, 6 May–5 Aug. 1984 (86 works)].

Cohn, Marjorie B. (ed.). *Mark Rothko's Harvard Murals.* Cambridge (MA): Center for Conservation and Technical Studies, 1988. illus.

Cologne, Museum Ludwig. *Mark Rothko 1903–1970: Retrospektive der Gemälde.* [exhibition catalogue, 30 Jan.–27 March 1988 (66 works)]. 213p., illus. Texts by Michael Compton, Robert Rosenblum, Mark Rothko.

Glimcher, Marc (ed.). *The art of Mark Rothko: into an unknown world.* [includes essays by Arnold Glimcher, Robert Rosenblum, Mark Stevens, Irving Sandler, Brian O'Doherty, and an interview by Arnold Glimcher]. New York: Clarkson N. Potter, 1991; London: Barrie & Jenkins, 1992. 168p., illus.

Kellein, Thomas. *Mark Rothko: Kaaba in New York.* [publ. on the occasion of an exhibition at Kunsthalle Basel, 19 Feb.–7 May 1989 (40 works); includes text by Michael Compton and interview by Arnold Glimcher]. Basel: Kunsthalle Basel, 1989. 95p., illus.

Liverpool, Tate Gallery Liverpool. *Mark Rothko: the Seagram Project.* [exhibition catalogue, 28 May 1988–12 Feb. 1989 (27 works)]. 32p., illus. Text by Michael Compton.

Madrid, Fundación Juan March. *Mark Rothko.* [exhibition catalogue, 23 Sept. 1987–3 Jan. 1988 (52 works)]. 120p., illus. Texts by Michael Compton, Mark Rothko.

Minneapolis, Walker Art Center. *Mark Rothko: seven paintings from the 1960s.* [exhibition catalogue, 6 Feb.–27 March 1983 (7 works)]. Text by Bonnie Clearwater.

New York, The Mark Rothko Foundation. *Eliminating the obstacles between the painter and the observer: The Mark Rothko Foundation: 1976–1986.* [includes texts by Donald M. Blinken, George DeSipio, David Roger Anthony, Bonnie Clearwater, Dana Cranmer]. New York: The Mark Rothko Foundation, 1986. 56p.

New York, Pace Gallery. *Mark Rothko: the 1958–1959 murals.* [exhibition catalogue, 28 Oct.–25 Nov. 1978 (10 works)]. 16p., illus. Interview by Arnold Glimcher.

New York, Pace Gallery. *Mark Rothko: the Surrealist years.* [exhibition catalogue, 24 April–30 May 1981 (45 works)]. 40p., illus. Text by Robert Rosenblum.

New York, Pace Gallery. *Mark Rothko: paintings 1948–1969.* [exhibition catalogue, 1–30 April 1983 (15 works)]. 42p., illus. Text by Irving Sandler.

New York, Pace Gallery. *Mark Rothko: the dark paintings 1969–70.* [exhibition catalogue, 29 March–27 April 1985 (15 works)]. 32p., illus. Text by Brian O'Doherty.

New York, Pace Gallery. *Mark Rothko: Multiforms.* [exhibition catalogue, 12 Jan.–10 Feb. 1990 (15 works)]. 47p., illus. Text by Mark Stevens.

New York, Pace Gallery. *Mark Rothko: the last paintings.* [exhibition catalogue, 18 Feb.–19 March 1994 (11 works)]. 38p., illus. Text by Brian O'Doherty.

St Ives, Tate Gallery St Ives. *Mark Rothko in Cornwall.* [exhibition catalogue, 4 May–3 Nov. 1996 (3 works)]. 14p., illus. Text by Chris Stephens.

San Francisco, Museum of Modern Art. *Mark Rothko 1949: a year in transition / selections from the Mark Rothko Foundation.* [exhibition catalogue, 18 March 1983–16 Sept. 1984 (9 works)]. 32p., illus. Text by Karen Tsujimoto.

Seldes, Lee. *The legacy of Mark Rothko.* London: Secker and Warburg, 1978. 372p., illus.

Tokyo, Museum of Contemporary Art. *Mark Rothko.* [exhibition catalogue, 17 Feb.–24 March 1996 (50+ works)] 226p., illus. Texts by David Anfam, Nobuyuki Hiromoto, Sumi Hatashi, Naoko Seki.

Waldman, Diane. *Mark Rothko.* New York: Harry N. Abrams, for Solomon R. Guggenheim Museum; London: Thames and Hudson, 1978. 296p., illus. [publ. on the occasion of the exhibition *Mark Rothko 1903–1970: a retrospective,* at the Solomon R. Guggenheim Museum, New York, 27 Oct. 1978–14 Jan. 1979 (198 works)].

Waldman, Diane. *Mark Rothko in New York* [Rothko's works in the Brooklyn Museum, Solomon R. Guggenheim Museum, Metropolitan Museum of Art, Museum of Modern Art, Whitney Museum of American Art]. New York: Solomon R. Guggenheim Museum of Art, 1994. 142p., illus.

2 Sections in general books, group exhibitions and public collection catalogues

Adams, Laurie. *Art on trial: from Whistler to Rothko.* New York: Walker, c.1976. pp.169–210, illus.

Berlin, Orangerie des Schloss Charlottenberg. *Zeichen des Glaubens: Geist der Avantgarde-Religiose Tendenzen in der Kunst des 20 Jahrhunderts* [exhibition catalogue 31 May–13 July 1980]. pp.35–6, illus. Text by H. Weitemeier-Steckel.

Buettner, Stewart. *American art theory 1945–1970,* Ann Arbor, Mich.: UMI Research Press, c.1981. passim. (Studies in the fine arts: art theory; no.1)

Cologne, Galerie Gmurzynska. *Klassische Moderne = Classical moderns* [exhibition catalogue May–Aug. 1981]. (1 work) pp.204–5, illus.

Cox, Annette. *Art as politics: the abstract expressionist avante-garde and society.* Ann Arbor, Mich.: UMI Research Press, c.1982. passim, illus. (Studies in the fine arts: the avant garde; no.26)

Edinburgh. City Art Centre and Fruitmarket Gallery. *American abstract expressionists* [exhibition catalogue 13 Aug.–12 Sept. 1981]. (5 works), illus. Introd. by Waldo Rasmussen.

Endicott Barnett, Vivian. *100 works by modern masters from the Guggenheim Museum.* Introd. and selected by Thomas M. Messer. New York: Harry N. Abrams, 1984. p.180, pl.88. On Mark Rothko's 'Violet, black, orange, yellow on white and red' 1949.

Fort Lauderdale (Fla.), Museum of Art. *An American Renaissance, painting and sculpture since 1940* [exhibition catalogue 12 Jan.–30 March 1986]. (1 work). pp.14–25, illus. General essay by Harry F. Gough.

Foster, Stephen C. *The critics of abstract expressionism.* Ann Arbor, Mich.: UMI Research Press, c.1980. passim, illus. (Studies in the fine arts: criticism: no.2)

Guilbaut, Serge. *How New York stole the idea of modern art: abstract expressionism, freedom and the cold war.* Chicago; London: University of Chicago Press, 1983. passim.

Hobbs, Robert Carleton and Gail Levin. *Abstract expressionism: the formative years.* Ithaca; London: Cornell University Press, 1981. passim, illus. Originally published as the catalogue of the exhibition held Ithaca, Herbert F. Johnson Museum of Art 30 March–14 May 1978.

Johnson, Ellen H. *American artists on art from 1940–1980.* New York: Harper & Row, c.1982. pp.10–14, illus. Includes Adolph Gottlieb and Mark Rothko (with the assistance of Barnett Newman). Letter to Edward Alden Jewell, Art Editor, *New York Times,* 7 June 1943.

London. Tate Gallery. *Catalogue of the Tate Gallery's collection of modern art other than works by British artists.* London: Tate Gallery: Sotheby Parke Bernet, 1981. pp.657–63, illus. Text by Ronald Alley.

London. Wildenstein Gallery. *Ten Americans from Pace* [exhibition catalogue 18 June–18 July 1980]. (2 works). n.p., illus.

Munich, Haus der Kunst. *Amerikanische Malerie 1930–1980* [exhibition catalogue 14 Nov. 1981–31 Jan. 1982]. (4 works). pp.20, 34–8, illus.

Paris, Centre Georges Pompidou. *Paris–New York* [exhibition catalogue 1 June–19 Sept. 1977]. p.527, illus. Text by Alfred Pacquement.

Roeder, George H. *Forum of uncertainty: confrontations with modern painting in twentieth century American thought.* Ann Arbor, Mich.: UMI Research Press, c.1980. (Studies in American history and culture; no.22).

Rose, Barbara. *American Painting: the twentieth century,* Geneva: Skira; New York: Rizzoli, 1986. pp.70–95, illus.

Sandler, Irving, *The New York School, the painters and sculptors of the fifties.* New York; London: Harper and Row, c.1978. pp.4, 10, 13, 35, 78, 82.

Seattle, Art Museum. *The Richard and Judy Lang Collection* [exhibition catalogue 2 Feb.–1 April 1984]. (4 works). pp.53–7, illus. commentary by Barbara Johns.

Seitz. William C. *Abstract expressionist painting in America.* Cambridge, Mass.; London: Harvard University Press for the National Gallery of Art, Washington, 1983. passim., illus. (The Ailsa Mellon Bruce studies in American art)

Selz, Peter. *Art in a turbulent era.* Ann Arbor, Mich.: UMI Research Press, c.1985. pp.257–63. (Contemporary American art critics; no.6)

Shestack, A. *Yale University Art Gallery: selections.* New Haven: Yale University Art Gallery, 1983. p.90, illus. Text by Lesley K. Baier. On 'Untitled' 1954.

Thorson. Victoria. *Great drawings of all time: the twentieth century.* Vol.2. New York: Shorewood Fine Art Books, 1979. n.p., illus. Text by Irving Sandler.

Toronto, Art Gallery of Ontario. *Mark Rothko memorial portfolio* [exhibition catalogue of work by 13 British artists in memory of Mark Rothko held 1984–5]. 4p., illus. Introd. by Karen Finlay.

Vevey, Musée Jenisch. *Peintres du silence: Julius Bissier, Giorgio Morandi, Ben Nicholson, Mark Rothko, Mark Tobey, Italo Valenti* [exhibition catalogue 13 Sept.–22 Nov. 1981]. (3 works). pp.71–7, illus. Introd. by Bernard Blatter. Text by Felix Andreas Baumann.

Washington, Corcoran Gallery. *Adolph Gottlieb: a retrospective* [exhibition catalogue 24 April–6 June 1981]. pp.40–2, 169–71. Includes Adolph Gottlieb and Mark Rothko (with the assistance of Barnett Newman). Letter to Edward Alden Jewell, Art Editor, *New York Times*, 7 June 1943 and Adolph Gottlieb and Mark Rothko. *The portrait and the modern artist* typescript of broadcast made on Radio WNYC, 13 Oct. 1943.

Washington, Hirshhorn Museum and Sculpture Garden. *The fifties: aspects of painting in New York* [exhibition catalogue 22 May–21 Sept 1980]. (2 works) passim, illus. Essay by Phyllis Rosenzweig.

Washington, National Gallery of Art, *American art at mid-century: the subjects of the artist* [exhibition catalogue 1 June 1978–14 Jan. 1979]. (8 works). pp.242–69, illus. Text by E.A. Carmean and Eliza E. Raithbone with Thomas B. Hess.

3 Articles and reviews

1978

Hilton Kramer. Rough deal [review of *The legacy of Mark Rothko* by Lee Seldes]. *New York Times*, Book Review Section, 26 March 1978. pp.8, 16, illus.

Laurie Adams. Legacy of a legal battle [review of *The legacy of Mark Rothko* by Lee Seldes]. *American Artist*, April 1978 (vol.42), pp.33–4.

Malcolm N. Carter. Art, money and the troubles of Mark Rothko. *Horizon*, Oct. 1978, pp.20–9, illus.

Malcolm N. Carter. He committed suicide and then the scandal began ... *San Francisco Chronicle*, 15 Oct. 1978. This World Section, p.45, illus.

Hilton Kramer. [Review of the Guggenheim exhibition 1978–9]. *New York Times* [News Service Supplementary Material], 27 Oct. 1978, pp.90–1.

Robert Hughes. The Rabbi and the moving blur [review of the Guggenheim exhibition 1978–9] *Time*, 112, no.19 (Nov. 1978), pp.64–5.

Hilton Kramer. Rothko – a sense of curious paradox [review of the Guggenheim exhibition 1978–9]. *San Francisco Chronicle*, 5 Nov. 1978, This World Section, p.53.

Hilton Kramer. Mark Rothko [review of the Guggenheim exhibition 1978–9]. *New York Times*, 6 Nov. 1978, p.55.

Hilton Kramer. Rothko – art as religious faith [review of the Guggenheim exhibition 1978–9 and the Pace Gallery exhibition 1978]. *New York Times*, 12 Nov. 1978, II, pp.1, 35, illus.

Rothko al Guggenheim [review of the exhibition held 1978–9]. *Casabella*, Dec. 1978 (no.42), p.[3].

Peter Fuller. The legacy of Mark Rothko. *Art Monthly*, Oct. 1978 (no.20), pp.3–5.

William Packer. Mark Rothko – the inward landscape [review of the Guggenheim exhibition 1978–9]. *Financial Times*, 7 Nov. 1978, p.21, illus.

Peter Fuller. The art world's Watergate. *New Society*, 7 Dec. 1978, pp.590–1, illus. Letter in reply from Sir Norman Reid in *New Society*. 21 Dec. 1978, p.720.

Robert Hughes. Blue chip sublime. *New York Review of Books*, 11 Dec. 1978, pp.8, 12–16.

Michael Shepherd. Art and Mammon [review of *The legacy of Mark Rothko* by Lee Seldes], *Sunday Telegraph*, 17 Dec. 1978, p.14.

1979

Michael Merz. Ich sammle keine Kunst, ich sammle geld geschichten um der Rothko-Prozess. *Du*, 1979 (no.4), pp.4–6.

Barbara Cavaliere. Mark Rothko [review of the Pace Gallery exhibition 1978]. *Arts Magazine*, Jan. 1979 (vol.53, no.5), p.20.

Donald Goddard. Rothko's journey into the unknown. *Art News*, Jan. 1979 (vol.78, no.1), pp.36–40.

Joseph Liss. Willem de Kooning remembers Mark Rothko: 'his house had many mansions' [interview] *Art News*, Jan. 1979 (vol.78, no.1), pp.41–4, illus.

Mark Rothko [review of the Guggenheim exhibition 1978–91. *Art International*, Jan. 1979 (vol.22, no.8), p.42.

Stephen Polcari. Mark Rothko. *Arts Magazine*, Jan. 1979 (vol.53, no.5), p.3, illus.

John T. Spike [Review of the Guggenheim exhibition 1978–9]. *Burlington Magazine*, Jan. 1979 (vol.121, no.910), pp.63–4.

Alfred Frankenstein. The Guggenheim looks at Rothko: [review of the exhibition held 1978–9]. *San Francisco Chronicle*, 4 Jan. 1979, p.41, illus.

Fritz Neugass. Tragische Malerei das Werk Mark Rothkos in Guggenheim Museum: [review of the exhibition held 1978–9]. *Frankfurter Allgemeine Zeitung*, 9 Jan. 1979, p.[1].

John McEwen. Art coping [review of *The legacy of Mark Rothko* by Lee Seldes]. *Spectator*, 13 Jan. 1979, pp.22–3.

Denis Thomas. If it sells it's art [review of *The legacy of Mark Rothko* by Lee Seldes]. *Listener*, 18 Jan. 1979, pp.143–4.

Barbara Cavaliere. Notes on Rothko. *Flash Art*, Jan.–Feb. 1979 (nos.86–7), pp.32–8, illus.

Dore Ashton. Rothko's passion. *Art International*, Feb. 1979 (vol.22, no.9), pp.6–13, illus.

Konstantin Bazarov. The Legacy of Mark Rothko by Lee Seldes [book review] *Art and Artists*, Feb. 1979 (vol.13, no.10), pp.46–8.

[Review of the Guggenheim exhibition 1978–9] *Kunstwerk*, Feb. 1979 (vol.32, no.1), pp.37–8.

T. Fujieda. Special feature: Mark Rothko. *Mizue*, March 1979 (no.888), pp.6–57, illus. Text in Japanese.

John Spurling. Hell on earth [reviews of *The legacy of Mark Rothko* by Lee Seldes; *Mark Rothko* by Diane Waldman]. *New Statesman*, 16 March 1979, pp.365–6.

Fred Hoffman. Glimpses of the transcendent [review of the Guggenheim exhibition on tour at the Museum of Fine Arts, Houston]. *Artweek*, 17 March 1979 (vol.10, no.11), pl., back page, illus.

Peter Schjeldahl. Rothko and belief. *Art in America*, March–April 1979 (vol.67, no.2), pp.78–85, illus.

Jessica Boissel. Technique de Rothko. *Art Press International*, April 1979 (no.27), pp.6–7, illus.

Nina Bremer. New York, The Solomon R. Guggenheim Museum. Exhibition: Mark Rothko 1903–1970: a retrospective [review]. *Pantheon*, April 1979 (no.37), p.128, illus.

Mark Rothko. Une texte de Mark Rothko: traduction Jessica Boissel. *Art Press International*, April 1979 (no.27), p.7.

Phillipe Sollers. Mark Rothko psaume. *Art Press International*, April 1979 (no.27), pp.4–6, illus.

William Packer. Rothko and Steinberg [review of Mark Rothko by Diane Waldman. *Financial Times*, 21 April 1977, p.120.

Jean-Luc Bordeaux. Rothko. *Connaisance des Arts*, May 1979 (no.327), pp.114–19, illus.

Rothko [review of the Guggenheim exhibition on tour at the County Museum of Art, Los Angeles 1971], *Oeil*, Sept. 1979 (no.290), p.69, illus.

Stephen Polcari. The intellectual roots of abstract expressionisim: Mark Rothko. *Arts Magazine*, Sept. 1979 (vol.54, no.1), pp.124–34, illus.

John and Natasha Stodder. Rothko on film [review of film *In search of Rothko by Courtney Sale*]. *Artweek*, 15 Sept. 1979 (vol.10), p.16, illus.

1981

Grace Glueck. Art: Rothko as surrealist in his pre abstract years: [review of the Pace Gallery exhibition 1981]. *New York Times*, 1 May 1981, 111, p.18.

Roberta Smith. Mark Rothko's surrealistic billows [review of the Pace Gallery exhibition 1981]. *Village Voice*, 6–12 May 1981, p.82, illus.

1983

Thomas Albright. Art: the critical year for Rothko: Mark Rothko 1949: a year in transition [review of the San Francisco Museum of Modern Art exhibition, 1983–4]. *San Francisco Chronicle*, 13 March 1983, Review Section, pp.11–12, illus.

Rothko. *Bulletin of the Walker Art Centre, Minneapolis*, Jan. 1983, p.1.

Valentine Tatransky. [Review of the Pace Gallery exhibition 1983] *in Kenneth Noland: as great as ever*. Arts *Magazine*, 1983 (vol.57, no.10), p.119.

Catherine Fox. Rothko abstracts evoke emotion on a large scale [review of the High Museum of Art exhibition 1983–4]. *Atlanta Constitution*, 30 Oct. 1983, Section H, pp.1, 8, illus.

Howard Singerman. Tainted image: Rothko on tv [review of *The Rothko Conspiracy*]. *Art in America*, Nov. 1983 (vol.71), pp.11–13, 15, illus.

1984

Rotliko show to open at National Gallery [preview of the National Gallery of Art exhibition held Washington 1984]. *American Federation of Arts Newsletter*, April 1984, pp.1, 4, illus.

Carla Hall. Celebrating the art of Rothko [review of the National Gallery of Art exhibition 1984]. *Washington Post*. 4 May 1984, Section B, pp.1, 8, illus.

Paul Richard. Rothko on paper: gazing at eternity [review of the National Gallery of Art exhibition 1984]. *Washington Post*, 13 May 1984, Section H, pp.1, 5.

Mark Rothko: works on paper [review of the National Gallery of Art exhibition 1984]. *Museum News*, June 1984 (vol.62, no.5), pp.71–2.

William Feaver. Art: [review of the National Gallery of Art exhibition 1984]. *Observer*, 3 June 1984, p.20.

Stephen Gardiner. New academic? [review *of About Rothko by Dore Ashton*]. *Listener*, 16 Aug. 1984, p.26.

Waldemar Januszczak. Elusive art [review of *About Rothko by Dore Ashton*]. *Guardian*, 23 Aug. 1984. p.8, illus.

William Feaver. American sublime [review *of About Rothko by Dore Ashton*]. *Observer*, 26 Aug. 1984, p.19.

Peregrine Horden. Dark on dark [review of *About Rothko by Dore Ashton*]. *Spectator*, 8 Sept. 1984, pp.28–9.

1985

Michael Brenson. Rothko: the dark paintings [review of the Pace Gallery exhibition 1985]. *New York Times*, 12 April 1985, III, p.23.

Michael Brenson. Rothko at the Guggenheim: [review of the National Gallery of Art exhibition 1984 on tour at the Guggenheim]. *New York Times*, 7 June 1985, III, pp.1, 24, illus.

Bonnie Clearwater. How Rothko looked at Rothko. *Art News*, Nov. 1985 (vol.84, no.9), pp.100–3, illus.

Robin Duthy. The Fortunes of Rothko: immensely admired his paintings are not always easy to sell. *Connoisseur*, Nov. 1985 (vol.215, no.886), pp.174–85, illus.

Irvin Molotsky. Six Rothko murals to hang at the National. *New York Times*, 10 Nov. 1985, I, p.81, illus.

1986

Rothko on paper [Oregon Art Institute, Portland]. *Southwest Art*, March 1986, vol.15, pp.82–3, illus.

Claude R. Cernuschi. Mark Rothko's mature paintings: a question of content. *Arts Magazine*, May 1986 (vol.60, pt.9) pp.54–7, illus.

1987

Roland Bothner. Mark Rothkos Modulationen. *Pantheon*, 1987 (vol.45), pp.175–8, illus.

David Lee. Brush with fame and death. *Times*, 13 June 1987, p.50, illus.

Richard Dorment. The colours of nothing [review of Tate exhibition]. *Daily Telegraph*, 18 June 1987, p.9, illus.

Waldemar Januszczak. Bright light in the dark [review of Tate exhibition]. *Guardian*, 20 June 1987, p.11, illus.

William Packer. Sensations of light [review of Tate exhibition]. *Financial Times*, 23 June 1987, p.21, illus.

Tim Hilton. In the colour field [review of Tate exhibition]. *Times Literary Supplement*, 26 June 1987, p.671, illus.

Marina Vaizey. Hovering on clouds of many colours [review of Tate exhibition]. *Sunday Times*, 28 June 1987, p.51, illus.

John Russell Taylor. Magisterial progression [incl. review of Tate exhibition]. *Times*, 1 July 1987, p.18, illus.

Richard Cork. Pictures as dramas [review of Tate exhibition]. *Listener*, 2 July 1987, pp.38–9, illus.

Larry Berryman. [review of Tate exhibition]. *Arts Review*, 3 July 1987 (vol.39), p.448.

Richard Boston. A bit on the side [review of Tate exhibition]. *Guardian*, 3 July 1987, p.21.

John Spurling. Tragedy in colour [review of Tate exhibition]. *New Statesman*, 3 July 1987, pp.22–3, illus.

William Feaver. The dead dragon [review of Tate exhibition]. *Observer*, 5 July 1987, p.20, illus.

Brian Sewell. A Fry's eye view of Rothko [review of Tate exhibition]. *Evening Standard*, 7 July 1987, illus.

Giles Auty. Rothko redux [incl. review of Tate exhibition]. *Spectator*, 27 July 1987, p.42, illus.

Laure Meyer. [review of Tate exhibition]. *L'Oeil*, July/Aug. 1987 (no.384/5), p.83.

Peter Fuller. Mark Rothko, 1903–1970. *Burlington Magazine*, Aug. 1987 (vol.129), pp.545–7.

Martin Holman. [review of Tate exhibition]. *Tablet*, 8 Aug. 1987, p.849.

David Anfam. Mark Rothko at the Tate Gallery. *Art International*, Autumn 1987 (no.1), pp.96–9.

Robin Stemp. Mark Rothko at the Tate Gallery. *The Artist*, Sept. 1987 (vol.102), p.32–3.

Francisco Prados de la Plaza. La inquietud de Rothko en buesca de respuetas. *Goya*, Nov./Dec. 1987 (no.201), pp.186–7, illus.

1988

Gerhard Kolberg. Mark Rothko: Meditationsbilder. *Kölner Museums-Bulletin*, 1988 (no.1), pp.22–33, illus.

Jonathan Harris. Mark Rothko and the development of American Modernism 1938–1948. *Oxford Art Journal*, 1988 (vol.11, no.1), pp.40–50, illus.

Katy Deepwell, Juliet Steyn. Readings of the Jewish artist in late Modernism. *Art Monthly*, Feb. 1988 (no.113), pp.6–9, illus.

Stephen Polcari. Mark Rothko: heritage, environment, and tradition. *Smithsonian Studies in American Art*, Spring 1988 (vol.2, no.2), pp.32–63, illus.

Alexander Theroux. Artists who kill, and other acts of creative mayhem. *Art & Antiques*, Sept. 1988, pp.95–8, 101–4, illus.

Eric Gibson. The other Rothko scandal. *New Criterion*, Oct. 1988 (vol.7), pp.85–8.

Richard Roud. The sorry saga of Rothko at Harvard. *Guardian*, 28 Oct. 1988, p.34.

Charles Giuliano. Blaming the victim. *Art News*, Nov. 1988 (vol.87), p.38.

Haun Saussy. [review of Harvard exhibition]. *Arts Magazine*, Nov. 1988 (vol.63, no.3), p.96, illus.

J.R.R. Christie, Fred Orton. Writing on a text of the life. *Art History*, Dec. 1988 (vol.11, no.4), pp.545–64.

1989

Frances K. Pohl. Antifascism in American art. *Archives of American Art Journal*, 1989 (vol.29, no.1–2), pp.52–6, illus.

Thomas Kellein. Mark Rothko: sieben 'Seagram Murals' für Japan und zwei fehlende in London. *Kunst-Bulletin des Schweizerischen Kunstvereins*, March 1989, pp.2–9, illus.

Hilton Kramer. Was Rothko an abstract painter? *New Criterion*, March 1989 (vol.7, no.7), pp.1–5.

Patrick Heron. Can Mark Rothko's work survive? *Modern Painters*, Summer 1989 (vol.2, no.2), pp.36–7, 39, illus.

Volker Baumeister. [review of Kunsthalle Basel exhibition]. *Das Kunstwerk*, June 1989 (vol.42), pp.50–1.

Avis Berman. Art destroyed: sixteen shocking case histories. *Connoisseur*, July 1989 (vol.219, no.930), pp.74–81, illus.

Andrew Becker. Rothko's legacy: the Mark Rothko Foundation closes shop. *Art News*, Sept. 1989 (vol.88), p.41.

Terry Atkinson. Rothko: convention and deconstruction. *Art Monthly*, Nov. 1989 (no.131), pp.10–12, 14, 16, illus.

1990

Thomas Trischler. Mark Rothko: subject as abstraction. *Revue d'Art Canadienne/ Canadian Art Review*, 1990 (vol.17, no.2), pp.187–92.

Elizabeth Hayt-Atkins. [review of Pace Gallery exhibition]. *Art News*, May 1990, (vol.89, no.5), p.204, illus.

David Carrier. [review of Pace Gallery exhibition]. *Art International*, Summer 1990 (no.11), pp.66–7.

1991

Nancy Jachec. The space between art and political action: Abstract Expressionism and ethical choice in postwar America 1945–1950. *Oxford Art Journal*, 1991, (vol.14, no.2), pp.18–27, illus.

1992

Kosme de Baranano. Rothko: la humedad de la luz. *Kalias*, 1992 (vol.4, no.7), pp.30–3, 147, illus.

Anthony O'Hear. The real or the Real? Chardin or Rothko? *Modern Painters*, Spring 1992 (vol.5, no.1), pp.58–62, illus.

Claude Cernuschi. Communication without conventions? reading Rothko's abstractions. *Notes in the History of Art*, Spring–Summer 1992 (vol.11, no.3–4), pp.65–9, illus.

1993

Lucinda Barnes. A proclamation of moment: Adolph Gottlieb, Mark Rothko, and Barnett Newman and the letter to the New York Times. *Allen Memorial Art Museum Bulletin*, 1993 (vol.47, no.1), pp.2–13, illus.

Vincent J. Bruno. Mark Rothko and the Second Style: the art of the color-field in Roman murals. *Studies in the History of Art*, 1993 (vol.43), pp.234–55, illus.

Paola Serra Zanetti. Rothko o la tragedia di un solitario. *Arte*, Jan. 1993 (vol.23, no.236), pp.52–7, illus.

Robin Cembalest. Rothko revealed [the Rothko murals at Cambridge, Mass.]. *Art News*. April 1993 (vol.92), p.42, illus.

1994

Peter Conrad. Abstracting a life [review of Breslin's biography of Rothko]. *Observer*, 9 Jan. 1994, p.17, illus.

Julia Neuberger. The man the past never left alone [review of Breslin's biography of Rothko]. *Times*, 10 Jan. 1994, p.32, illus.

T.J. Clark. In defense of Abstract Expressionism: on vulgarity as a reflection of bourgeois taste in the New York School painters. *October*, Summer 1994 (no.69), pp.22–48, illus.

Simon Morley. Fields of colour, fields of despair: the closing-in of Mark Rothko's 'joyful vision of absence' [review of Breslin's biography of Rothko]. *Times Literary Supplement*, 3 June 1994, pp.18–19, illus.

Steven Henry Madoff. [review of Pace Gallery exhibition]. *Art News*, Summer 1994 (vol.93), p.176.

1996

Rachel Barnes. Leaving a mark [interview with Patrick Heron, on the occasion of the St Ives exhibition]. *Art Review*, May 1996, pp.28, 30, illus.

Martin Gayford. Black and white view of nature [review of St Ives exhibition]. *Daily Telegraph*, 8 May 1996, illus.

Adrian Searle. When Mr Gloom came to play [review of St. Ives exhibition]. *Guardian*, 14 May 1996, illus.

Michael Compton. The big picture [on the occasion of the St Ives exhibition]. *Tate*, Summer 1996, pp.49–51, illus.

Sam Richards. Objects of contemplation [review of St Ives exhibition]. *South West*, June 1996, p.23, illus.

Simon Morley. Yanks: Tobey and Rothko in England [review of St Ives exhibition]. *Art Monthly*, July–Aug. 1996 (no.198), pp.9–12, illus.

4 General articles and reviews

1978

F. Poli. Gloria, debiti, opere: Guai per gli eredi d'artista: Quando un artista muore. *Bolaffiarte*, April 1978 (vol.9, no.78), pp.54–7.

Paul Richard. Seven abstract American heroes [review of the group exhibition *American art at mid century* held National Gallery of Art, Washington 1978–79]. *Washington Post*, 11 June 1978, Section k, p.1, illus.

B.H. Friedman. 'The Irascibles': a split second in art history. *Arts Magazine*, Sept. 1978 (vol.53, no.1), pp.96–102.

1979

Ian Dunlop. Edvard Munch. Barnett Newman and Mark Rothko: the search for the sublime. *Arts Magazine*, Feb. 1979 (vol.53, no.6), pp.128–30.

Catherine Millett. De Kooning, Newman, Rothko: des bâtards. *Art Press International*, March 1979 (no.26), p.24.

Richard Wollheim. L'oeuvre d'art comme object. *Cahiers du Musée National d'Art Moderne*, July/Sept 1979 (vol.1, pt.1), pp.122–35.

1981

Rolf-Gunter Dienst. Absolute Malerei: zu einer Kunst der Reduktion und Differenzierung. *Kunstwerk*. 1981 (vol.34, no.4), pp.3–47, illus.

E.A. Carmean. The sandwiches of the artist. *October*, no.16 (Spring 1981), pp.87–101, illus.

Ann Gibson. Regression and color in abstract expressionism: Barnett Newman, Mark Rothko and Clyfford Still. *Arts Magazine*, March 1981 (vol.55, no.7), pp.144–53, illus.

Evan R. Firestone. Color in abstract expressionismn: sources and background for meaning. *Arts Magazine*, March 1981 (vol.55, pt.7), pp.140–3.

Anna-Mei Chadwick. American abstract expressionists: [review of the group exhibition held Edinburgh. City Art Centre and Fruitmarket Gallery, 1981]. *Connoisseur*, Aug. 1981 (vol.207, no.834), pp.244–5.

Barbara Cavaliere. Possibilities II. *Arts Magazine*, Sept. 1981 (vol.56, no.1), pp.104–11, illus.

1982

Kart Ruhrberg. Gegenbilder. Grenzüberschreitungen bei Barnett Newman und Mark Rothko. *Kunst und Kirche*, 1983 (no.3), pp.156–8, illus.

Bonnie Clearwater. Shared myths: reconsideration of Rothko's and Gottlieb's letter to the New York Times. *Archives of American Art Journal*, 1984 (vol.24, no.1), pp.23–5, illus.

Ingrid Rein. Jenseits von Eden: [die Kunstler des abstrakten expressionismus]. *Du*, 1984 (no.5), pp.64–73, illus.

1985

J. Hernando Carrasco. Expresionismo cromatico en España: la leccion de Rothko. *Goya*, Jan./Feb. 1985 (no.184), pp.227–38.

1986

Barry Schwabsky. 'The real situation': Philip Guston and Mark Rothko at the end of the sixties. *Arts Magazine*, Dec. 1986 (vol.61, no.4), pp.46–7, illus.

Addenda: Publications since 1996 edition

1997

New York, PaceWildenstein. *Bonnard, Rothko: colour and light*. (exhibition catalogue, 19 Feb. –22 March 1997). 69p., illus. Text by Bernice Rose.

Nodelman, Shelton. *The Rothko Chapel paintings: origins, structure, meaning* (on the occasion of an exhibition at the Menil Foundation, Houston). Houston: Menil Foundation; Austin: University of Texas Press, 1997. 359p., illus.

1998

Anfam, David. *Mark Rothko: the works on canvas: catalogue raisonné*. New Haven, London, Washington: Yale University Press, 1998. 708p., illus.

Washington, National Gallery of Art. *Mark Rothko*. (exhibition catalogue, 3 May–16 Aug. 1998; travelling to Whitney Museum of American Art, New York, 10 Sept.–29 Nov. 1998 (116 works), and Musée d'art moderne de la ville de Paris, 8 Jan.–18 Apr. 1999 [see below]. 376p., illus. Text by Jeffrey Weiss, John Gage, Barbara Novack and Brian O'Doherty, Carol Mancusi-Ungaro, Jessica Stewart.

Rosenblum, Robert. Isn't it romantic? (Review of Washinton exhibition). *Artforum*, May 1998, vol.36, no.9, pp.116–19.

Robertson, Bryan. About Rothko (on the occasion of the Washington exhibition). *Modern Painters*, Autumn 1998, vol.11, no.3, pp.24–9.

1999

Paris, Musée d'art moderne de la ville de Paris. *Mark Rothko* (exhibition catalogue, 8 Jan. – 18 Apr. 1999) 292p., illus. Text by John Gage, Barbara Novak and Brian O'Doherty, Carol Mancusi-Ungaro, Jeffrey Weiss, Eric Michaud, Jessica Stewart.

List of Lenders

Sarah Campbell Blaffer Foundation 38
Buffalo, Albright-Knox Art Gallery 54

Cologne, Museum Ludwig 45

Dallas Museum of Art 77
Denmark, Louisiana Museum of Art 12

Mr and Mrs Graham Gund 49

London, Tate Gallery 39, 57, 62–70, 82

Milwaukee Art Museum 53

Mrs Barnett Newman 10
New York, Solomon R. Guggenheim Museum 16, 25, 34
New York, Metropolitan Museum of Art 14, 28, 29
New York, Museum of Modern Art 33, 55, 75
New York, Whitney Museum of American Art 42

Philadelphia Museum of Art 13, 50
Pittsburgh, Carnegie Museum of Art 51

Rhode Island School of Design, Museum of Art 46
Christopher Rothko and Kate Rothko Prizel 3, 5, 21, 37, 43,
 58, 76
Estate of Mark Rothko 6, 7, 18, 20, 26, 31, 35, 36, 47, 48,
 52, 56, 71, 72, 73, 79, 80, 83, 84, 87, 88, 90

Joseph E. Seagram & Sons Inc. 60
Lelila and Melville Straus 61

Mr and Mrs Allen M. Turner 32

Washington, National Gallery of Art 1, 2, 4, 8, 9, 11, 15, 17,
 19, 22, 23, 24, 27, 30, 40, 59, 74, 78, 81, 85, 86, 89, 91,
 92, 93
Washington, Phillips Collection 41

Yale University Art Gallery 44

Photographic credits